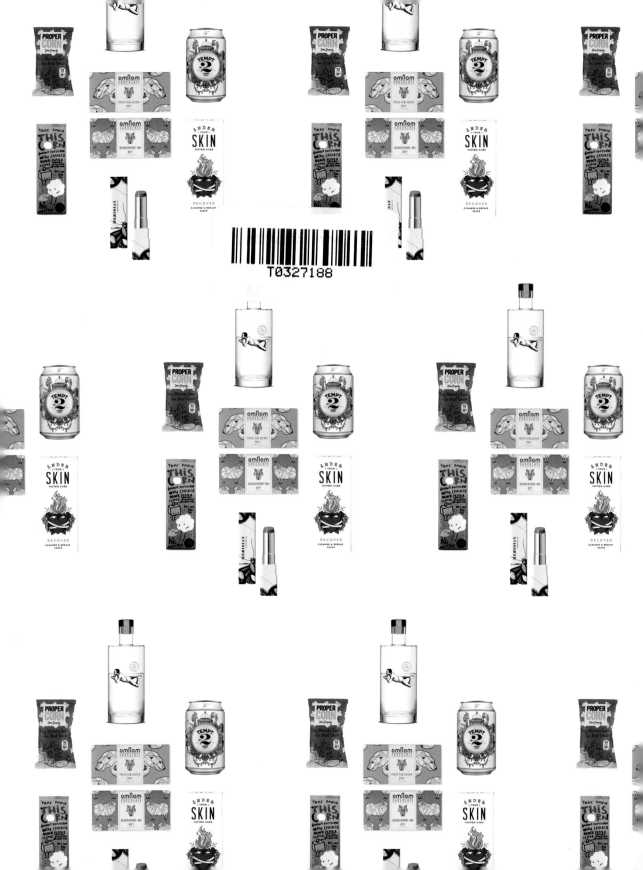

T0327188

-illustrated-
PACKAGING

(Desing and Illustration packaging)

Copyright © 2016 Instituto Monsa de Ediciones

Editor, concept, and project director
Josep María Minguet

Co-author
Carolina Amell

Art director, design and layout
Carolina Amell
(Monsa Publications)

Cover design
Carolina Amell
(Monsa Publications)

INSTITUTO MONSA DE EDICIONES
Gravina 43 (08930)
Sant Adrià de Besòs
Barcelona (Spain)
Tlf. +34 93 381 00 50
www.monsa.com
monsa@monsa.com

Visit our official online store!
www.monsashop.com

Follow us on facebook!
facebook.com/monsashop

ISBN: 978-84-16500-08-6
D.L. B 26818-2015
Printed by Grafo

Cover and back cover image courtesy of Horse-studio.com

-illustrated-
PACKAGING
(Desing and Illustration packaging)

BY CAROLINA AMELL

monsa

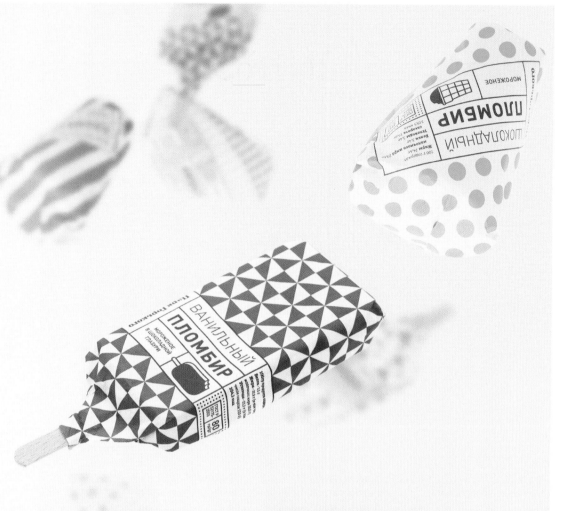
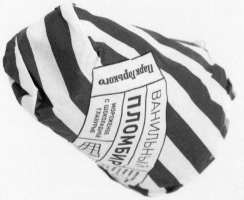

INTRO

For the most important brands, Packaging now is a different type of concept. It is now the main image for the product, and as such the utmost care is taken of way the product is presented. It is the packaging which helps consumers to understand and to wish to own a perfume, a piece of jewellery, a drink, a meal...

We are perfectly capable of differentiating between certain products simply using their packaging as a reference point.

In this book our aim has been to find a different and more contemporary concept for compiling the material. We are referring to the concept of "illustration". We shall encounter authentic works of art made out of different materials and a variety of techniques, in what is more contemporary packaging.

We have sorted the material into different categories such as Food, Beverages, and Cosmetics products and on this occasion, we also thought it was apt to include Projects created by students - this category covers these new designers' trends, and also more recent studies, which show us a new vision of the world of packaging.

El concepto de Packaging ha tomado un nuevo sentido para las grandes marcas, haciendo de este la imagen principal del producto, cuidando más que nunca la presentación, lo que ayuda a entender y a desear un perfume, una joya, una bebida, una comida...

Sabemos diferenciar perfectamente ciertos artículos sólo por su packaging.

Para este libro hemos querido buscar un concepto diferente para la recopilación del material, nos referimos a "la ilustración".

En el encontraréis auténticas obras de arte plasmadas en diferentes materiales y con variadas técnicas que dan actualidad a sus embalajes.

Ordenamos el material en diferentes categorías: Alimentación, Bebidas y Productos de cosmética. En esta ocasión hemos creído importante incluir también proyectos realizados por estudiantes, que aportan nuevas tendencias y una frescura e ilusión inigualables.

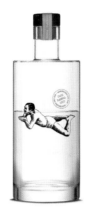
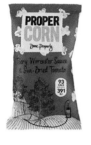
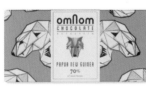
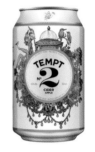
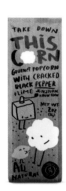
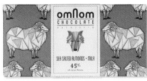

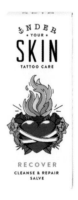

INDEX

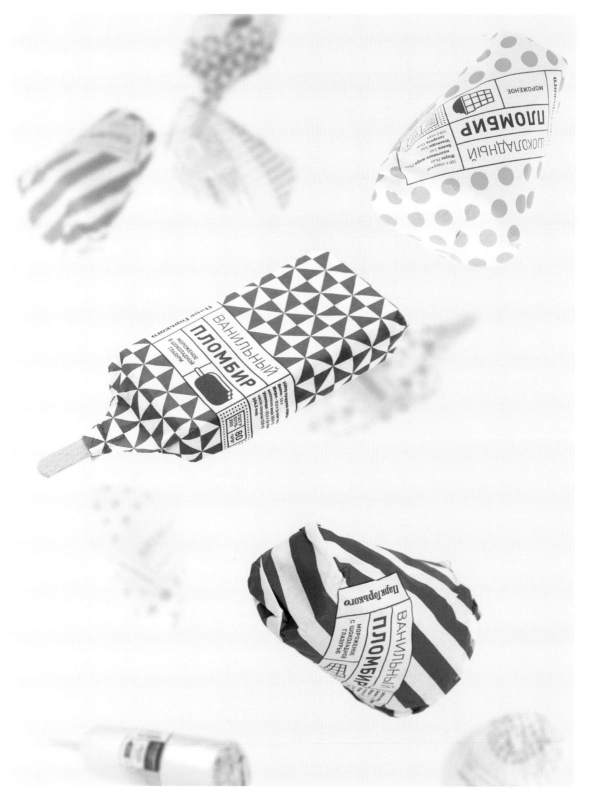

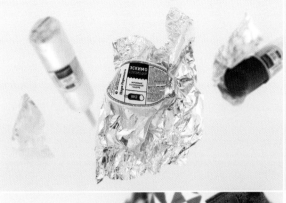
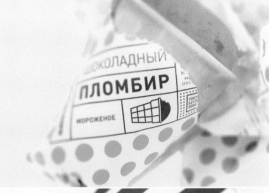
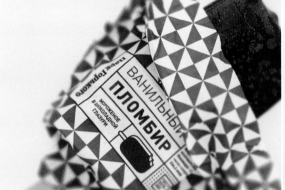
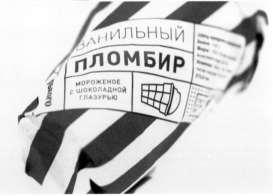

Art direction
Misha Gannushkin

Graphic designer
Anastasia Genkina

Project
Gorky Park ice cream

Client
Gorky Park ice cream

Project description
This ice cream has been a treat inseparable from a walk in the Moscow Gorky Park for decades. The special taste of creamy vanilla and waffle cone became a memory of childhood for several generations, and it has remained true to the old fashioned recipe. The aim to connect the historical value with modern recognition through design was achieved by developing patterns, inspired by key symbols of the Park's life. Each pattern corresponds with one of the six flavours.

Dirección artística
Misha Gannushkin

Diseñador gráfico
Anastasia Genkina

Proyecto
Gorky Park ice cream

Cliente
Gorky Park ice cream

Descripción del proyecto
Este helado ha sido un premio inseparable de un paseo por el Parque Gorki de Moscú durante décadas. El especial sabor de su cremosa vainilla y del cucurucho de barquillo se convirtió en un recuerdo de la infancia de muchas generaciones y sigue fiel a la antigua receta. El objetivo de conectar el valor histórico con el reconocimiento moderno a través del diseño se logró desarrollando patrones, inspirados en símbolos clave de la vida del Parque. Cada patrón se corresponde con uno de los seis sabores.

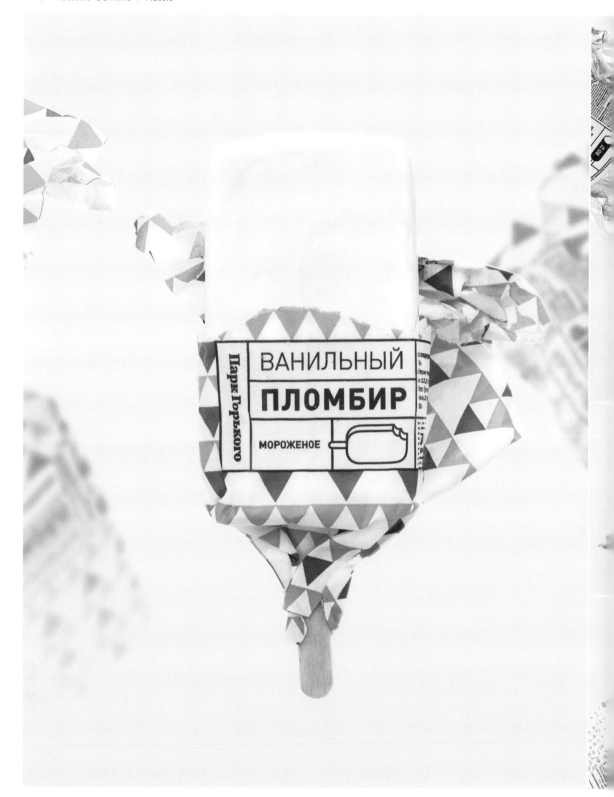

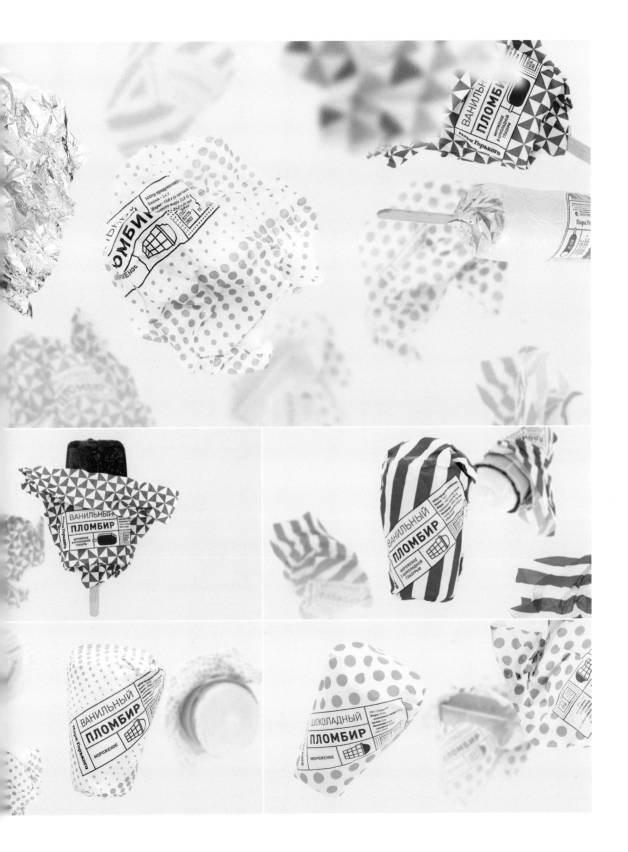

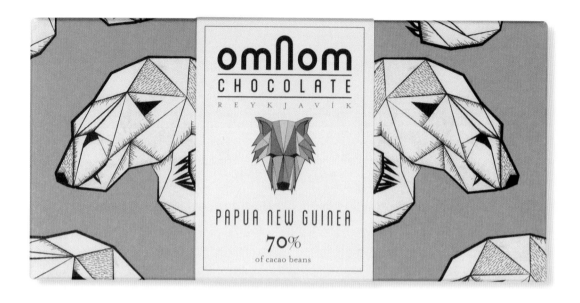

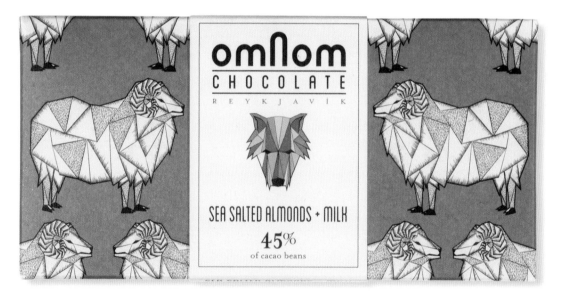

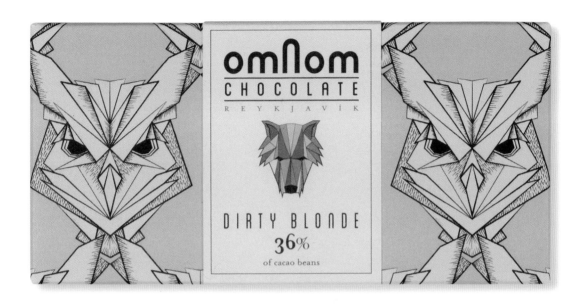

omNom
CHOCOLATE
REYKJAVÍK

DIRTY BLONDE
36%
of cacao beans

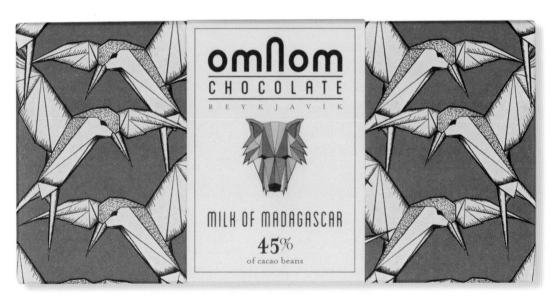

omNom
CHOCOLATE
REYKJAVÍK

MILK OF MADAGASCAR
45%
of cacao beans

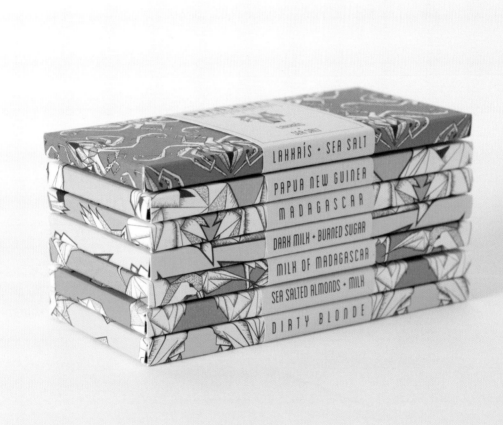

LAKKRÍS · SEA SALT

PAPUA NEW GUINEA

MADAGASCAR

DARK MILK · BURNED SUGAR

MILK OF MADAGASCAR

SEA SALTED ALMONDS · MILK

DIRTY BLONDE

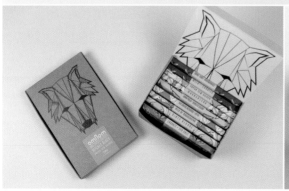

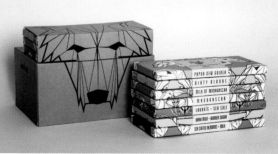

Art direction
The North South Studio

Project
Omnom Chocolate

Client
Omnom Chocolate

Project description
Packaging is the first visual and last physical contact a brand has with a customer and we wanted it to be a lasting one.

Ultimately we aimed to design packaging for Omnom Chocolate that would add value and function to the product.

At the same time it had to be aesthetically pleasing and possess an attraction that will in turn elevate it to a must-have item.
The packaging unfolds into a serving tray - complete with glacier tops - to enjoy and share, then it collapse

back into the envelope box state to protect any uneaten chocolate safely and neatly.

The illustrated characters were created out of inspiration from living and traveling in Iceland. They are both real and mythical. We are developing a continuous adventure world of Omnom that will be added graphically to the packaging as the brand grows and expands, keeping

the same functionality of the packaging.

Our packaging won Award of Exellence in the Grapevine Product Design Awards 2015, Bronze in the European design Awards 2015 and a Silver for Best Packaging in the Academy of Chocolate Awards 2015.

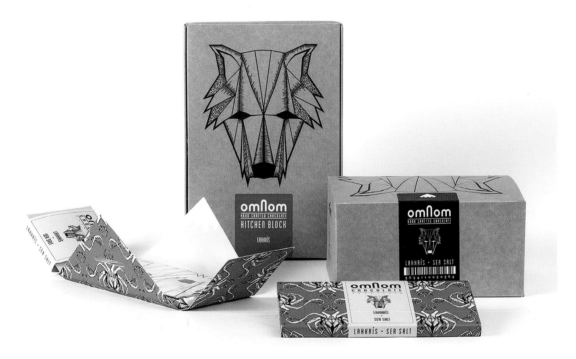

Dirección artística
The North South Studio

Proyecto
Omnom Chocolate

Cliente
Omnom Chocolate

Descripción del proyecto
El packaging es el primer contacto visual y el último contacto físico que una marca tiene con un cliente y nosotros queríamos que fuese uno que durase.

Básicamente pretendíamos diseñar un packaging para Omnom Chocolate que añadiera valor y funcionalidad al producto.

Al mismo tiempo tenía que ser agradable desde el punto de vista estético y poseer una atracción que lo convirtiese en un "must have".
El packaging se abre en una bandeja – rematada con cumbres de glaciares – para disfrutar y compartir.

Luego, se cierra como una caja en forma de sobre para proteger, de forma segura y cuidadosa, el chocolate que haya quedado.

Los personajes ilustrados se crearon a partir de la inspiración de vivir y viajar por Islandia. Son reales y míticos.
Estamos desarrollando un mundo ininterrumpido de aventuras de Omnom que se añadirá de forma gráfica al packaging a medida

que la marca crezca y se expanda, manteniendo la funcionalidad del packaging.

Nuestro packaging ha ganado el premio Grapevine Product Design Awards 2015, el Bronce en los premios europeos European Design Awards 2015 y la Plata para el Mejor Packaging en los premios Academy of Chocolate Awards 2015.

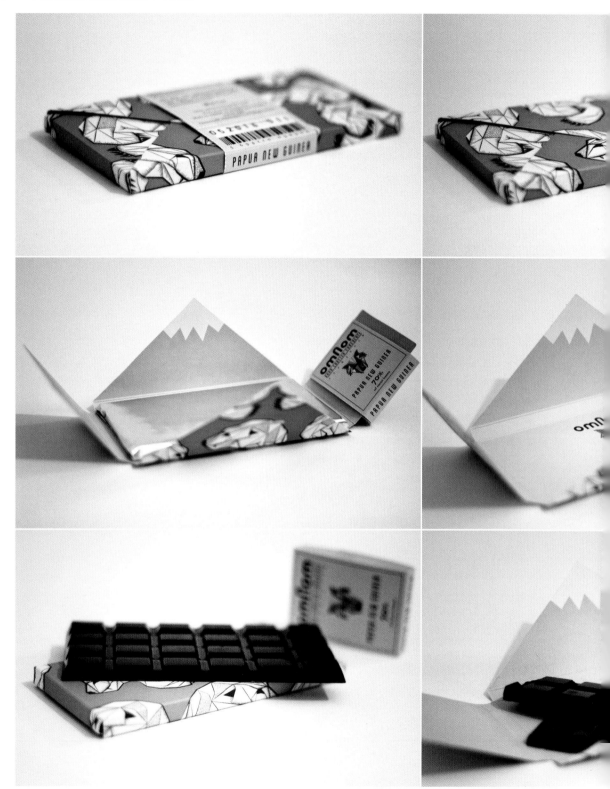

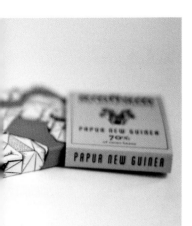

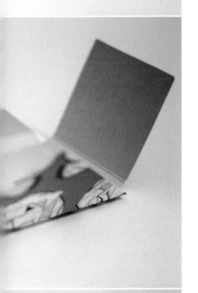

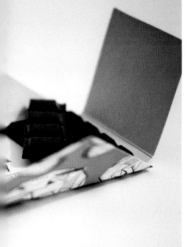

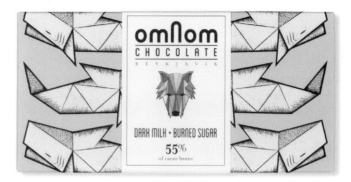

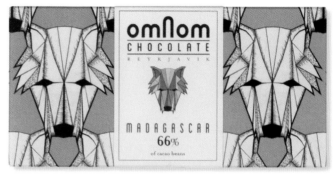

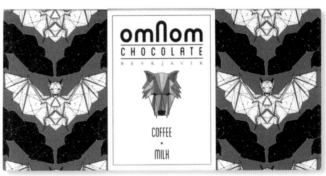

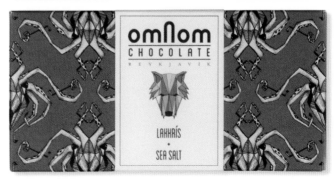

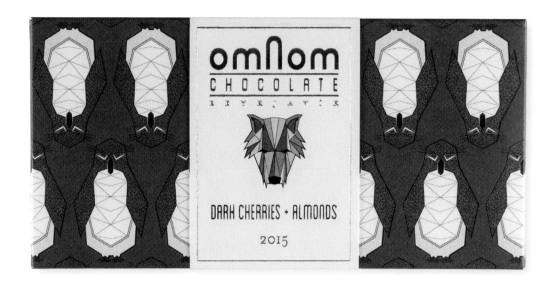

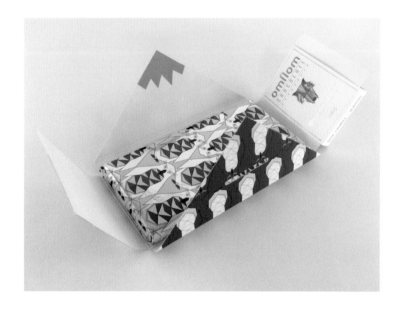

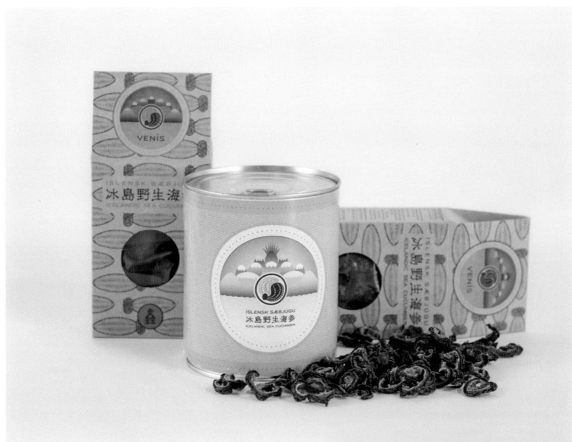

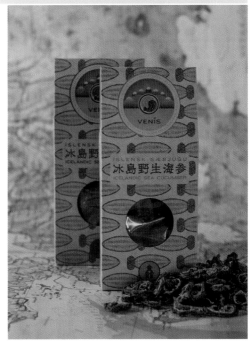

Art direction
The North South Studio

Project
Icelandic Sea Cucumber

Client
Venís

Project description
We were asked to create a brand identity and packaging for sustainably sourced Icelandic sea cucumbers by Venís in the cold waters of the Arctic.
The yin and yang were central to the brief.

Dirección artística
The North South Studio

Proyecto
Icelandic Sea Cucumber

Cliente
Venís

Descripción del proyecto
Venís, de las frías aguas del Ártico, nos pidió que creáramos un packaging e identidad de marca para pepinos de mar islandeses de origen sostenible.
El yin y el yang fueron el centro del trabajo.

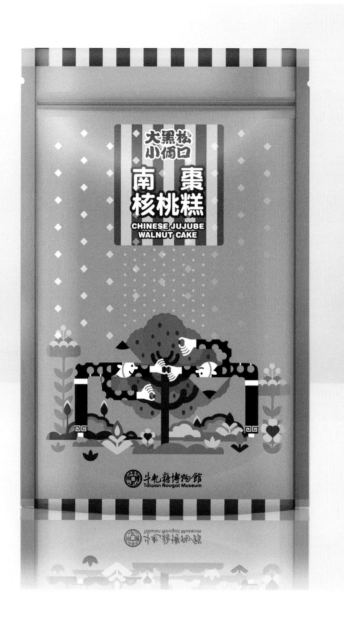

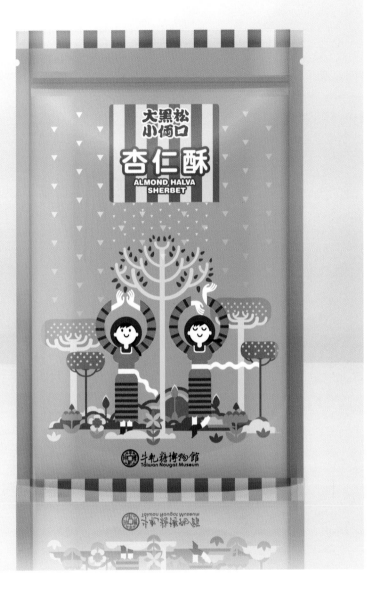

Art director
Lai Shin

Project
Salico Foods

Client
Salico Foods

Project description
The Salico Foods enterprise is one of the most famous desert (or souvenir) brand in Taiwan.

The clients need a new design concept differ from the past to enhance the quantities from different sides of consumers. This series packing go with brighter, vivid colors and accompany with cute, humor drawing, revealing a joyfully and abundantly scenes.

Dirección artística
Lai Shin

Proyecto
Salico Foods

Cliente
Salico Foods

Descripción del proyecto
La empresa Salico Foods es una de las marcas más famosas de postres (o souvernirs) de Taiwán.

El cliente necesita un nuevo concepto de diseño que se distinga del pasado para mejorar las ventas entre distintos tipos de clientes. Esta serie de embalajes va con colores alegres, más brillantes, y con dibujos lindos y divertidos que sugieren lugares ricos y alegres.

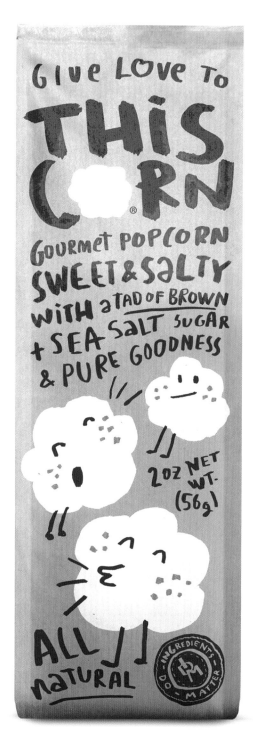

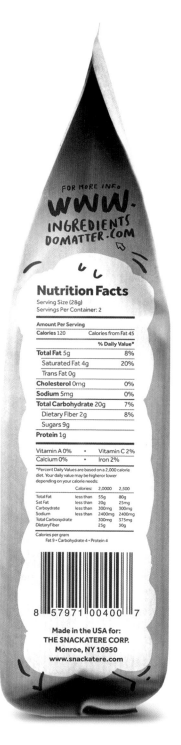

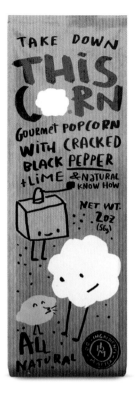

TAKE DOWN THIS CORN

GOURMET POPCORN WITH CRACKED BLACK PEPPER +LIME & NATURAL KNOW HOW

NET WT. 2oz (56g)

ALL NATURAL

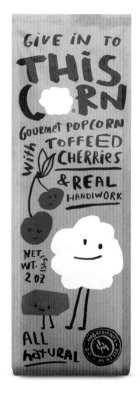

GIVE IN TO THIS CORN

GOURMET POPCORN WITH TOFFEED CHERRIES & REAL HANDIWORK

NET WT. 2 oz (56g)

ALL natural

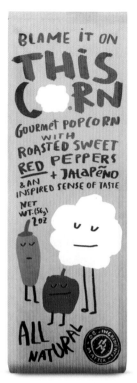

BLAME IT ON THIS CORN

GOURMET POPCORN WITH ROASTED SWEET RED PEPPERS + JALAPEÑO & AN INSPIRED SENSE OF TASTE

NET WT. (56g) 2oz

ALL NATURAL

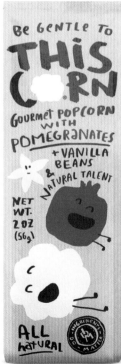

BE GENTLE TO THIS CORN

GOURMET POPCORN WITH POMEGRANATES + VANILLA BEANS & NATURAL TALENT

NET WT. 2 oz (56g)

ALL natural

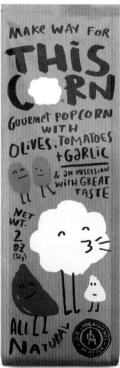

MAKE WAY FOR THIS CORN

GOURMET POPCORN WITH OLIVES, TOMATOES + GARLIC & AN OBSESSION WITH GREAT TASTE

NET WT. 2 oz (56g)

ALL NATURAL

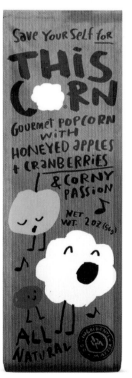

Save Your Self for THIS CORN

GOURMET POPCORN WITH HONEYED APPLES + CRANBERRIES & CORNY PASSION

NET WT. 2 oz (56g)

ALL NATURAL

Art direction
Peter GregsonStudio

Project
This corn gourmet kettle popcorn. 2013

Client
The Snackatere Corp.

Project description
Task: Naming, brand ID and packaging design for gourmet kettle popcorn.
Intention: To create wittily identity with the clever, memorable name, that will communicate more than ingredients and taste.
Design elements: Character illustration instead of appealing photos, colorful palette, handwritten copy.
Results: Unique and memorable Brand ID and lovely packaging which strongly stand out from the other snack products.

Dirección artística
Peter GregsonStudio

Proyecto
This corn gourmet kettle popcorn. 2013

Cliente
The Snackatere Corp.

Descripción del proyecto
Tarea: diseño del packaging, identidad de marca y nombre para unas palomitas gourmet.
Intención: crear una identidad divertida con un nombre inteligente y fácil de recordar que comunique más que los ingredientes y el sabor.
Elementos de diseño: ilustración de un personaje en lugar de fotos atractivas, una paleta llena de color, copias manuscritas.
Resultados: identidad de marca exclusiva y fácil de recordar y un bonito packaging que resalta ampliamente sobre los demás tentempiés

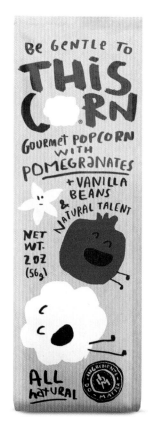

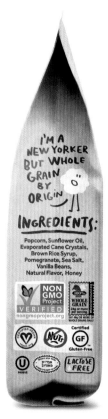

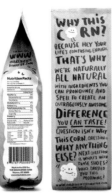

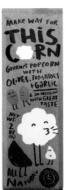

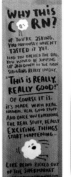

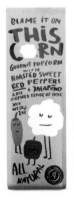
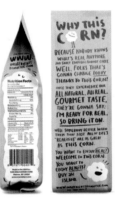

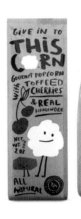

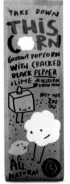

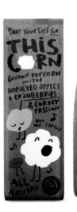

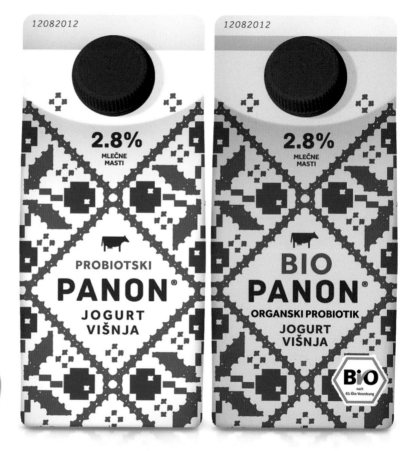

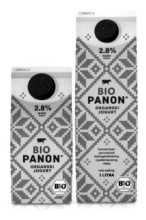
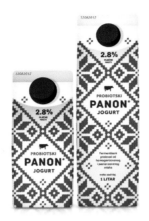
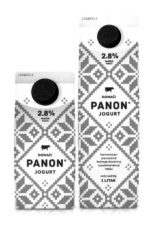
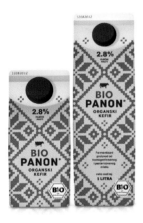
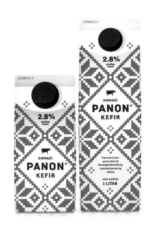
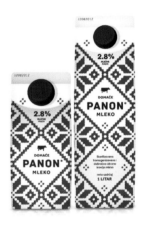

Art direction
Peter GregsonStudio

Project
Biopanon organic and non-organic dairy products. 2013

Client
Global Seed

Project description
Task: Brand ID and packaging design for organic and non-organic dairy products named PANON and BIOPANON. Intention: Recognizing an opportunity - to go back to the basics, both in design and tradition.
Design elements: Traditional embroidery pattern turned it into a simple graphic form. Simple color solutions without appealing narrative elements.
Results: Unique and memorable Brand ID, completely different consumers perception of dairy products.

Dirección artística
Peter GregsonStudio

Proyecto
Biopanon organic and non-organic dairy products. 2013

Cliente
Global Seed

Descripción del proyecto
Tarea: diseño del packaging e identidad de marca de productos lácteos orgánicos y no orgánicos llamados BIOPANON y PANON. Intención: reconocimiento de una oportunidad, volver a los básicos, tanto en el diseño como en la tradición.
Elementos de diseño: los patrones de bordado tradicionales se vuelven formas gráficas simples. Soluciones de color simples con elementos narrativos atractivos.
Resultados: identidad de marca exclusiva y fácil de recordar, completamente distinta a la percepción de los productos lácteos de los consumidores.

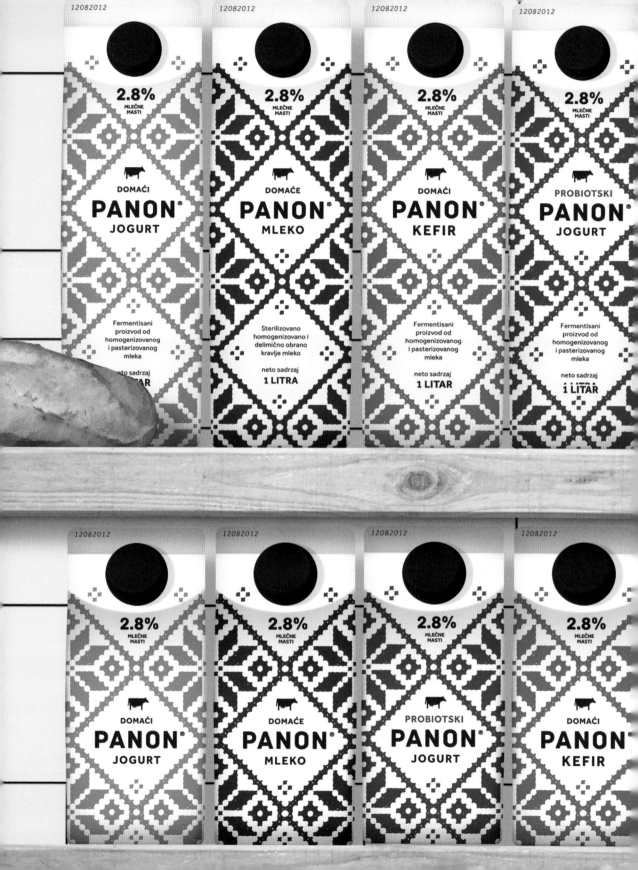

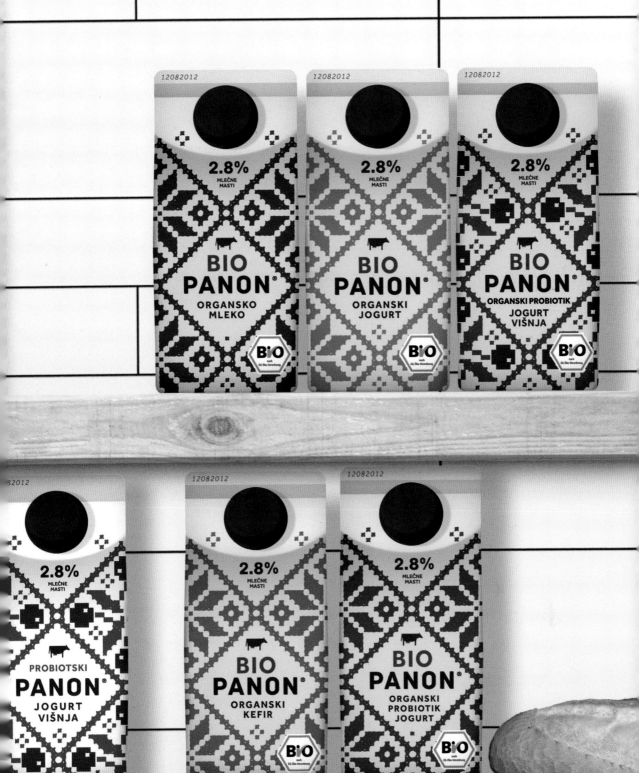

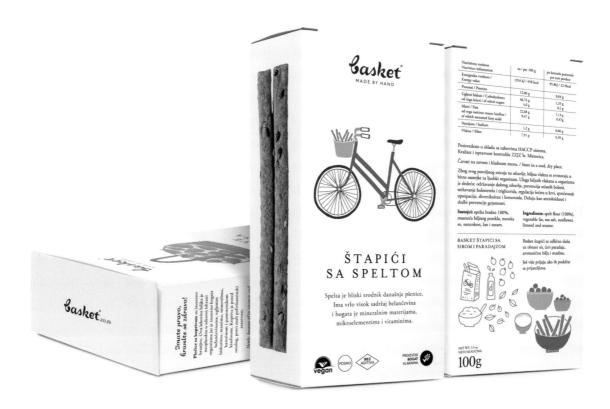

Art direction
Peter GregsonStudio

Project
Basket snacks. 2013

Client
Basket

Project description
Task:Packaging and ID redesign for hand made, rustic, low calorie snack.
Intention: To create brand ID that will became Love brand and synonym for this kind of snacks, but also to communicate ingredients origin and snacks quality.
Design elements: Clear facing, leaving the unnecessary information out, lovely illustration that refer on local iconographic.
Results: Better perception on the shelves in the market, clear distinction from similar products and drastic increase in sales.

Dirección artística
Peter GregsonStudio

Proyecto
Basket snacks. 2013

Cliente
Basket

Descripción del proyecto
Tarea: rediseñar el packaging y la identidad de marca de un tentempié bajo en calorías, rústico, casero.
Intención: crear una identidad de marca que se convierta en una love brand y sea sinónimo de este tipo de tentempiés pero también comunicar el origen de los ingredientes y la calidad.
Elementos de diseño: enfoque claro, dejando la información innecesaria fuera, ilustraciones bonitas que hagan referencia a la iconografía local.
Resultados: mejor percepción en los expositores del mercado, distinción clara de productos similares y aumento drástico de las ventas.

basket
MADE BY HAND

INTEGRALNI MIX

Seme suncokreta je bogato nezasićenim mastima i proteinima, kikiriki je odličan antioksidant, a kim doprinosi detoksikaciji celog organizma.

basket
MADE BY HAND

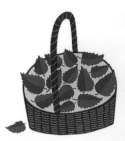

HRSKAVE PLOČICE SA KOPRIVOM

Kopriva se zbog svoje vitaminske i prehrambene vrednosti smatra izuzetno zdravim, korisnim i pristupačnim povrćem, naravno i lekom.

BLAGO LJUTI UKUS

basket
MADE BY HAND

HRSKAVE LANENE PLOČICE

Lan je biljka sa najvećim sadržajem omega 3 masnih kiselina, dok je izbalansirana mešavina 5 vrsta žitarica odličan izvor dijetetskih vlakana.

basket
MADE BY HAND

KREKERI BASKET 5

Golice bundeve, semenke suncokreta, lana i susama, kikiriki - 5 veličanstvenih sastojaka u jednom proizvodu. Zahvaljujući tome, Basket 5 je bogat vitaminima B grupe, vitaminom E, mineralima i biljnim vlaknima.

basket
MADE BY HAND

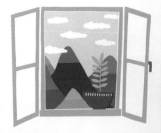

HRSKAVE HELJDINE PLOČICE

Heljda i rogač regulišu nivo holesterola u krvi i time smanjuju rizik od dijabetesa i arterioskleroze.

BLAGO SLADAK UKUS

basket
MADE BY HAND

HRSKAVE OVSENE PLOČICE

Ovas je jedna od najhranjivijih žitarica. Vrlo je dobar izvor kalcijuma i masnih kiselina koje su raspoređene u izuzetno povoljnoj meri.

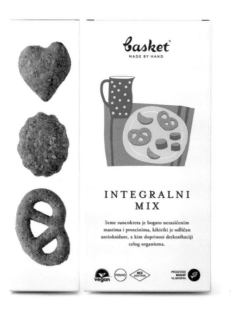

INTEGRALNI MIX

Seme suncokreta je bogato nezasićenim mastima i proteinima, kikiriki je odličan antioksidant, a kim doprinosi detoksikaciji celog organizma.

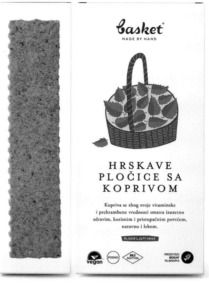

HRSKAVE PLOČICE SA KOPRIVOM

Kopriva se zbog svoje vitaminske i prehrambene vrednosti smatra izuzetno zdravim, korisnim i pristupačnim povrćem, naravno i lekom.

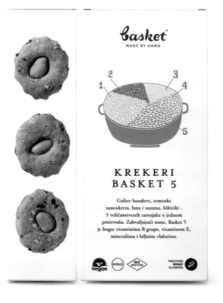

KREKERI BASKET 5

Golice bundeve, semenke suncokreta, lana i susama, kikiriki - 5 veličanstvenih sastojaka u jednom proizvodu. Zahvaljujući tome, Basket 5 je bogat vitaminima B grupe, vitaminom E, mineralima i biljnim vlaknima.

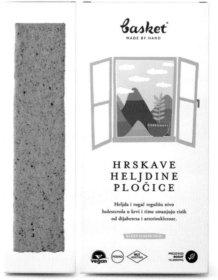

HRSKAVE HELJDINE PLOČICE

Heljda i rogač regulišu nivo holesterola u krvi i time smanjuju rizik od dijabetesa i arterioskleroze.

SKAVE
NENE
ČICE

a najvećim sadržajem
nih kiselina, dok je
elavina 5 vrsta žitarica
dijetetskih vlakana.

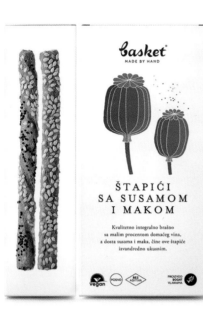

basket
MADE BY HAND

ŠTAPIĆI
SA SUSAMOM
I MAKOM

Kvalitetno integralno brašno
sa malim procentom domaćeg vina,
a dosta susama i maka, čine ove štapiće
izvanredno ukusnim.

vegan · POSNO · BEZ ADITIVA · PROIZVOD BOGAT VLAKNIMA

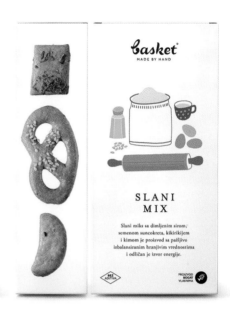

basket
MADE BY HAND

SLANI
MIX

Slani miks sa dimljenim sirom,
semenom suncokreta, kikirikijem
i kimom je proizvod sa pažljivo
izbalansiranim hranjivim vrednostima
i odličan je izvor energije.

BEZ ADITIVA · PROIZVOD BOGAT VLAKNIMA

KAVE
SENE
ČICE

najhranjivijih žitarica.
or kalcijuma i masnih
asporedene u izuzetno
jnoj meri.

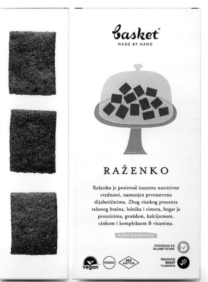

basket
MADE BY HAND

RAŽENKO

Raženko je proizvod izuzetne nutritivne
vrednosti, namenjen prvenstveno
dijabetičarima. Zbog visokog procenta
raženog brašna, lešnika i cimeta, bogat je
proteinima, gvožđem, kalcijumom,
cinkom i kompleksom B vitamina.

BLAGO SLADAK UKUS

POGODAN ZA DIJABETIČARE

vegan · POSNO · BEZ ADITIVA · PROIZVOD BOGAT VLAKNIMA

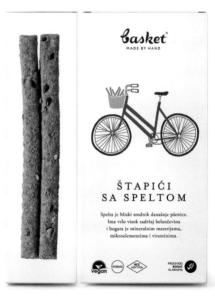

basket
MADE BY HAND

ŠTAPIĆI
SA SPELTOM

Spelta je bliski srodnik današnje pšenice.
Ima vrlo visok sadržaj belančevina
i bogata je mineralnim materijama,
mikroelementima i vitaminima.

vegan · POSNO · BEZ ADITIVA · PROIZVOD BOGAT VLAKNIMA

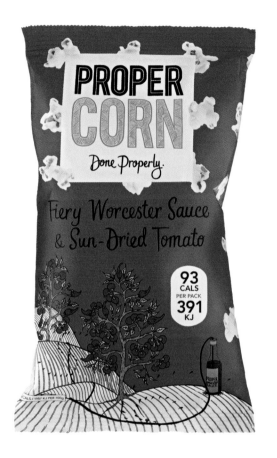

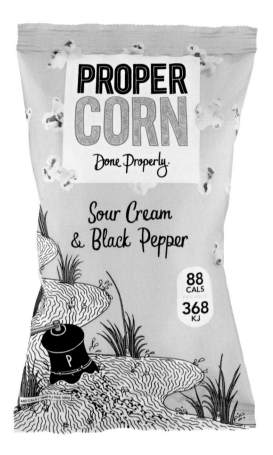

Art direction
done in-house by our
creative team

Illustration Edward Wood

Project
PROPERCORN

Client
PROPERCORN

Project description
Cassandra Stavrou,
Propercorn's co-founder,
designed our initial packaging
4 years ago. The first crude
sketches were created by
pen and Powerpoint and
brought to life through the
wonderful illustrations of Zoe
More O'Ferrall. As the brand
has evolved, package design
has developed into a truly
collaborative process within
the team, with each piece
developed in-house from
concept to artworking. Our
new packaging was illustrated
by the enormously talented,
Edward Wood, who also drew
all the typography. The level
of care and thought that goes
into every part of the brand
and, more specifically, its
aesthetics, is something that
we never compromise on.

Results: shelf standout,
market differentiation and
expression of our creativity.

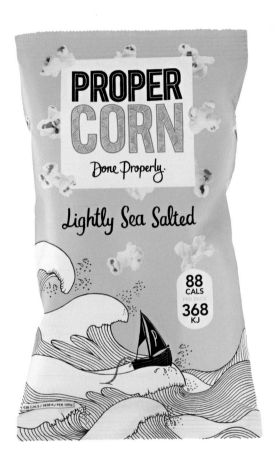

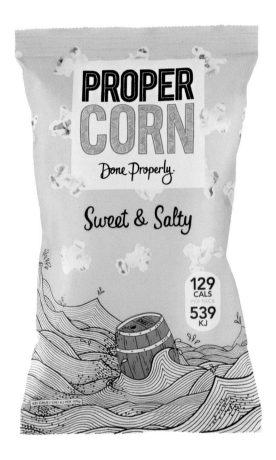

Dirección artística
done in-house by our
creative team

Ilustración Edward Wood

Proyecto
PROPERCORN

Cliente
PROPERCORN

Descripción del proyecto
Cassandra Stavrou,
cofundadora de Propercorn,
diseñó nuestro packaging
inicial hace cuatro años. Los
primeros bocetos se crearon
con bolígrafo y PowerPoint y
cobraron vida a través de las
maravillosas ilustraciones de
Zoe More O'Ferrall. Al tiempo
que la marca ha evolucionado,
el diseño del packaging se ha
transformado en un proceso
de colaboración dentro
del equipo, desarrollando
internamente cada pieza
desde el concepto hasta el
diseño. El prodigioso Edward
Wood, que también dibujó
toda la tipografía, ilustró
nuestro nuevo packaging. El
nivel de cuidado y reflexión
que va en cada parte de
la marca y, de forma más
concreta, su estética,
es algo a lo que nunca
renunciaremos.

Resultados: notoriedad en
el expositor, diferenciación
de mercado y expresión de
nuestra creatividad.

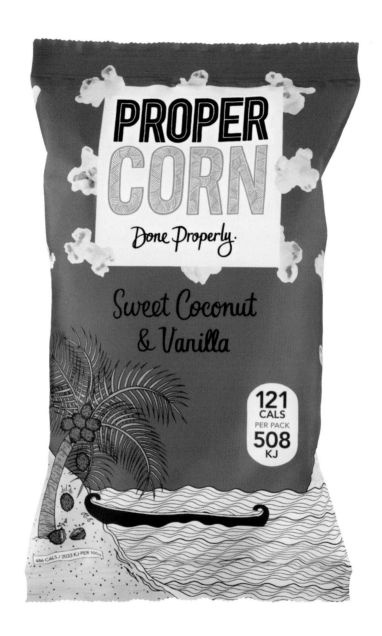

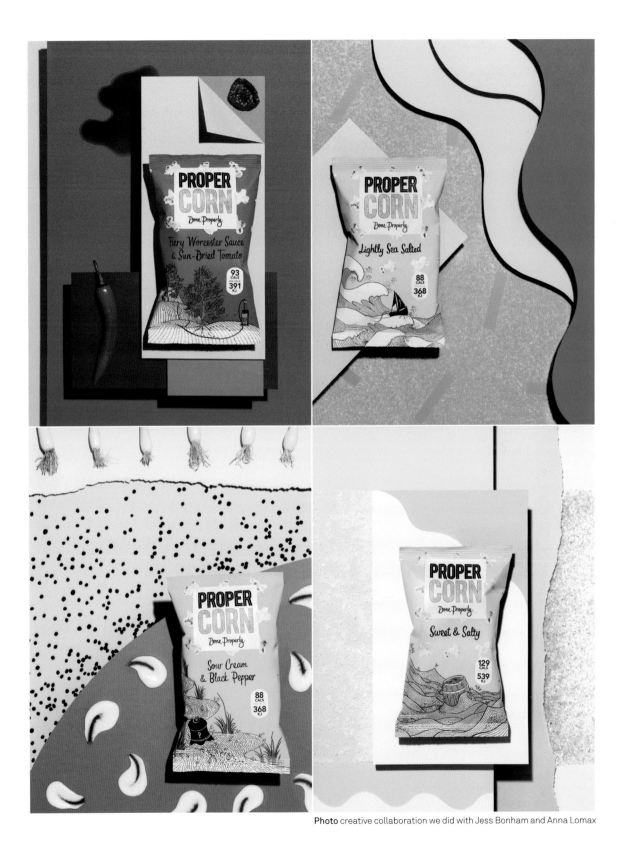

Photo creative collaboration we did with Jess Bonham and Anna Lomax

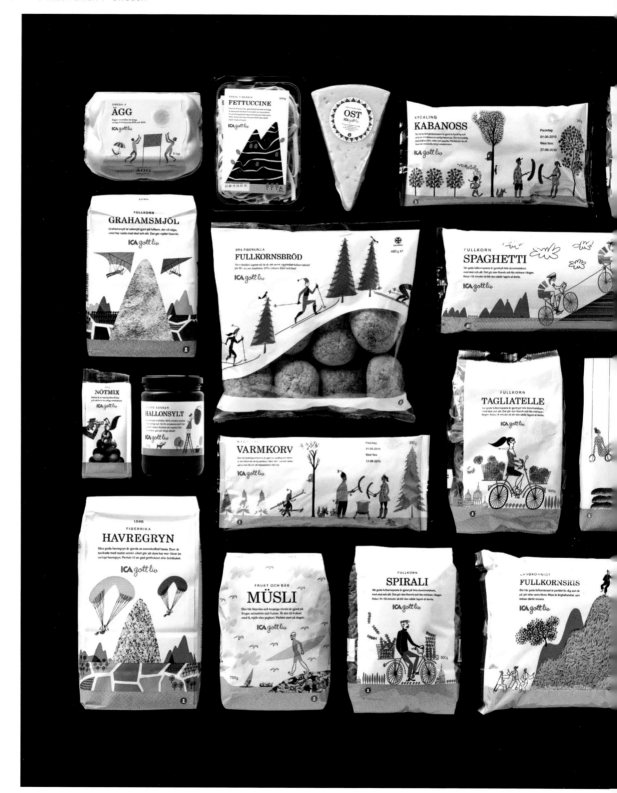

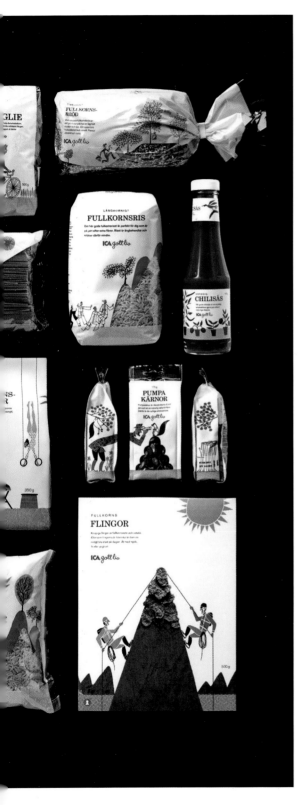

Illustration
Klas Fahlen

Project
ICA good life

Client
ICA

Project description
ICA is Sweden's biggest food chain and the brief was to create a packaging concept for their private health label, containing about a hundred products. The task was to visualize "healthy living" in a way which would create interest for all costumers not just the health conscious ones.

We began to look at the competition in Sweden - and then did the opposite of what had been done before. Instead of being bland we chose to be more personal, instead of being scientific we chose to be more explanatory. We wanted the product line to be real, more personal and foremost a real tasty choice. Therefore, we created a healthy, playful world with characters and situations all connecting to a "healthy and good active life" without being too rigorous, boring or "healthy=tasteless".

Ilustración
Klas Fahlen

Proyecto
ICA good life

Cliente
ICA

Descripción del proyecto
ICA es la cadena de comida sueca más grande y el encargo era crear un concepto de packaging para su marca blanca de productos sanos, que tiene unos cien productos. La tarea consistía en visualizar la «vida sana» de forma que se cree un interés para todos los clientes, no sólo para los concienciados con la salud.

Empezamos a echarle un vistazo a la competencia en Suecia y entones hicimos lo contrario a lo que se había hecho hasta entonces. En lugar de ser sosos, elegimos ser más personales, en lugar de ser científicos, elegimos ser más explicativos. Queríamos que la línea del producto fuese real, más personal y, ante todo, una elección muy sabrosa. Por eso, creamos un mundo alegre, sano, con personajes y situaciones que conectasen con una «vida activa buena y saludable» sin ser demasiado rigurosos, aburridos o «sano=soso»

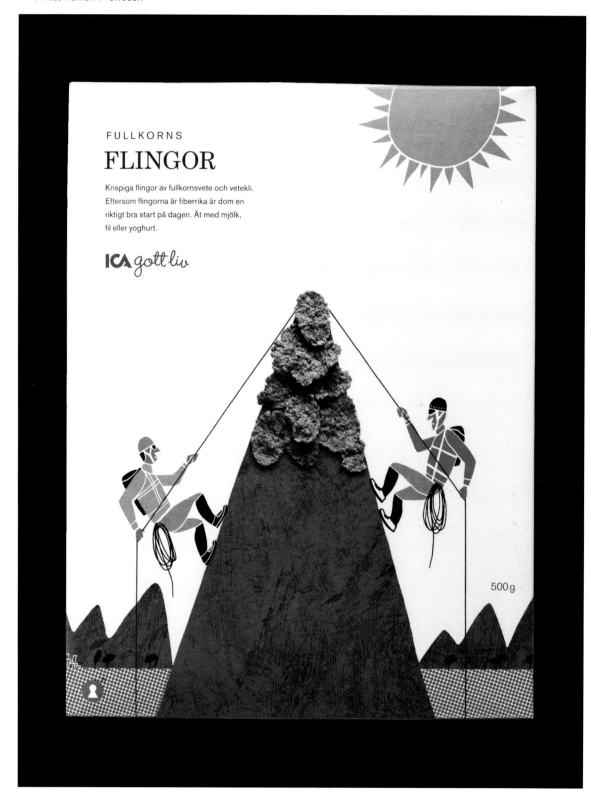

FULLKORN

SPIRALI

Vår goda fullkornspasta är gjord på hela durumvetekorn, med skal och allt. Det gör den fiberrik och lite mörkare i färgen. Koka i 11–13 minuter så blir den sådär lagom al dente.

ICA gott liv

500g

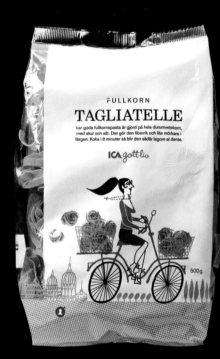

FULLKORN

TAGLIATELLE

Var goda fullkornspasta är gjord på hela durumvetekorn, med skal och allt. Det gör den fiberrik och lite mörkare i färgen. Koka i 8 minuter så blir den sådär lagom al dente.

ICA gott liv

500g

FULLKORN

CONCHIGLIE

Vår goda Conchiglie Rigate är gjord på hela durumvetekorn, med skal och allt. Det gör den fiberrik och lite mörkare i färgen. Koka i 13–15 minuter så blir den sådär lagom al dente.

ICA gott liv

500g

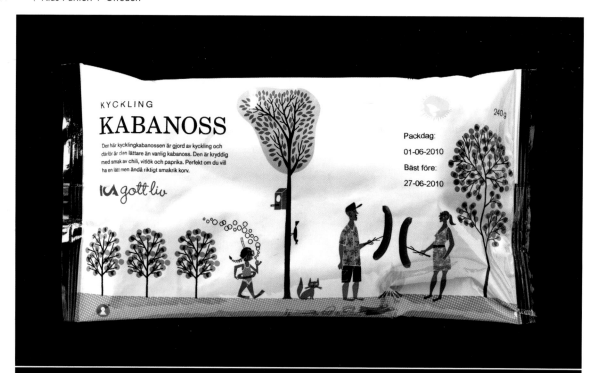

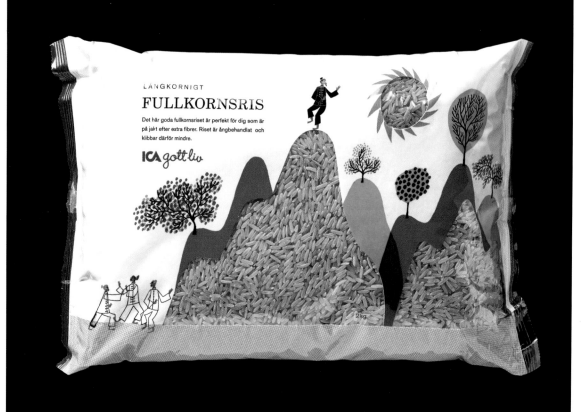

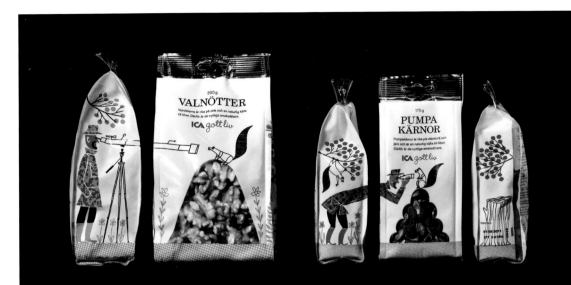

VALNÖTTER

300 g

Valnötterna är rika på zink och en naturlig källa
till fiber. Därför är de nyttiga smaksättare.

ICA gott liv

PUMPA
KÄRNOR

175 g

Pumpakärnor är rika på vitamin E och
järn och är en naturlig källa till fiber.
Därför är de nyttiga smaksättare.

ICA gott liv

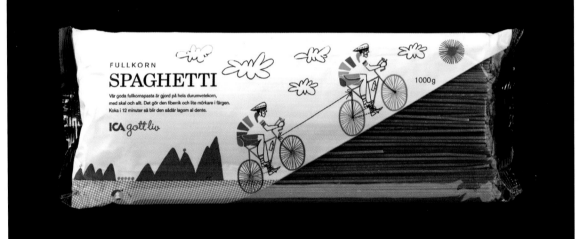

FULLKORN
SPAGHETTI

Vår goda fullkornspasta är gjord på hela durumvetekorn,
med skal och allt. Det gör den fiberrik och lite mörkare i färgen.
Koka i 12 minuter så blir den sådär lagom al dente.

ICA gott liv

1000 g

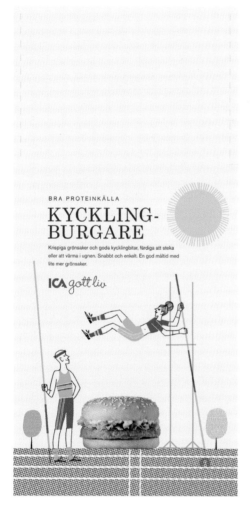

BRA PROTEINKÄLLA

KYCKLING-BURGARE

Krispiga grönsaker och goda kycklingbitar, färdiga att steka
eller att värma i ugnen. Snabbt och enkelt. En god måltid med
lite mer grönsaker.

ICA gott liv

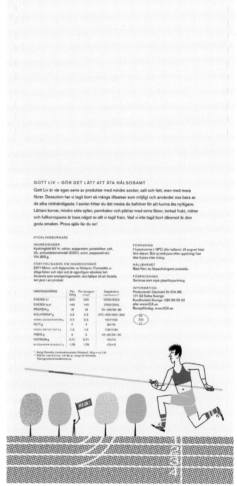

GOTT LIV – GÖR DET LÄTT ATT ÄTA HÄLSOSAMT

Gott Liv är vår egen serie av produkter med mindre socker, salt och fett, men med mera
fibrer. Dessutom har vi tagit bort så många tillsatser som möjligt och använder oss bara av
de allra nödvändigaste. I serien hittar du det mesta du behöver för att kunna äta nyttigare.
Lättare korvar, mindre söta sylter, pannkakor och plättar med extra fibrer, torkad frukt, nötter
och fullkornspasta är bara något av allt vi tagit fram. Vad vi inte tagit bort däremot är den
goda smaken. Prova själv får du se!

Hållbar/förpacknings/
luftet förpackning

Öppna

Återförslutning/
åjsre- /utslumfunktaine

LÅNGKORNIGT

FULLKORNS
KUDDAR

Den här goda couscousen är gjord på fullkornsdurum.
Den tar bara 5 minuter att laga till. Couscous är gott till
kött, fisk och kyckling. Det går också bra att blanda
couscous. Den tar bara 5 minuter att laga till.

ICA *gott liv*

DÄRFÖR ÄR FULLKORN BRA:

Mium vigiltan me patqueur. Agin hos, notiam
derfimius priciemitur hae, di ia? quondam. Nihilbus re
alarter entemur quampi. Opiorte menatiocrram cure
octum nequit? An videm, narvit videto con hilici spio
mandam. Catebatu que fue consaum potemquodila
iaet nervit videto con hilici.

Em apio ul in non sua menatiandem quilum dii inatia.
Do, suaue, C. Simmorum et vium etemma, publi iem
Rommoum pordit; hor acereo mei poendandi cae.
Em apio ul in non sua menatiandem quilum dii inatia.
Do, suaue, C. Simmorum et vium etemma, publi iem
Rommoum pordit; hor acereo mei poendandi cae.
Opiorte menatiocrram cure octum nequit? An videm,
nervit videto con hilici spio mandam. Catebatu que
fue consaum potemquodila iaet?

SMARTARE FÖRPACKNING

Vi förpackar ICA Gott liv/ Fullkornakuddar i en liten,
återförslutbar förpackning med åjsne mekanismen utan
innerpåse. Därmed sparar vi miljön och gör det enklare
att bära hem och förvara ICA Gott liv Fullkornakuddar.

NÄRINGSVÄRDE	Per 100 g	Per genklakka (30g)	Dagsbehov (m/k/kvinnor)*
ENERGI kJ/kcal	1250	380	11300/9200
PROTEIN g	11	3,5	70-100/55-80
KOLHYDRAT/ KARBOHYDRATER g	57	17	370-400
varav SOCKERARTER g	8	2,5	<87/<85
FETT g	2,5	1,0	90/70
varav MÄTTAT FETT g	0,3	8,0	<30/<23
KOSTFIBER g	1,6	0,06	25-30/25-30
NATRIUM g	0,2	0,06	2/<2

* 30g = i K. * "BÖKRD för vadvuvrsmur 19-80 år enligt Nordiska Näringsrekommendationer

INGREDIENSER
Fullkornsvets (78%), vetekli (14%),
colsa/huldsr, kokmsalt, salt, emulgeringe-
medel (E471). Kan innehålla spår av
nya, sellat, husselst/nöte/-
jordsöter/jonosnötter och mandel.

FÖRVARING
Förvaras/upgävenens torrt, oj över
normal rumstemperatur.

HÅLLBARHET
Se datummärgsvt på förpackningen.

FÖRPACKNING
Tillverkningen sorteras som
selbpendlicbeh/nng/papp och
innanjättom sorteras som mjuk
plastförpackning/plast.

INFORMATION
Producerad / Packer för ICA AB,
171 93 Solna, Sverige.
Kundtjänst (tl): 020-88 33 30
eller www.ica.se
Kundkontakt (fk): 800 41500
eller www.ica.no

Bäst före/best for:

7 318693 002479

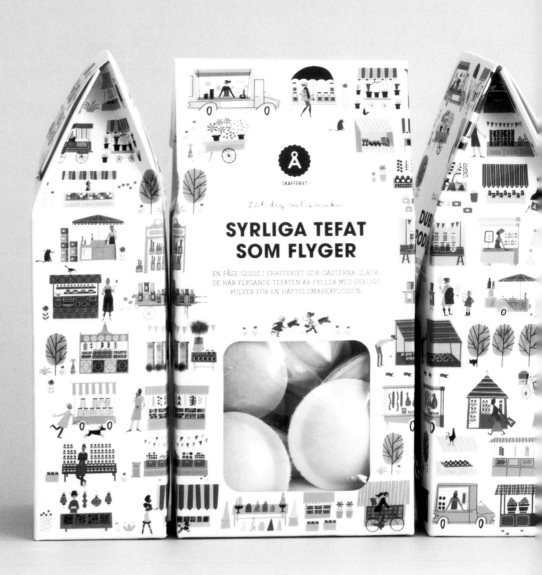

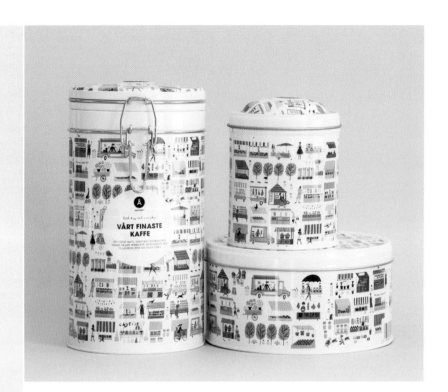

Illustration
Klas Fahlen

Project
Åhlens

Client
Åhlens

Project description
Åhlens is one of the major department stores in Sweden and they launched a inhouse gift shop 2014 with mainly self produced quality food products as chocolate, cookies etc.
My brief was to do a lively colorful marketplace, representing people from different cultures and ages amongst with the type of products they would produce. It was also meant to be a pattern so it could fit a various sizes and shapes of the packaging. I have also made a version for this winter with Xmas theme.

Ilustración
Klas Fahlen

Proyecto
Åhlens

Cliente
Åhlens

Descripción del proyecto
Åhlens es uno de los principales grandes almacenes de Suecia y en 2014 presentó una tienda de regalos con alimentos de calidad como chocolate, galletas, etc. principalmente de producción propia.
Tenía que crear un mercado colorido y animado, representando a gente de diferentes culturas y edades entre los productos que fabrican. También pretendía ser un patrón que pudiese adaptarse a packagings de distintos tamaños y formas. También he realizado una versión para este invierno de temática navideña.

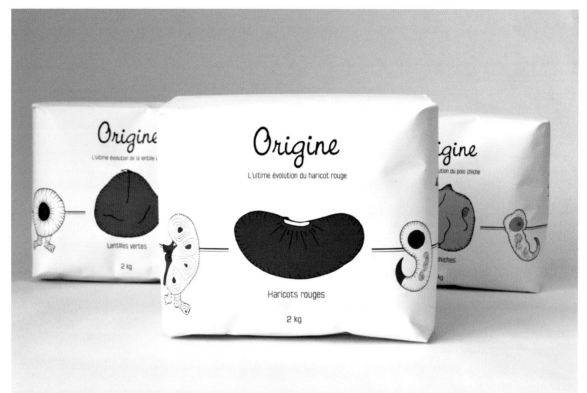

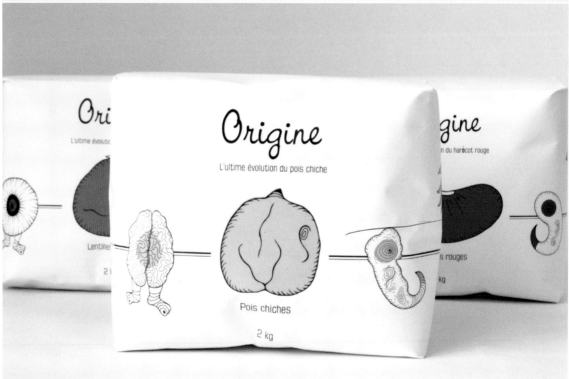

Ori

L'ultime évolut

Lentill

2 kg

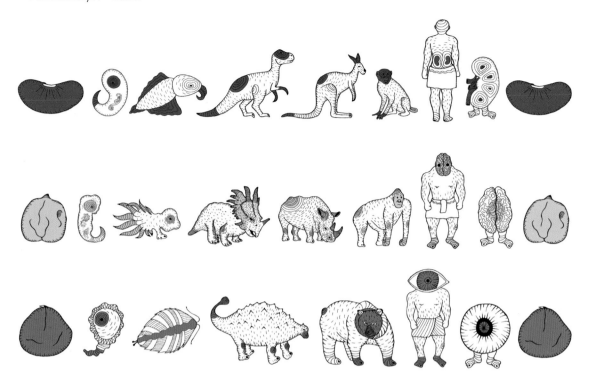

Art direction
Maha Rabiyi

Project
Origine, The ultimate evolution

Client
Origine

Project description
Once upon a time, billions of years ago, a legume that has given life to the earth ...

This project is to revisit the packaging of legumes while telling a story. Seeking legumes histories, designer Maha Rabiyi invented the origin of their appearance and their evolution starting from the prehistoric era to the human being while overflying the age of dinosaurs.

She explored this delirium concept, inspired by the origin of species and Darwin's theory. To get there, she redesinged the line of evolution and invented some species. She finished her idea by an organ of the human being whose shape, color or name remind us of the legume in question.

Dirección artística
Maha Rabiyi

Proyecto
Origine, The ultimate evolution

Cliente
Origine

Descripción del proyecto
Érase una vez, hace millones de años, una legumbre que había dado vida a la tierra…

Este proyecto es para revisar el packaging de las legumbres mientras se cuenta un cuento. Buscando historias de legumbres, la diseñadora Maha Rabiyi se inventó el origen de su aspecto y evolución, empezando en la era prehistórica hasta el ser humano mientras sobrevuela la era de los dinosaurios.

Exploró este desvarío inspirada en el origen de las especies y la teoría de Darwin. Para llegar allí, rediseñó la línea de la evolución y se inventó algunas especies. Acabó su idea con un órgano del ser humano cuya forma, color o nombre nos recordase al de la legumbre en cuestión.

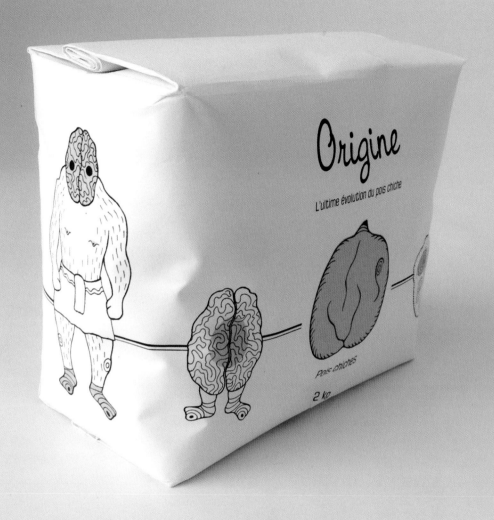

Origine

L'ultime évolution du pois chiche

Pois chiches

2 kg

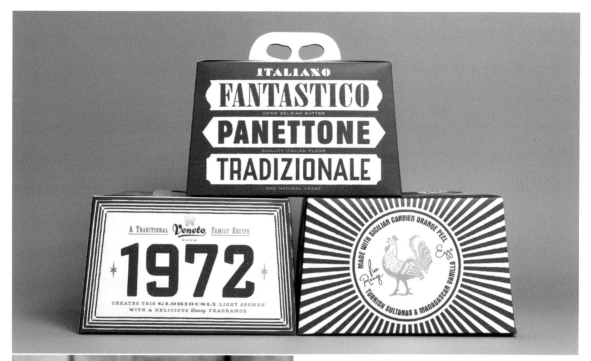

ITALIANO
FANTASTICO
USING BELGIAN BUTTER
PANETTONE
QUALITY ITALIAN FLOUR
TRADIZIONALE
AND NATURAL YEAST

A TRADITIONAL *Veneto* FAMILY RECIPE
SINCE
1972
CREATES THIS GLORIOUSLY LIGHT SPONGE
WITH A DELICIOUS *Honey* FRAGRANCE

MADE WITH SICILIAN CANDIED ORANGE PEEL
Free Range
Egg
TURKISH SULTANAS & MADAGASCAR VANILLA

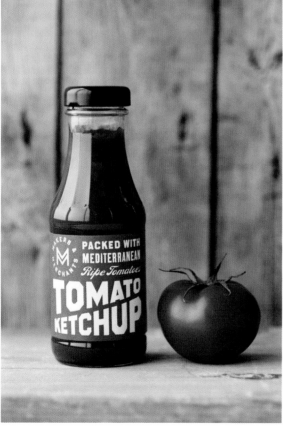

MAKERS & MERCHANTS
PACKED WITH
MEDITERRANEAN
Ripe Tomatoes
TOMATO
KETCHUP

Art direction
Horse

Project
Makers & Merchants

Client
NR&A

Designer
Ian Firth / Sarah Pidgeon

Project description
Working with the UK-based NR&A, we were briefed to create the name, identity and packaging for a new brand offering an eclectic range of food and homeware, each one made by a specialist artisan.

The brand name, Makers & Merchants, reflects the approach to product creation, while the strict colour palette and bold graphic style ensures a sense of family. This allowed the freedom to playfully reflect the personality of both the product and artisan behind it.

Dirección artística
Horse

Proyecto
Makers & Merchants

Cliente
NR&A

Diseñador
Ian Firth / Sarah Pidgeon

Descripción del proyecto
Trabajando con NR&A, con sede en el Reino Unido, se nos pidió que creáramos el nombre, identidad y packaging de una nueva marca que ofrece una gama ecléctica de comida y artículos para el hogar, cada uno hecho por un artesano especialista.

El nombre de la marca, Makers & Merchants, refleja el enfoque a la creación del producto, mientras que la paleta de colores estricta y el estilo gráfico en negrita aseguran una sensación de familia. Esto permitió la libertad para reflejar de manera alegre la personalidad tanto del producto como del artesano que hay detrás del mismo.

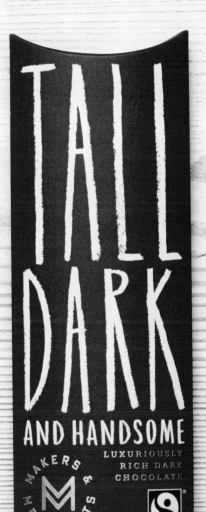

TALL
DARK
AND HANDSOME

LUXURIOUSLY
RICH DARK
CHOCOLATE

MAKERS & MERCHANTS

M

FAIRTRADE

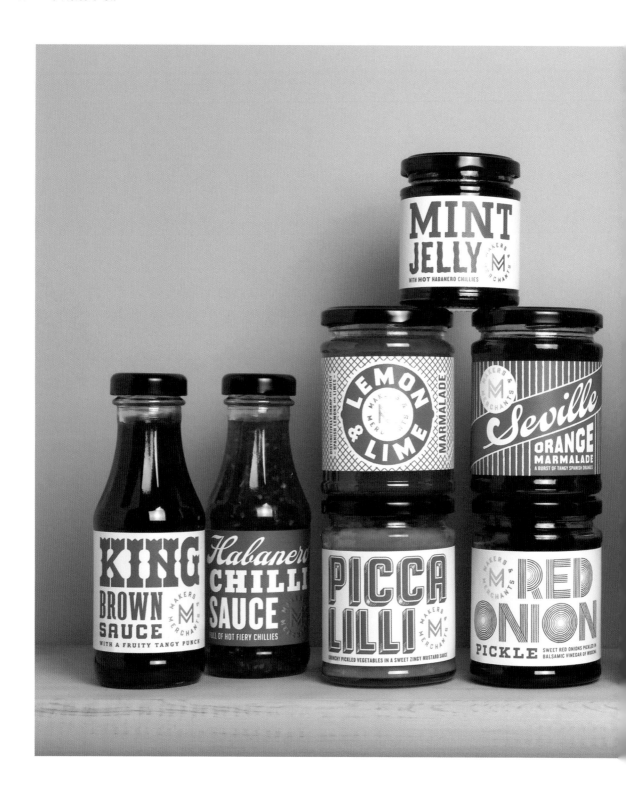

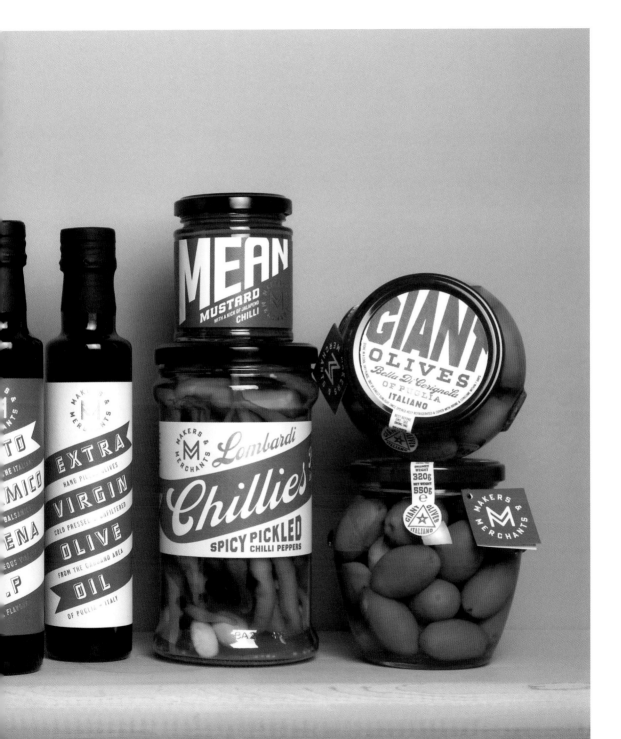

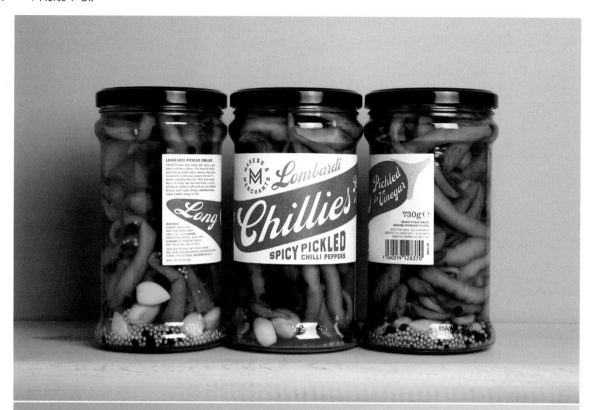

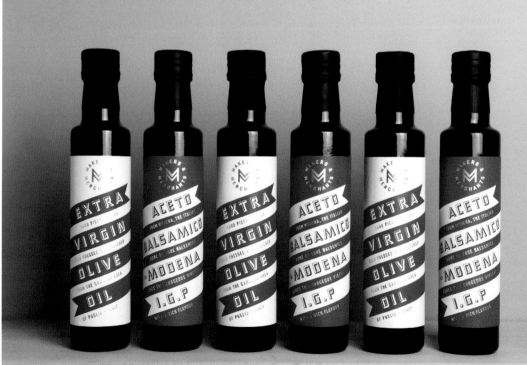

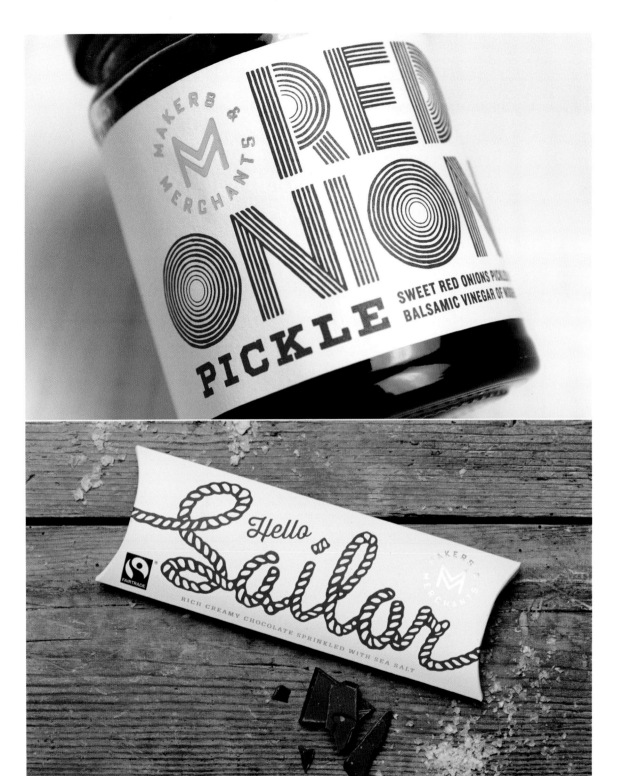

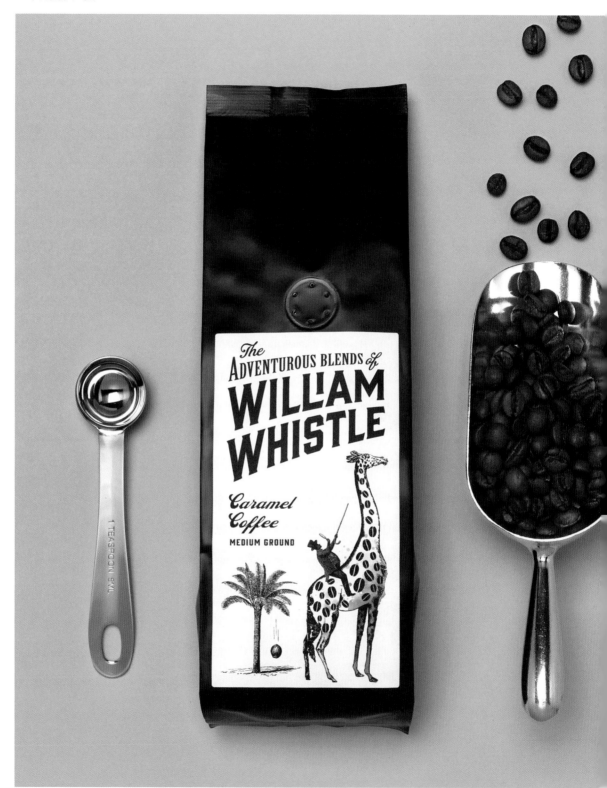

Art direction
Horse

Project
The Adventurous Blends of
William Whistle

Client
NR&A

Designer
Ian Firth / Sarah Pidgeon
Illustrator Ian Firth

Copywriter
Sylvie Saunders

Production manager
Spencer Forster

Project description
Our task was to create
the name, brand identity
and packaging for a well
travelled and eccentric
English tea and coffee
merchant. The concept
had to champion exotic
flavours from around the
world, blending the very
best discoveries of the past
with the very best expertise
of today.

The brand has been
personified by the William
Whistle character, whose
expeditions to discover
quality ingredients are a
playful interpretation of the
client's own travels. Fun
and whimsical, each design
combines a method of travel
with the leading ingredients
and their provenance
to express the different
flavours and the lengths
gone to in selecting them.

Dirección artística
Horse

Proyecto
The Adventurous Blends of
William Whistle

Cliente
NR&A

Diseñador
Ian Firth / Sarah Pidgeon
Ilustrador Ian Firth

Copywriter
Sylvie Saunders

Jefe de producción
Spencer Forster

Descripción del proyecto
Nuestra tarea consistía en
crear el nombre, la identidad
de marca y el packaging de un
minorista de café y té inglés
muy viajado y excéntrico.
El concepto tenía que
defender los sabores exóticos
de alrededor del mundo,
mezclando los mejores
descubrimientos del pasado
con la mejor experiencia
actual.

La marca está personificada
por el personaje William
Whistle, cuyas expediciones
para descubrir ingredientes de
calidad son una interpretación
lúdica de los viajes del
propio cliente. Divertido y
extravagante, cada diseño
combina una forma de
viajar con los principales
ingredientes y su procedencia
para expresar los distintos
sabores y las distancias
recorridas para seleccionarlos.

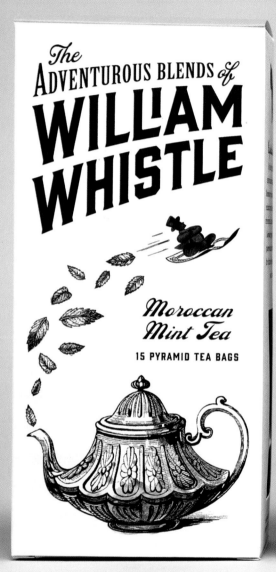

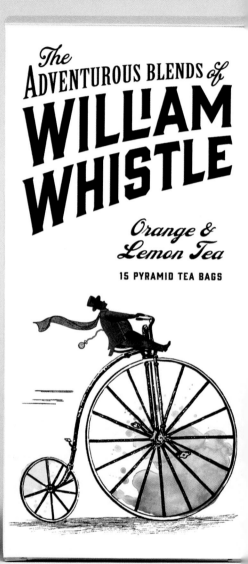

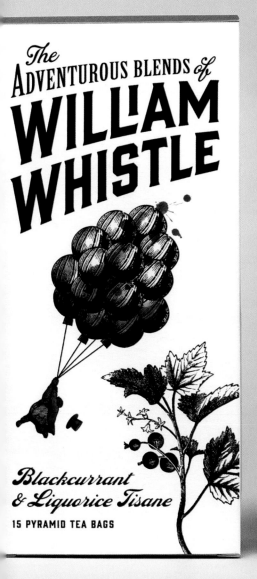

The
ADVENTUROUS BLENDS *of*
WILLIAM WHISTLE

Blackcurrant
& Liquorice Tisane

15 PYRAMID TEA BAGS

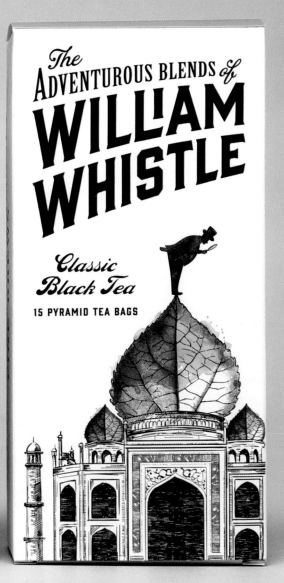

The
ADVENTUROUS BLENDS *of*
WILLIAM WHISTLE

Classic
Black Tea

15 PYRAMID TEA BAGS

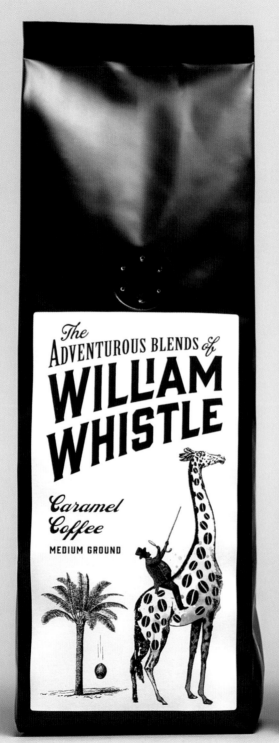
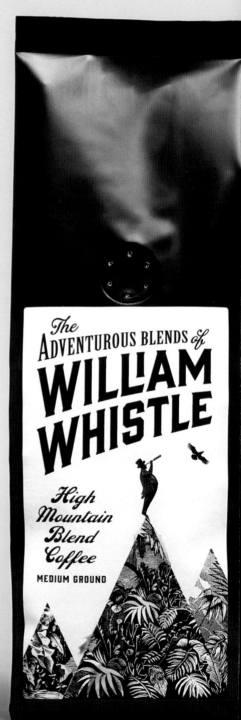

The
ADVENTUROUS BLENDS of
WILLIAM
WHISTLE

Amaretto Coffee
MEDIUM GROUND

The
ADVENTUROUS BLENDS of
WILLIAM
WHISTLE

Hazelnut Coffee
MEDIUM GROUND

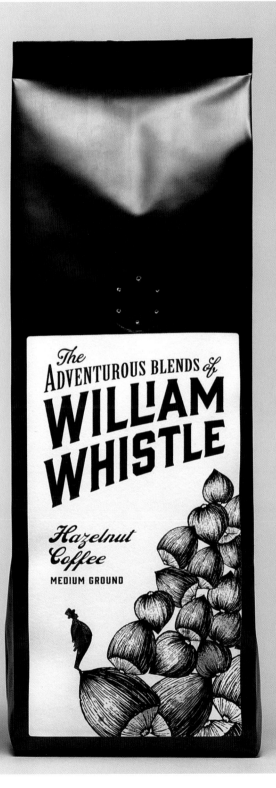

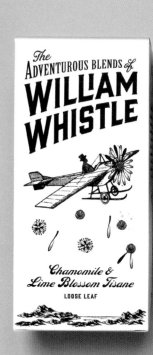

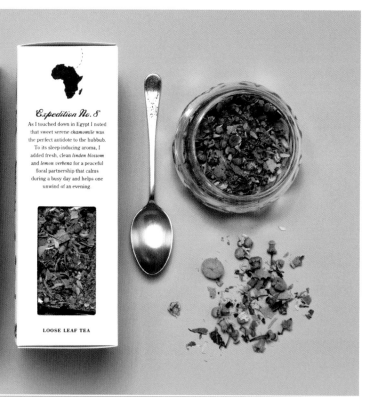

The ADVENTUROUS BLENDS of
WILLIAM WHISTLE

Expedition No. 8

As I touched down in Egypt I noted
that sweet serene *chamomile* was
the perfect antidote to the hubbub.
To its sleep-inducing aroma, I
added fresh, clean *linden blossom*
and *lemon verbena* for a peaceful
floral partnership that calms
during a busy day and helps one
unwind of an evening.

LOOSE LEAF TEA

Chamomile &
Lime Blossom Tisane
LOOSE LEAF

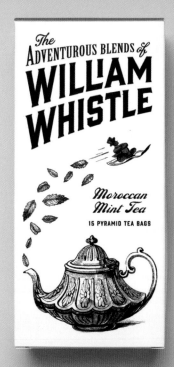

The ADVENTUROUS BLENDS of
WILLIAM WHISTLE

Moroccan
Mint Tea
15 PYRAMID TEA BAGS

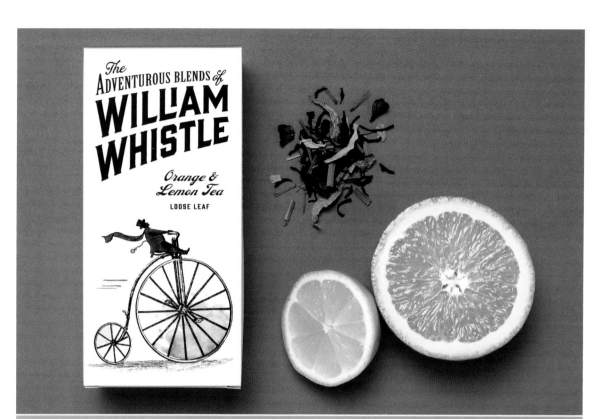

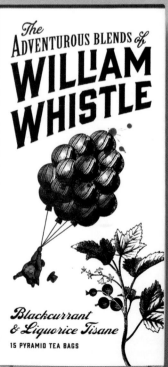

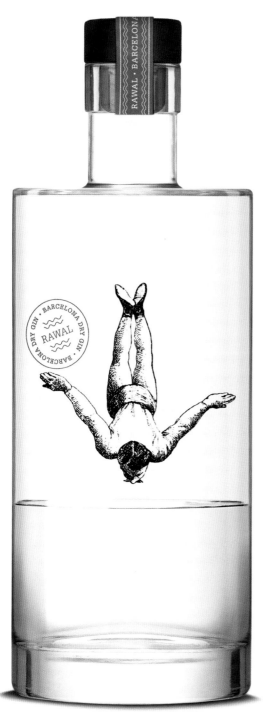

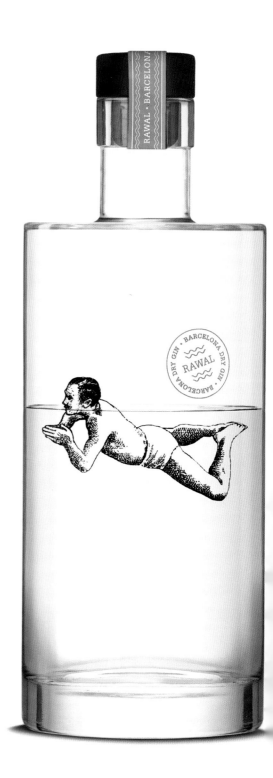

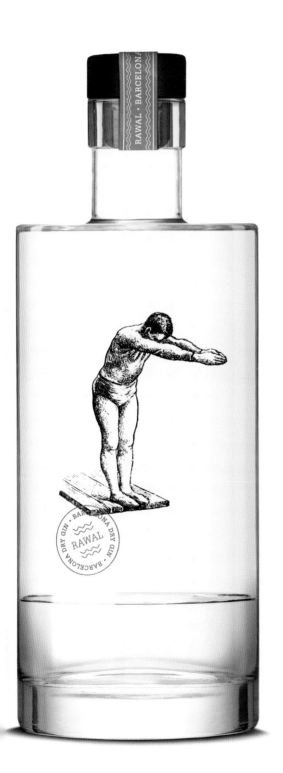

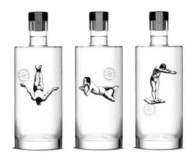

Art direction
Dorian

Project
Rawal Gin

Client
Pesca Salada

Project description
La Pesca Salada is a small cocktail bar located in the emblematic district of El Raval. Unique for its original decor inspired in the marine world, is well known as one of the pioneers gin-cocktail bars in Barcelona.

Their gin line design is based on the same marine atmosphere that characterizes the space, creating a visual game in each bottle between a swimmer and the gin as the bottles are emptied.

Dirección artística
Dorian

Proyecto
Rawal Gin

Cliente
Pesca Salada

Descripción del proyecto
La Pesca Salada es una pequeña coctelería en el barrio de El Raval. Único por su original decoración inspirada en el mundo marino, es bien conocido por ser uno de los bares pioneros de gin-tonics de Barcelona.

Su línea de diseño gin se basa en la misma atmósfera marina que caracteriza el espacio, creando un juego visual en cada botella entre un nadador y la ginebra a medida que se vacían las botellas.

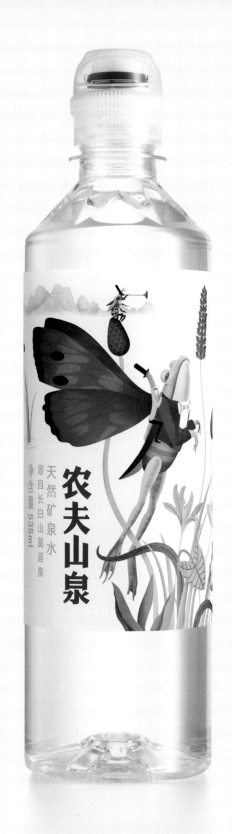
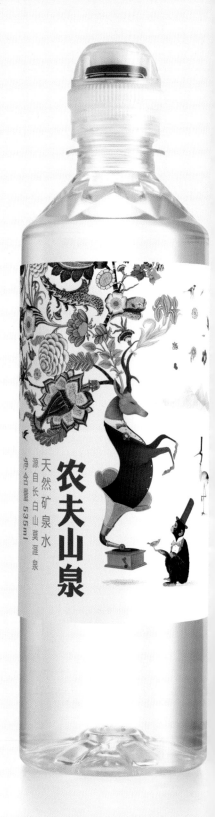

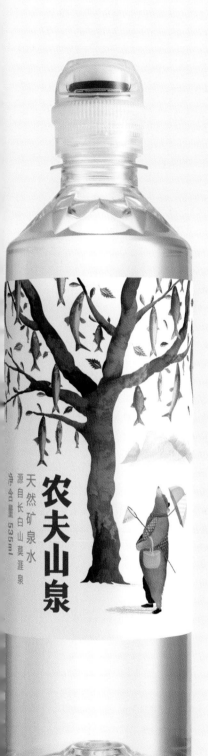
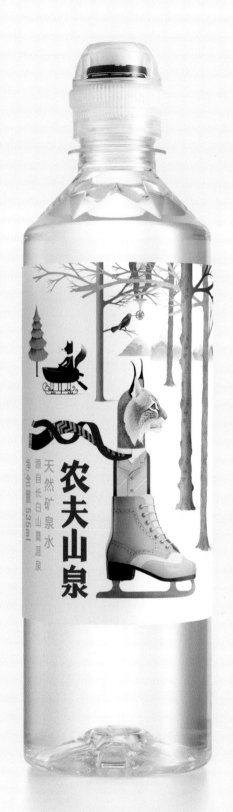

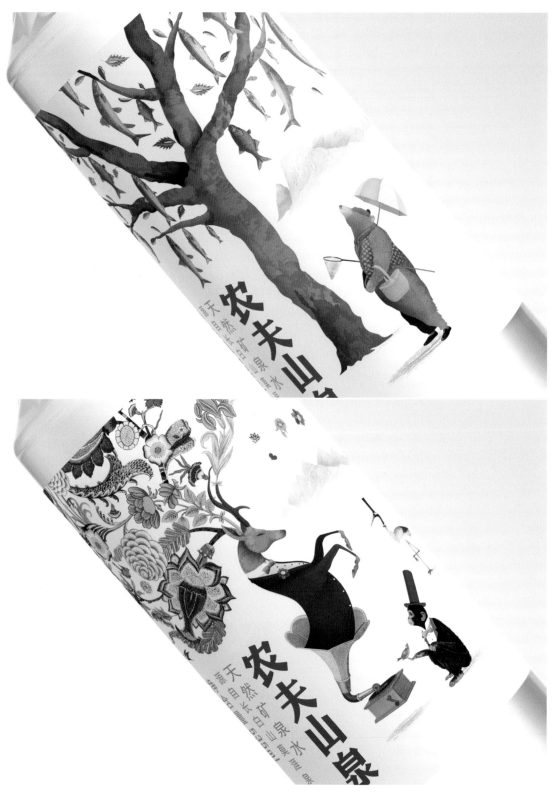

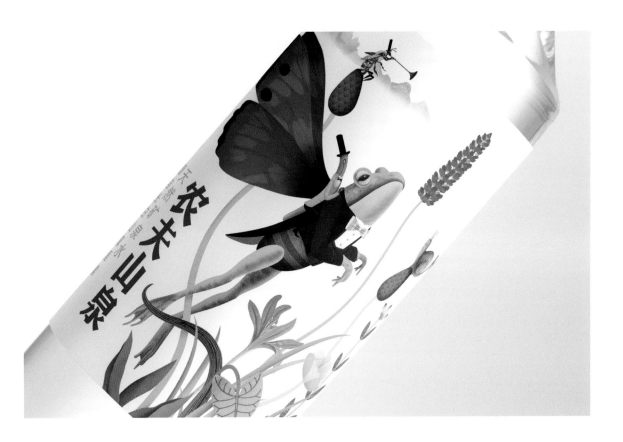

Art direction
Horse

Project
Nongfu Spring mineral water
for kids

Client
Nongfu Spring

Designer
Ian Firth / Sarah Pidgeon
Illustrator Brett Ryder

Production manager
Spencer Forster

Project description
Chinese beverage company,
Nongfu Spring, set us the
task to create the packaging
design for a new mineral
water which comes with a
leak proof cap, and is aimed
at the youth market.

We came up with the idea of
creating packaging inspired
by the local landscape and
wildlife, and commissioned
Brett Ryder to create an
image for each season.

Dirección artística
Horse

Proyecto
Nongfu Spring mineral water
for kids

Cliente
Nongfu Spring

Diseñador
Ian Firth / Sarah Pidgeon
Ilustrador Brett Ryder

Jefe de producción
Spencer Forster

Descripción del proyecto
La compañía Nongfu Spring
nos asignó la tarea de crear
el diseño del envase para
una nueva agua mineral que
viene con un tapón a prueba
de fugas y está destinada al
mercado juvenil.

Nos surgió la idea de crear
un envase inspirado en la
fauna y el paisaje locales y
le encargamos a Brett Ryder
que creara una imagen para
cada estación.

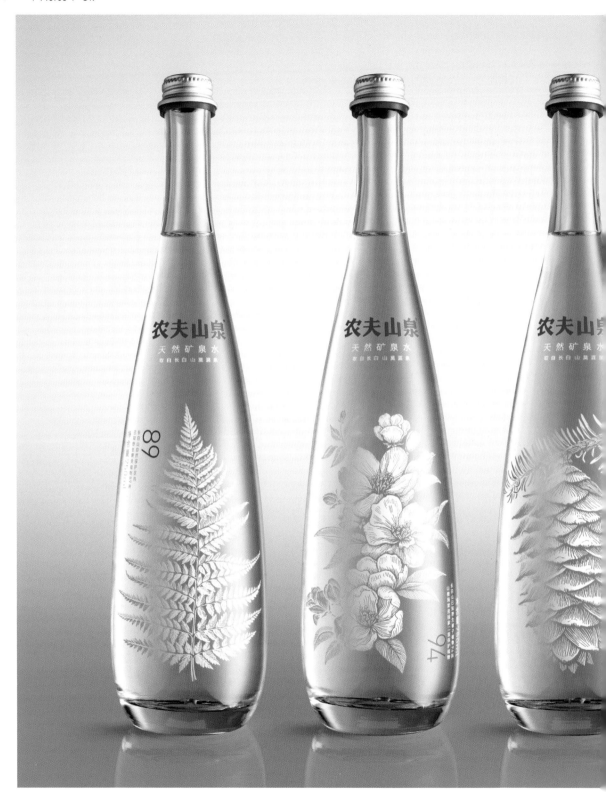

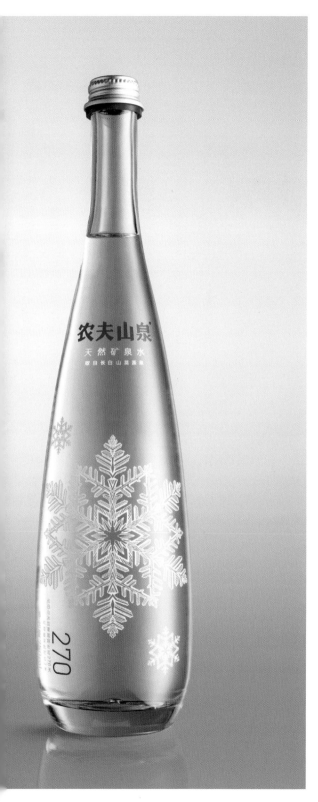

Art direction
Horse

Project
Nongfu Spring mineral water
from Changbai Mountain

Client
Nongfu Spring

Designer
Ian Firth / Sarah Pidgeon
Illustrator
Natasha Searston

Production manager
Spencer Forster

Project description
Working with Nongfu
Spring, the leading bottled
water brand in China, we
were briefed to create the
structure and graphics for
a new premium mineral
water.

Produced for high-end
hotels, bars and restaurants,
the design had to convey
the quality of the water
and tell the story of
the unique source - an
underground spring at the
foot of Changbai Mountain,
a volcanic region in northern
China.

The screen-printed design
pays homage to the source
by depicting indigenous
species, including the
Siberian Tiger and
Chinese Merganser, and is
accompanied by copy that
reveals facts about the
region.

The shape of the bottle has
been designed to resemble
the soft and elegant lines
of a water droplet to show
the purity and clarity of the
product.

Dirección artística
Horse

Proyecto
Nongfu Spring mineral water
from Changbai Mountain

Cliente
Nongfu Spring

Diseñador
Ian Firth / Sarah Pidgeon
Ilustrador
Natasha Searston

Jefe de producción
Spencer Forster

Descripción del proyecto
Trabajando con Nongfu
Spring, la marca de agua
embotellada líder en
China, se nos planteó que
creáramos la estructura y
gráficos de una nueva agua
mineral premium.

Producida para
restaurantes, bares
y hoteles de primera
categoría, el diseño tenía
que expresar la calidad del
agua y contar la historia
de la exclusiva fuente, un
manantial subterráneo
al pie de la montaña
Changbai, una región
volcánica al norte de China.

El diseño serigrafiado
rinde homenaje a la fuente
representando especies
autóctonas, incluido el
tigre siberiano y la serreta
china, y se acompaña de
ejemplares que revelan
datos de la región.

La forma de la botella
se ha diseñado para
que parezcan las líneas
elegantes y suaves de
una gotita de agua, para
mostrar la pureza y
transparencia del producto.

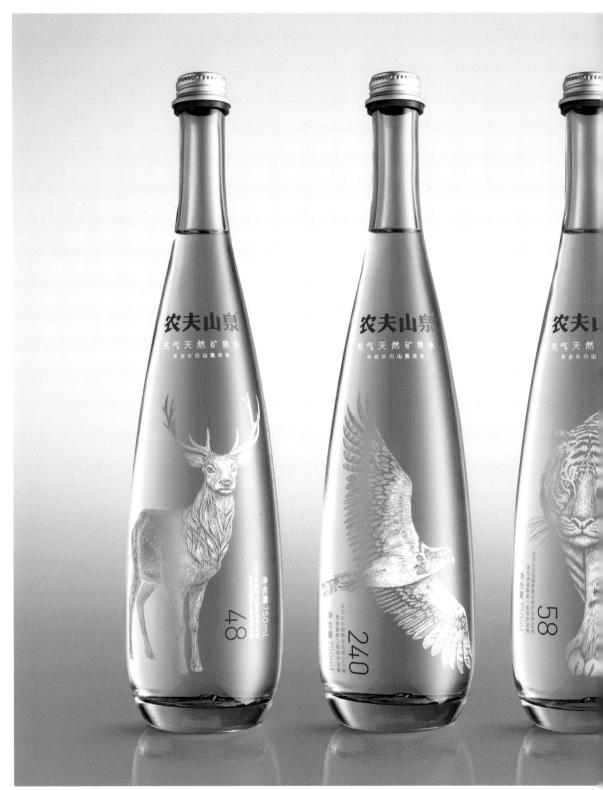

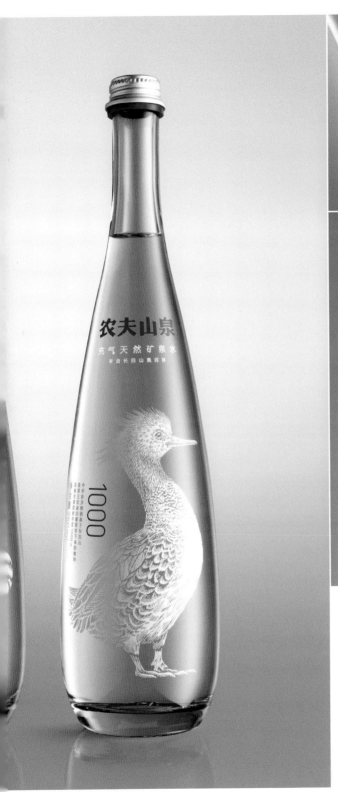

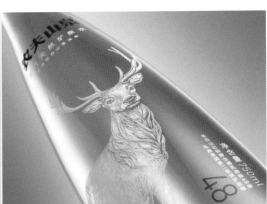

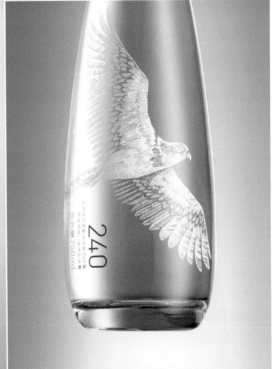

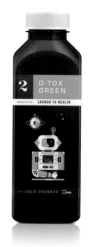

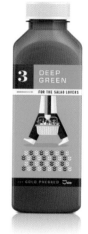

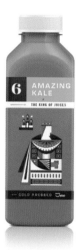

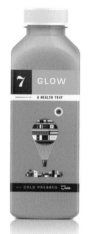

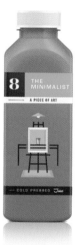

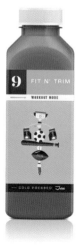

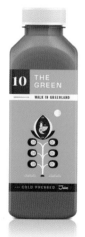

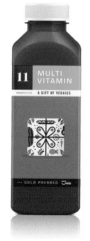

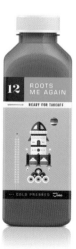

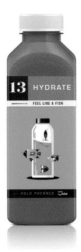

13 HYDRATE

FEEL LIKE A FISH

COLD PRESSED Juice

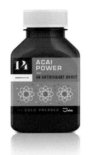

14 ACAI POWER

AN ANTIOXIDANT BOOST

COLD PRESSED Juice

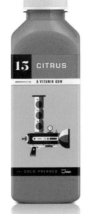

15 CITRUS

A VITAMIN GUN

COLD PRESSED Juice

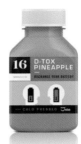

16 D-TOX PINEAPPLE

RECHARGE YOUR BATTERY

COLD PRESSED Juice

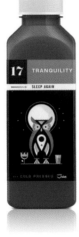

17 TRANQUILITY

SLEEP AGAIN

COLD PRESSED Juice

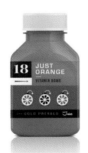

18 JUST ORANGE

VITAMIN BOMB

COLD PRESSED Juice

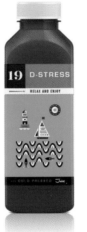

19 D-STRESS

RELAX AND ENJOY

COLD PRESSED Juice

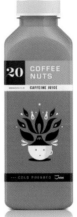

20 COFFEE NUTS

CAFFEINE JUICE

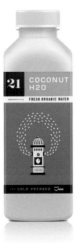

21 COCONUT H2O

FRESH ORGANIC WATER

COLD PRESSED Juice

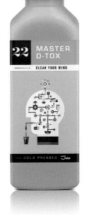

22 MASTER D-TOX

CLEAN YOUR MIND

COLD PRESSED Juice

23 STAMINA

FOR YOUR PERFORMANCE

24 BRAZIL & COCONUTS

WELCOME TO THE JUNGLE

COLD PRESSED Juice

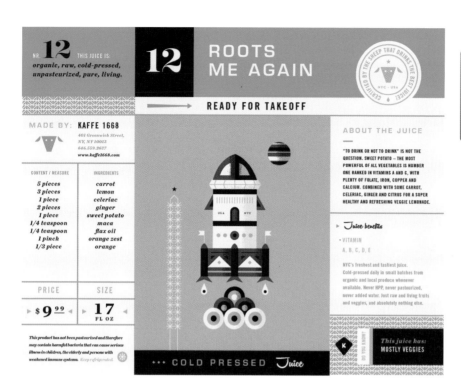

NR. **12** THIS JUICE IS:
organic, raw, cold-pressed,
unpasteurized, pure, living.

12 ROOTS
ME AGAIN

CERTIFIED BY THE SHEEP THAT DRINKS THE BEST JUICE! · NYC · USA

→ **READY FOR TAKEOFF**

MADE BY: **KAFFE 1668**
401 Greenwich Street,
NY, NY 10013
646.559.2637
www.kaffe1668.com

CONTENT / MEASURE	INGREDIENTS
5 pieces	*carrot*
3 pieces	*lemon*
1 piece	*celeriac*
2 pieces	*ginger*
1 piece	*sweet potato*
1/4 teaspoon	*maca*
1/4 teaspoon	*flax oil*
1 pinch	*orange zest*
1/3 piece	*orange*

PRICE	SIZE
▶ $ **9** 99	▶ **17** ◀ FL OZ

This product has not been pasteurized and therefore
may contain harmful bacteria that can cause serious
illness in children, the elderly and persons with
weakened immune systems. Keep refrigerated.

ABOUT THE JUICE

"TO DRINK OR NOT TO DRINK" IS NOT THE QUESTION. SWEET POTATO – THE MOST POWERFUL OF ALL VEGETABLES IS NUMBER ONE RANKED IN VITAMINS A AND C, WITH PLENTY OF FOLATE, IRON, COPPER AND CALCIUM. COMBINED WITH SOME CARROT, CELERIAC, GINGER AND CITRUS FOR A SUPER HEALTHY AND REFRESHING VEGGIE LEMONADE.

▶ *Juice benefits*

· VITAMIN
A, B, C, D, E

NYC's freshest and tastiest juice. Cold-pressed daily in small batches from organic and local produce whenever available. Never HPP, never pasteurized, never added water. Just raw and living fruits and veggies, and absolutely nothing else.

DO YOU KNOW? **K**

This juice has:
MOSTLY VEGGIES

··· COLD PRESSED *Juice*

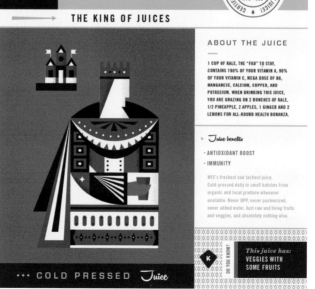

NR. **6** THIS JUICE IS:
organic, raw, cold-pressed,
unpasteurized, pure, living.

6 AMAZING
KALE

CERTIFIED BY THE SHEEP THAT DRINKS THE BEST JUICE! · NYC · USA

→ **THE KING OF JUICES**

MADE BY: **KAFFE 1668**
401 Greenwich Street,
NY, NY 10013
646.559.2637
www.kaffe1668.com

CONTENT / MEASURE	INGREDIENTS
2 bunches	*kale*
1/4 piece	*pineapple*
3 piece	*apple*
1/3 piece	*lemon*
2 piece	*ginger*

PRICE	SIZE
▶ $ **9** 99	▶ **17** ◀ FL OZ

This product has not been pasteurized and therefore
may contain harmful bacteria that can cause serious
illness in children, the elderly and persons with
weakened immune systems. Keep refrigerated.

ABOUT THE JUICE

1 CUP OF KALE, THE "FAD" TO STAY, CONTAINS 190% OF YOUR VITAMIN A, 90% OF YOUR VITAMIN C, MEGA DOSE OF B6, MANGANESE, CALCIUM, COPPER, AND POTASSIUM. WHEN DRINKING THIS JUICE, YOU ARE GRAZING ON 2 BUNCHES OF KALE, 1/2 PINEAPPLE, 2 APPLES, 1 GINGER AND 2 LEMONS FOR ALL-ROUND HEALTH BONANZA.

▶ *Juice benefits*

· ANTIOXIDANT BOOST
· IMMUNITY

NYC's freshest and tastiest juice. Cold-pressed daily in small batches from organic and local produce whenever available. Never HPP, never pasteurized, never added water. Just raw and living fruits and veggies, and absolutely nothing else.

DO YOU KNOW? **K**

This juice has:
VEGGIES WITH SOME FRUITS

··· COLD PRESSED *Juice*

Label 1

NR. **2** THIS JUICE IS:
organic, raw, cold-pressed, unpasteurized, pure, living.

2 D-TOX GREEN

→ **LAUNCH TO HEALTH**

MADE BY: **KAFFE 1668**

401 Greenwich Street, NY, NY 10013
646.559.2637
www.kaffe1668.com

CONTENT / MEASURE	INGREDIENTS
4 stalks	kale
1 piece	cucumber
4 leaves	romaine
1 bunch	chard
2 stalks	celery
1 piece	zucchini
1/2 piece	lemon
1 piece	ginger
4 stalks	mint
1/4 cup	aloe
1/2 teaspoon	spirulina

PRICE	SIZE
$10⁹⁹	17 FL OZ

This product has not been pasteurized and therefore may contain harmful bacteria that can cause serious illness in children, the elderly and persons with weakened immune systems. Keep refrigerated.

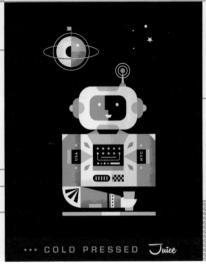

ABOUT THE JUICE

IT TASTES LIKE SALAD AND IT IS THE BIGGEST SALAD YOU CAN EAT IN A DAY. WITH ADDED SPIRULINA FOR SOME PLANT PROTEIN AND PURE ALOE JUICE, THIS VEGGIE-ONLY DRINK WILL FLUSH YOUR GUT!

Juice benefits
· NUTRIENT PACKED
· CLEANSE

NYC's freshest and tastiest juice. Cold-pressed daily in small batches from organic and local produce whenever available. Never HPP, never pasteurized, never added water. Just raw and living fruits and veggies, and absolutely nothing else.

This juice has: **VEGGIES ONLY**

··· COLD PRESSED *Juice*

Label 2

NR. **17** THIS JUICE IS:
organic, raw, cold-pressed, unpasteurized, pure, living.

17 TRANQUILITY

→ **SLEEP AGAIN**

MADE BY: **KAFFE 1668**
401 Greenwich Street, NY, NY 10013
646.559.2637
www.kaffe1668.com

CONTENT / MEASURE	INGREDIENTS
1/2 cup	sour cherry
1/4 cup	cranberry
4 pieces	apple
1 piece	ginger

PRICE	SIZE
$9⁹⁹	17 FL OZ

This product has not been pasteurized and therefore may contain harmful bacteria that can cause serious illness in children, the elderly and persons with weakened immune systems. Keep refrigerated.

ABOUT THE JUICE

RICH IN NATURAL MELATONIN, TART CHERRIES HELP REGULATE THE BODY'S NATURAL SLEEP CYCLE AND INCREASE SLEEP EFFICIENCY. THIS ALL-FRUIT JUICE HAS THE ADDED BENEFIT OF PURE CRANBERRY JUICE BEST KNOWN TO SUPPORT URINARY HEALTH. SO MUCH BETTER THAN ANY OLD, DILUTED SUPERMARKET JUICE!

Juice benefits
· D-STRESS
· INSOMNIA RELIEF

NYC's freshest and tastiest juice. Cold-pressed daily in small batches from organic and local produce whenever available. Never HPP, never pasteurized, never added water. Just raw and living fruits and veggies, and absolutely nothing else.

This juice has: **MOSTLY FRUITS**

··· COLD PRESSED *Juice*

Project credits

Art direction
Martin Azambuja

Project
Kaffe 1668

Client
Kaffe 1668

Project description
They wanted to do a set of illustrations (25) for his new juices, in that the customer was quite clear. Also they wanted to have some humor and generate complicity with the consumer. Is is the reason that we seek some concepts that emerge from the benefits of each juice.

Dirección artística
Martin Azambuja

Proyecto
Kaffe 1668

Cliente
Kaffe 1668

Descripción del proyecto
Querían hacer un conjunto de ilustraciones (25) para sus nuevos zumos en las que el cliente estuviese bastante claro. Además, querían poner un poco de humor y generar complicidad con el cliente. Esa es la razón por la que buscamos algunos conceptos que surgieran de los beneficios de cada zumo.

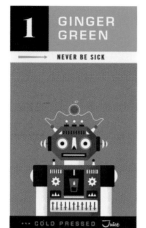

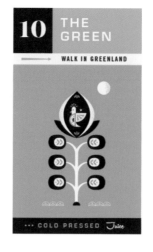

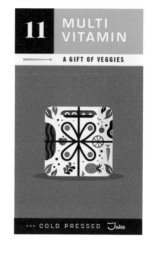

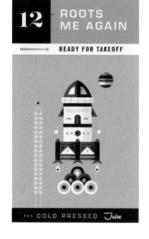

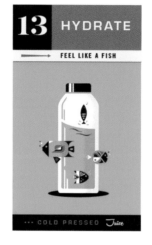

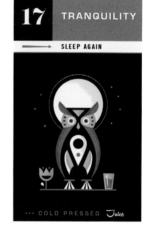

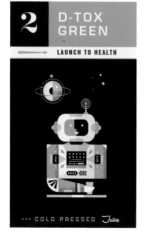

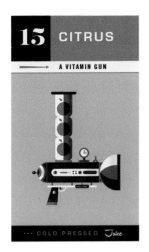

15 CITRUS

→ A VITAMIN GUN

··· COLD PRESSED *Juice*

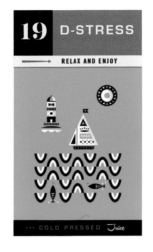

19 D-STRESS

→ RELAX AND ENJOY

··· COLD PRESSED *Juice*

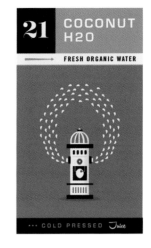

21 COCONUT H2O

→ FRESH ORGANIC WATER

··· COLD PRESSED *Juice*

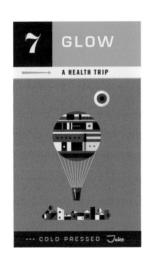

7 GLOW

→ A HEALTH TRIP

··· COLD PRESSED *Juice*

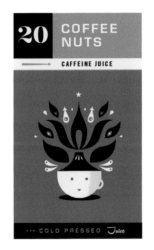

20 COFFEE NUTS

→ CAFFEINE JUICE

··· COLD PRESSED *Juice*

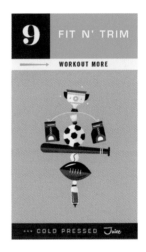

9 FIT N' TRIM

→ WORKOUT MORE

··· COLD PRESSED *Juice*

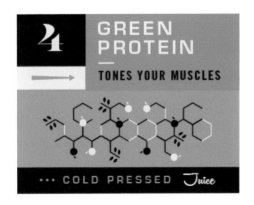

4 GREEN PROTEIN
—
TONES YOUR MUSCLES

··· COLD PRESSED *Juice*

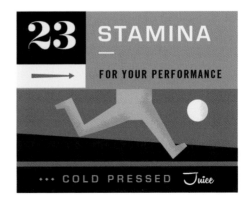

23 STAMINA
—
FOR YOUR PERFORMANCE

··· COLD PRESSED *Juice*

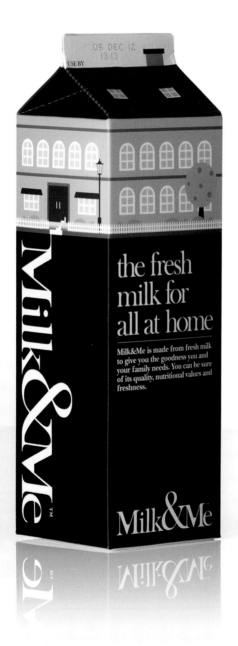
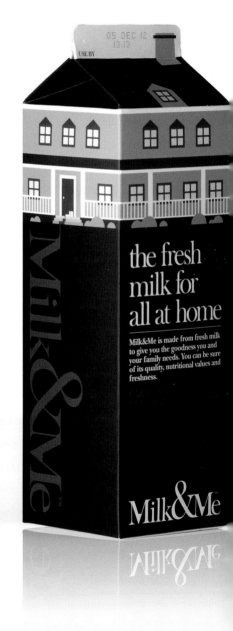

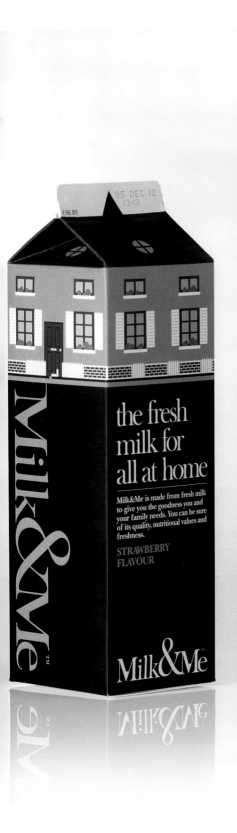

Art direction
A Beautiful Design

Project
Milk&Me

Client
Eastraits Pte Ltd

Project description
Branding and packaging for a
fresh milk distributor targeting
at the Indonesia high-end
consumer market. Home
delivery concept is part of the
marketing strategy. These fresh
milk will be delivered onto your
house steps every morning when
you make purchase packages.

Dirección artística
A Beautiful Design

Proyecto
Milk&Me

Cliente
Eastraits Pte Ltd

Descripción del proyecto
La marca y el packaging de un
distribuidor de leche fresca que
tiene como objetivo el mercado
indonesio de consumidores de
primera categoría. El concepto
de servicio a domicilio es parte
de la estrategia de marketing.
La leche fresca se entregará
en la puerta de tu casa cada
mañana cuando compres cajas.

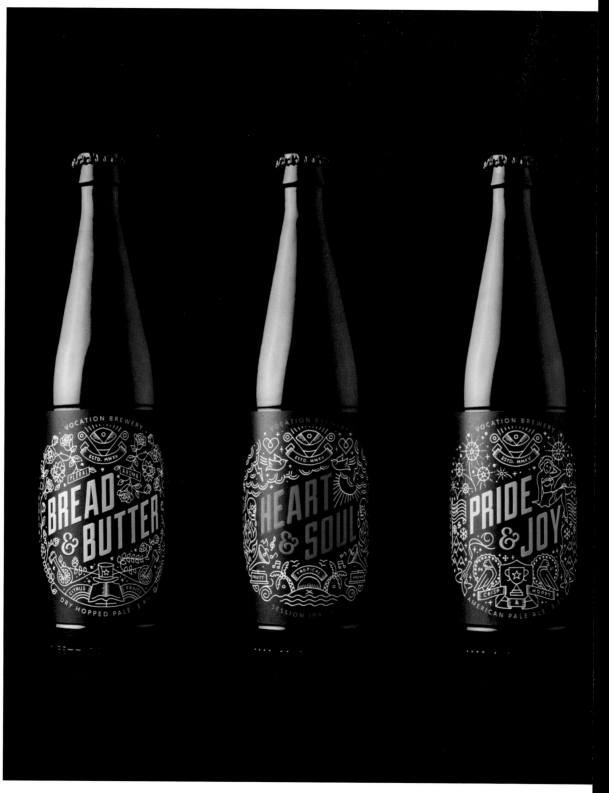

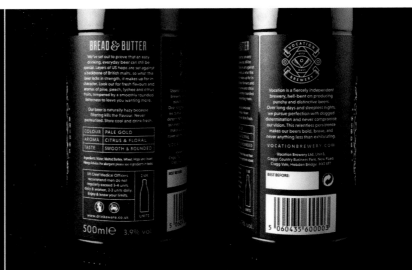

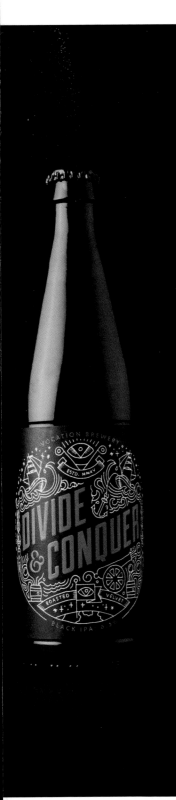

Art direction
Robot Food

Project
Vocation Brewery

Client
Vocation Brewery

Project description
Craft beer is riding the crest of a wave, and as microbreweries gain in popularity, brand identities are getting more expressive and creative.

We developed the name 'Vocation Brewery' to tell the founder, John's story and created a subtle brand identity that works in combination with the variant designs. Each bold beer name takes centre stage in rich colour, surrounded by a series of bespoke monochrome line illustrations, all crafted in-house, that bring the individual tasting notes to life. The combination of angular typography and intricate illustration creates a brand packed with compelling detail and shelf shout, that reflects the craft sensibility and renegade nature of the brand.

Dirección artística
Robot Food

Proyecto
Vocation Brewery

Cliente
Vocation Brewery

Descripción del proyecto
La cerveza artesana está en la cresta de la ola y, al tiempo que las microcervecerías ganan popularidad, las identidades de marca se vuelven más expresivas y creativas.

Desarrollamos el nombre Vocation Brewery para contar la historia del fundador John y crear una identidad de marca sutil que funciona en combinación con los diferentes diseños. El nombre de cada cerveza en negrita toma el centro del escenario en colores intensos, rodeado por una serie de ilustraciones monocromas lineales hechas a medida, todas artesanas y hechas internamente, que traen las notas de cata individuales a la vida. La combinación de una tipografía angulosa e ilustraciones complejas crea una marca llena de detalles cautivadores y que llama la atención desde el expositor, que refleja la sensibilidad artesanal y la naturaleza indómita de la marca.

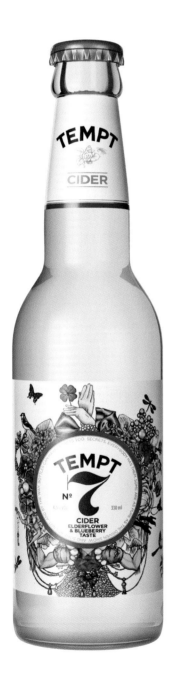

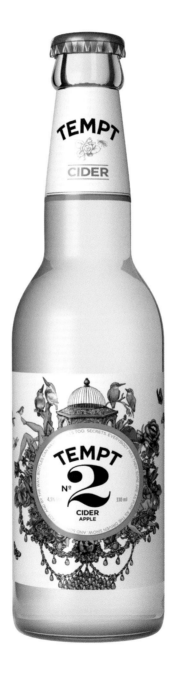

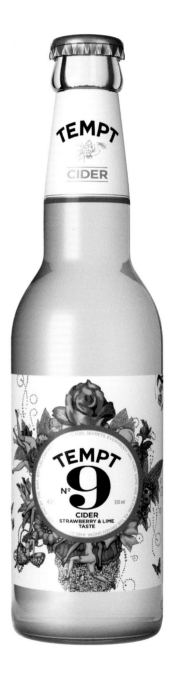

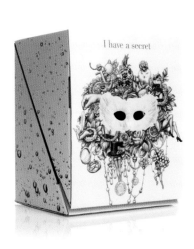

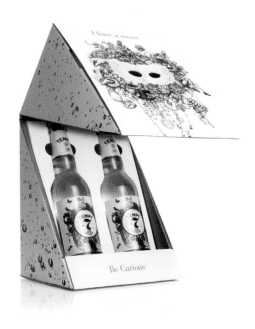

Art direction
DDB Copenhagen

Project
Tempt Cider Design

Client
Royal Unibrew

Designer
Gry Strange Echwald

Project description
Tempt Cider was a new addition to a Danish cider market completely dominated by Carlsberg's Somersby brand. With only half the marketing budget of the market leader, Tempt needed to have unique stand out qualities – both in design and campaign.

Tempt was defined as refreshing brand for the free and rebellious who dare to be tempted and follow their curiosity for the new experiences waiting around the corner. It is often said, that the magic is in the product, but in this case, that is certainly true. We wanted the product to be the media and help us support the brand position. This is why the Tempt design is full of secrets and charming details. Numbers that hold secret meanings, details in the illustrations that you want to explore and small stories for people who are curious enough to take a closer look beyond the innocent surface. For instance, on the back label we made a keyhole to the backside of the front label, where you could read a hidden message: "I have a secret – temptcider.com". On the website you could see, tell and share secrets. And you could find invitations for secret masquerade parties all over the country.

Dirección artística
DDB Copenhagen

Proyecto
Tempt Cider Design

Cliente
Royal Unibrew

Diseñador
Gry Strange Echwald

Descripción del proyecto
Tempt Cider era una nueva incorporación al mercado danés de la sidra dominado por completo por la marca Somersby de Carlsberg. Con solo la mitad del presupuesto del líder del mercado, Tempt Cider necesitaba tener atributos únicos que resaltasen, tanto en el diseño como en la campaña.

Tempt se definió como una marca innovadora para los que son rebeldes y libres, que se atreven a que les tienten y van detrás de su curiosidad hacia experiencias nuevas que les esperan a la vuelta de la esquina. A menudo se dice que la magia está en el producto, pero en este caso es realmente cierto. Queríamos que el producto fuese el medio y que nos ayudase a respaldar la posición de la marca. Es por esto que el diseño de Tempt está lleno de secretos y detalles fascinantes. Números que guardan significados secretos, detalles en la ilustración que quieres analizar y pequeñas historias para gente que es lo suficientemente curiosa como para examinar con detenimiento más allá del inocente exterior. Por ejemplo, en la etiqueta posterior hicimos una bocallave hacia la parte trasera de la etiqueta frontal donde se puede leer un mensaje oculto: «Tengo un secreto – Temptcider.com». En la página web puedes ver, contar y compartir secretos. Y puedes encontrar invitaciones para fiestas secretas de disfraces por todo el país.

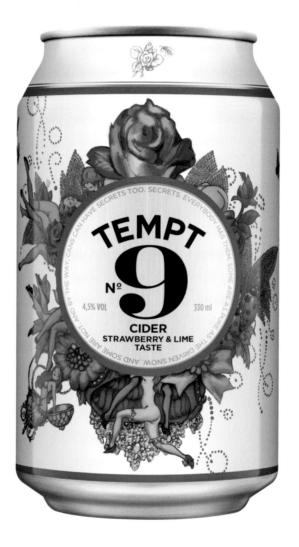
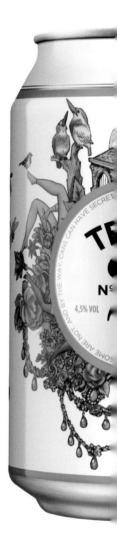

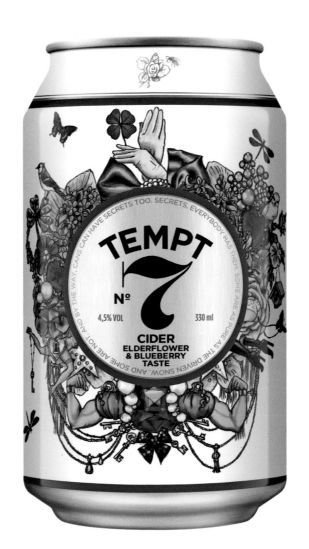

TEMPT

N° 7

4,5% VOL 330 ml

CIDER
ELDERFLOWER
& BLUEBERRY
TASTE

...S. EVERYBODY HAS THEM. SOME ARE AS PURE AS THE DRIV...

...EVERYBODY HAS THEM. SOME ARE AS PURE AS THE DRIVEN SNOW, AND SOME ARE NOT. AND BY THE WAY, CANS CAN HAVE SECRETS TOO. SECRETS. EVERYBODY HAS THEM. SOME ARE AS PURE...

330 ml

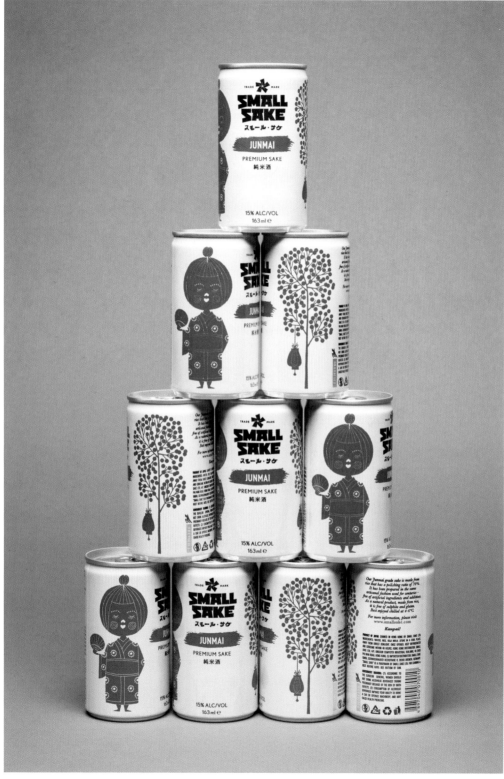

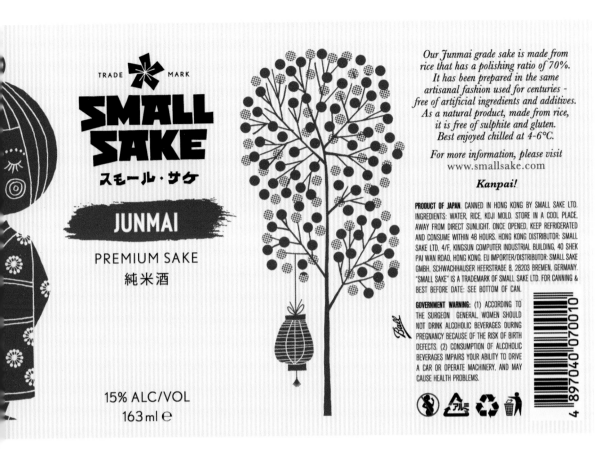

TRADE MARK

SMALL SAKE

スモール・サケ

JUNMAI

PREMIUM SAKE
純米酒

15% ALC/VOL
163 ml ℮

Our Junmai grade sake is made from rice that has a polishing ratio of 70%. It has been prepared in the same artisanal fashion used for centuries - free of artificial ingredients and additives. As a natural product, made from rice, it is free of sulphite and gluten. Best enjoyed chilled at 4-6°C.

For more information, please visit
www.smallsake.com

Kanpai!

PRODUCT OF JAPAN. CANNED IN HONG KONG BY SMALL SAKE LTD. INGREDIENTS: WATER, RICE, KOJI MOLD. STORE IN A COOL PLACE, AWAY FROM DIRECT SUNLIGHT. ONCE OPENED, KEEP REFRIGERATED AND CONSUME WITHIN 48 HOURS. HONG KONG DISTRIBUTOR: SMALL SAKE LTD. 4/F, KINGSUN COMPUTER INDUSTRIAL BUILDING, 40 SHEK PAI WAN ROAD, HONG KONG. EU IMPORTER/DISTRIBUTOR: SMALL SAKE GMBH, SCHWACHHAUSER HEERSTRAßE 8, 28203 BREMEN, GERMANY. "SMALL SAKE" IS A TRADEMARK OF SMALL SAKE LTD. FOR CANNING & BEST BEFORE DATE: SEE BOTTOM OF CAN.

GOVERNMENT WARNING: (1) ACCORDING TO THE SURGEON GENERAL, WOMEN SHOULD NOT DRINK ALCOHOLIC BEVERAGES DURING PREGNANCY BECAUSE OF THE RISK OF BIRTH DEFECTS. (2) CONSUMPTION OF ALCOHOLIC BEVERAGES IMPAIRS YOUR ABILITY TO DRIVE A CAR OR OPERATE MACHINERY, AND MAY CAUSE HEALTH PROBLEMS.

Ball

4 897040 070010

Illustration
Klas Fahlen

Project
Small Sake

Client
Small Sake brand

Project description
Pontus Karlsson a Swedish designer friend (one of the co founder to WESC) who lives in HongKong nurture a dream about making Sake a global interest, so he and another friend Marek Malcharczyk started the Small Sake brand. They asked me and my designer girlfriend Nina to come up with an idea of the can design. It should contain a typical Japanese symbols but in a fun and modern way. It´s also meant to be a serial with more motifs and tastes.

Ilustración
Klas Fahlen

Proyecto
Small Sake

Cliente
Small Sake brand

Descripción del proyecto
Pontus Karlsson, un amigo sueco diseñador (uno de los fundadores de WESC) que vive en Hong Kong, promueve un sueño para hacer del sake algo de interés general. Por eso, él y otro amigo, Marek Malcharczyk, crearon la marca Small Sake. Nos pidieron a mí y a mi novia Nina, que es diseñadora, que elaborásemos alguna idea para el diseño de la lata. Debía contener símbolos típicos japoneses, pero de forma divertida y moderna. Se supone que habrá una serie con más diseños y sabores

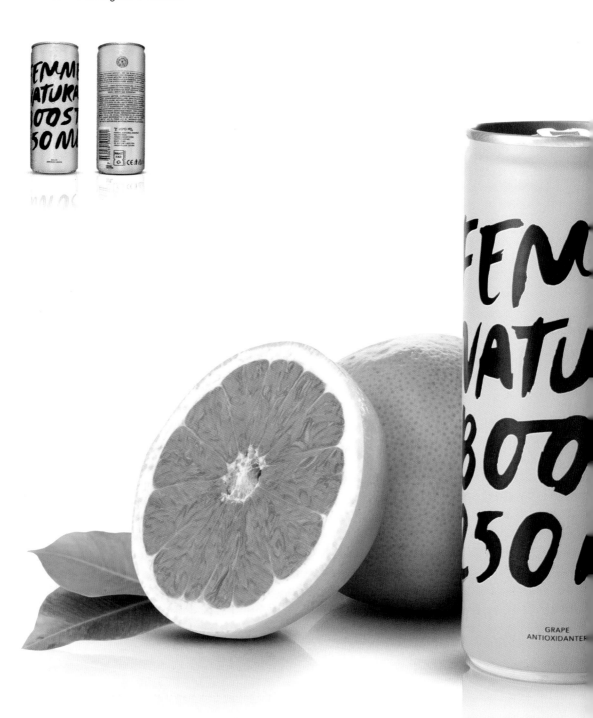

Art direction
Ehrenstråhle & Wågnert

Project
Femme Natural Boost

Client
Femme Natural Boost

Project description
Femme Natural Boost is an
energy drink that turns to
a female audience that, in
the current situation, have
no alternative available
in a product category in
which communication
signals mostly extreme
sports, masculinity and
testosterone. The challenge
was therefore to develop a
package that attracts the
audience without, for that
matter, alluding to the old
image of what is feminine.

Femininity and
independence were the
key words in the creation
of Femme's brand, which
included a complete
graphic profile and
packaging design. In terms
of branding we wanted
to express attitude and
self-confidence with the
female at the heart of it,
which sets Femme apart
from other competitors in
the energy drink market. By
working with a saturated yet
distinctive color along with
hand-drawn typeface, the
can got an expression that
was feminine without being
perceived as cliché-like.

Dirección artística
Ehrenstråhle & Wågnert

Proyecto
Femme Natural Boost

Cliente
Femme Natural Boost

Descripción del proyecto
Femme Natural Boost es una
bebida energética dirigida
a un público femenino que,
en la situación actual, no
tiene más alternativas
disponibles en una categoría
de productos en la que las
señales de comunicación
son en su mayoría sobre
deporte, masculinidad y
testosterona. Por tanto, el reto
era desarrollar un envase que
atrajera a la audiencia sin
que, en este sentido, aludiese
a una imagen antigua de lo
que es femenino.

Feminidad e independencia
eran las palabras clave en la
creación de la marca Femme,
que incluía el diseño del
packaging y un perfil gráfico
completo. En términos de
desarrollo de la marca,
queríamos expresar actitud
y confianza en sí misma,
con la mujer en el centro
de la misma, lo que sitúa a
Femme apartada de otros
competidores en el mercado
de las bebidas energéticas. Al
trabajar con un color saturado
pero distintivo junto con un
tipo de letra hecho a mano, la
lata conseguía una expresión
que era femenina sin que se
percibiese como un cliché.

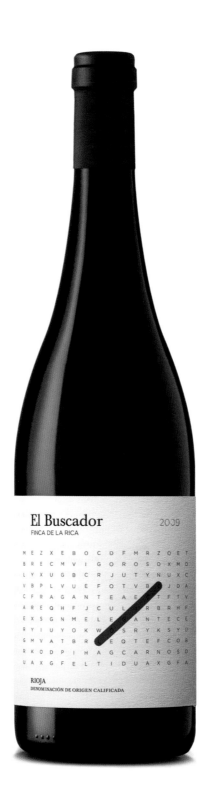

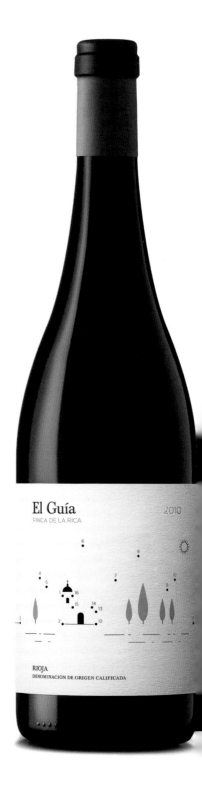

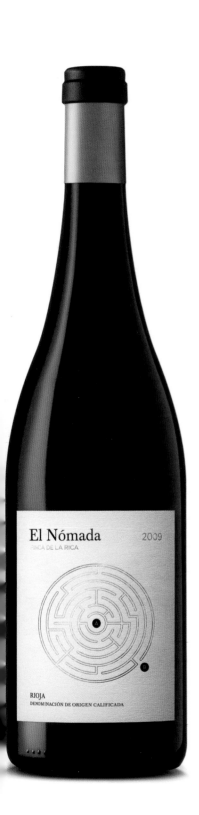

Art direction
Dorian

Project
Finca de la Rica

Client
Finca de la Rica

Project description
"El Buscador", "El Guía" and "El Nómada" are three wines from a line designed under the concept of leisure. The packaging focuses on the moment of relax and pleasure that gives you a good glass of wine, through a fun and original label that invites consumers to participate directly on the bottle itself to complete or resolve the puzzles.

Dirección artística
Dorian

Proyecto
Finca de la Rica

Cliente
Finca de la Rica

Descripción del proyecto
"El Buscador", "El Guía" y "El Nómada" son tres vinos de una línea diseñada bajo el concepto de ocio. La imagen se centra en el momento de relax y placer que te ofrece una buena copa de vino, a través de una etiqueta divertida y original que invita a los consumidores a intervenir directamente sobre la propia botella para resolver o completar los enigmas.

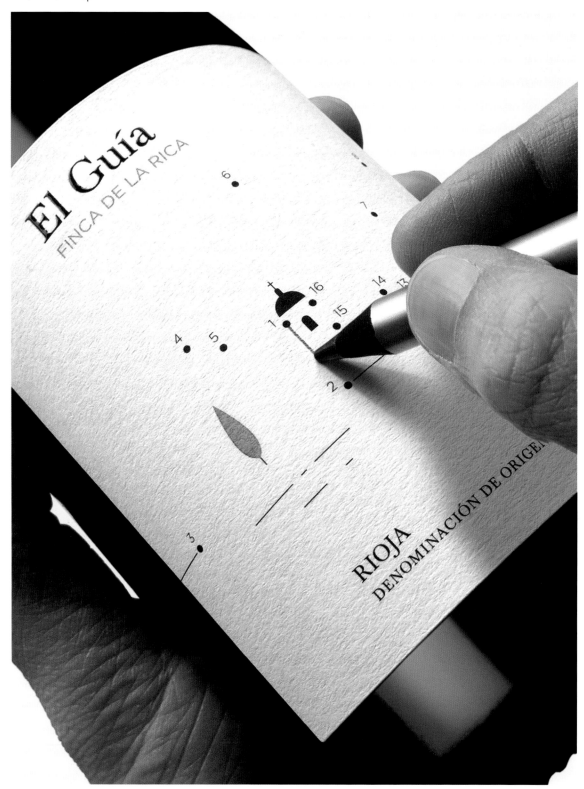

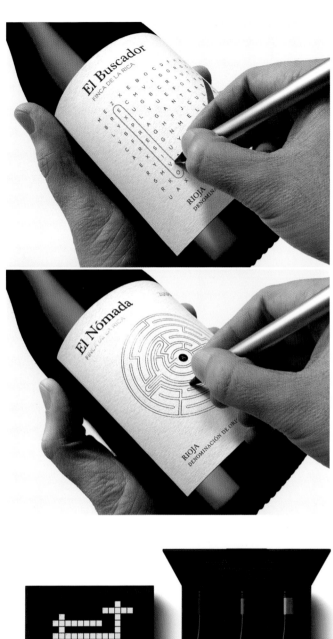

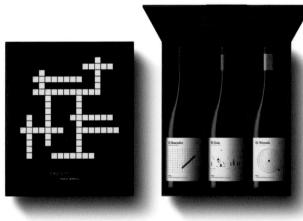

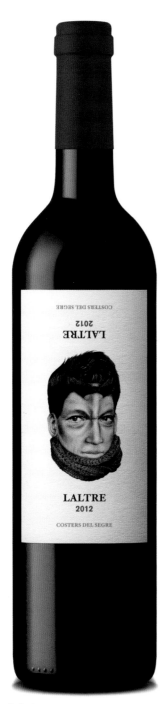
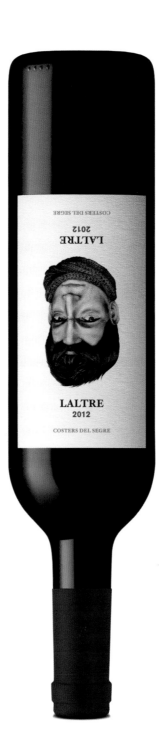

Art direction
Dorian

Project
Laltre

Client
Lagravera

Project description
At the gates of the Pyrenees, embraced by the norther mountain range "Sierra Larga" and halfway between the regions of Segrià and Noguera, lie the vineyard of the winery "Lagravera". A singular and unique vineyard in Catalonia for being located on an old gravel pit.
Laltre is the youngest wine they produce and its new design represents, through an optical illusion, the merged values of his youth with the experience and wisdom of the traditional methods which follows the winery.

Dirección artística
Dorian

Proyecto
Laltre

Cliente
Lagravera

Descripción del proyecto
A las puertas de los Pirineos, abrazados al norte por la Sierra Larga y a caballo entre las comarcas de Segrià y Noguera, se sitúan los viñedos de la bodega Lagravera. Unas viñas singulares y únicas en Cataluña por localizarse sobre una antigua gravera.
Laltre es el vino más joven que producen y su nuevo diseño representa, a través de un juego visual, la fusión de los valores de su juventud con la experiencia y sabiduría de los métodos de cultivo tradicionales que sigue la bodega.

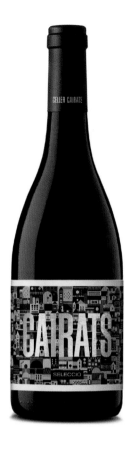

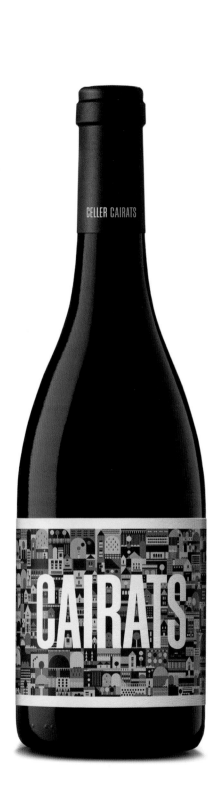

Art direction
Dorian

Project
Cairats

Client
Celler Cairats

Project description
Celler Cairats is a young
catalan winery that started
in 2010. Their vineyards
are located in Darmós y Els
Guiamets, two villages in the
region of Priorat that treasure
centuries of tradition in vine
growing.
The image created for their
two wines has focused on
highlighting the young nature
of the winery, representing
the rural environment that
surrounds the winery and
vineyards in very fresh and
attractive way.

Dirección artística
Dorian

Proyecto
Cairats

Cliente
Celler Cairats

Descripción del proyecto
Celler Cairats es una joven
bodega catalana puesta
en marcha en el año 2010.
Sus viñas se encuentran
ubicadas en Darmós y Els
Guiamets, dos municipios de
la comarca del Priorato que
atesoran siglos de tradición
en el cultivo de la vid.
La imagen creada para sus
dos vinos se ha centrado en
destacar el carácter joven
de la bodega, representando
de una manera fresca y
atractiva el entorno rural que
rodea a la bodega y sus viñas.

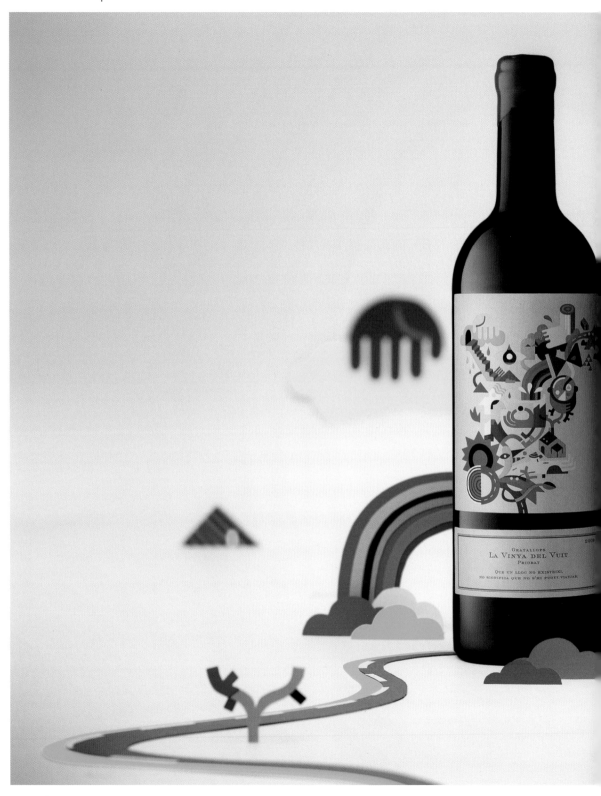

Art direction
Iván Bravo

Project
La Vinya del Vuit 2009

Client
La Vinya del Vuit

Art direction JJ Bertran

Illustration Iván Bravo

Photography Manu da Costa

Project description
Represent the psychological
and emotional landscape of
Priorat, where this wine is
made.

Dirección artística
Iván Bravo

Proyecto
La Vinya del Vuit 2009

Cliente
La Vinya del Vuit

Dirección artística JJ Bertran

Ilustración Iván Bravo

Fotografía Manu da Costa

Descripción del proyecto
Representa el paisaje
emocional y psicológico del
Priorato, donde se elabora
este vino.

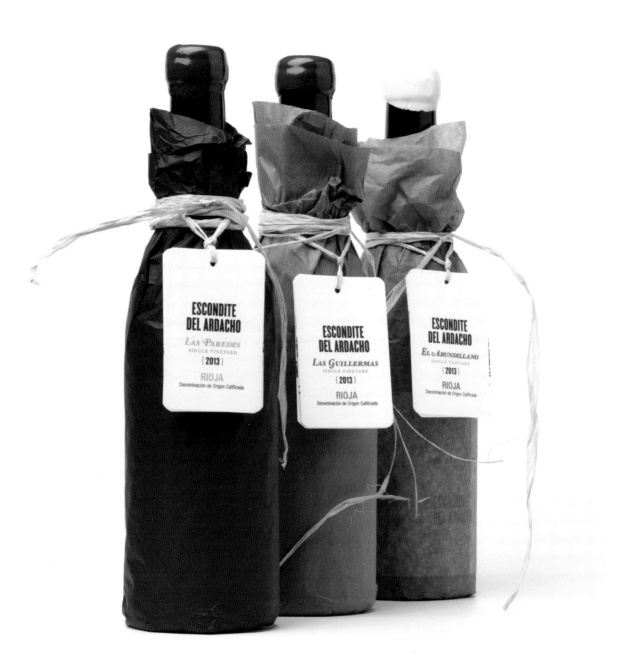

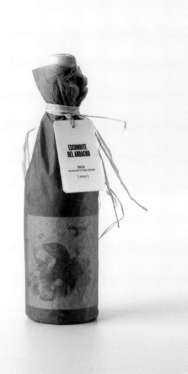
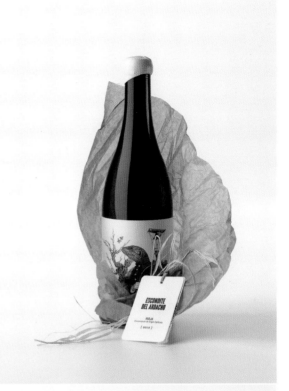
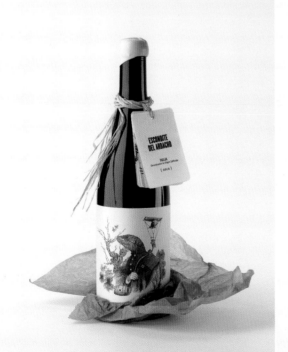
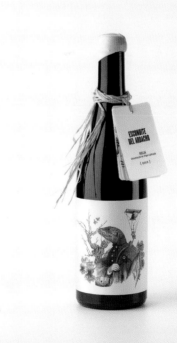

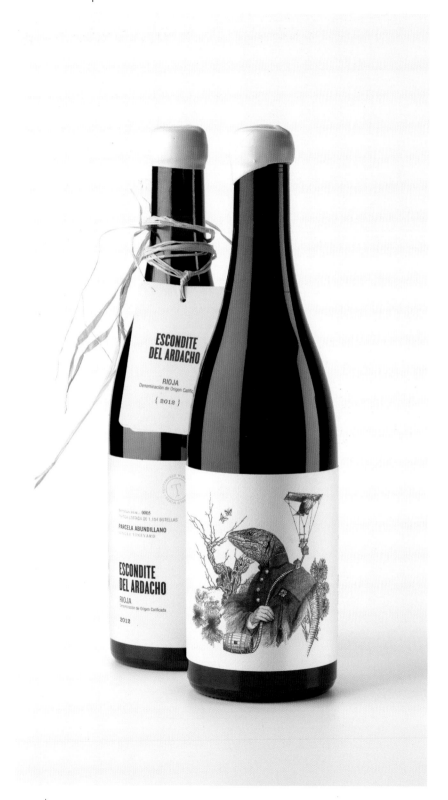

Art direction
Calcco

Project
Escondite del Ardacho

Client
Finca Abundillano, Las
Guillermas y Las Paredes

Project description
The customer raises the need
to develop a packaging that
differed radically from other
presentations of Rioja and
it gave us total freedom in
addressing and developing
the proposal. We seek a
differential value, a way of
dressing the product to do
it different and very visible
at the point of sale: wine
stores and specialty shops.
Therefore we committed to a
striking, stylish and colorful
packaging.

Dirección artística
Calcco

Proyecto
Escondite del Ardacho

Cliente
Finca Abundillano, Las
Guillermas y Las Paredes

Descripción del proyecto
El cliente planteó la
necesidad de desarrollar
un packaging que se
diferenciara radicalmente
del resto de presentaciones
de Rioja y para ello nos
dio libertad total a la hora
de abordar y desarrollar
la propuesta. Buscamos
un valor diferencial, una
forma de vestir al producto
que lo hiciera diferente y
muy visible en el punto de
venta: vinotecas y tiendas
especializadas. Por ello
apostamos por un envoltorio
llamativo, elegante y colorido.

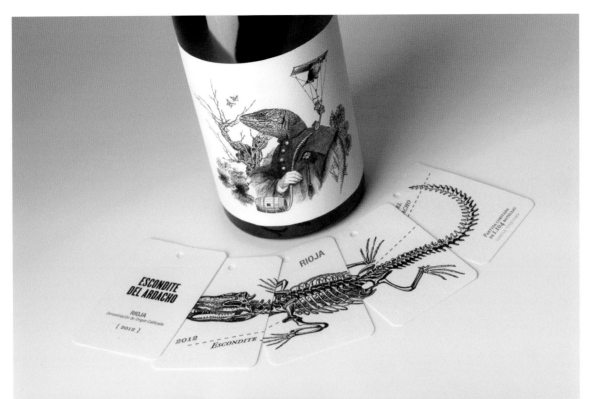

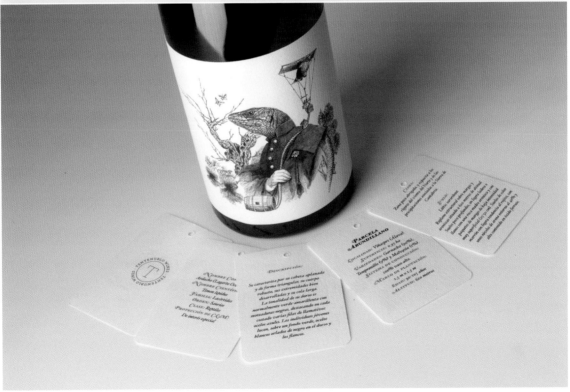

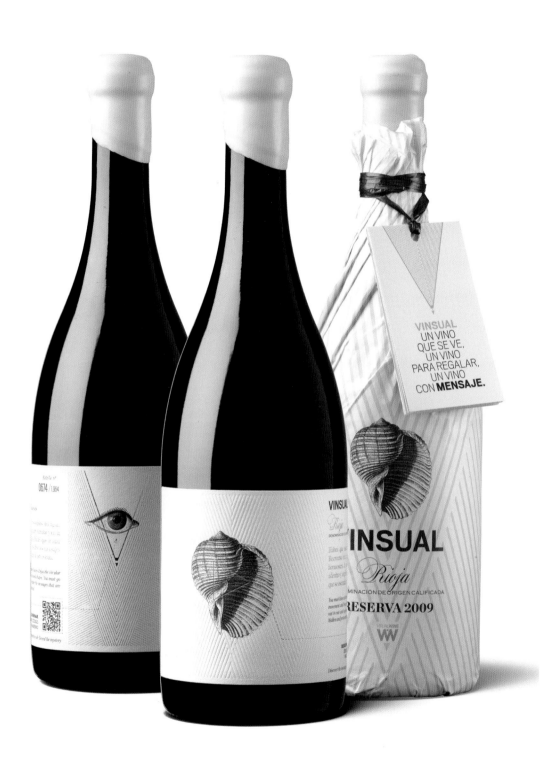

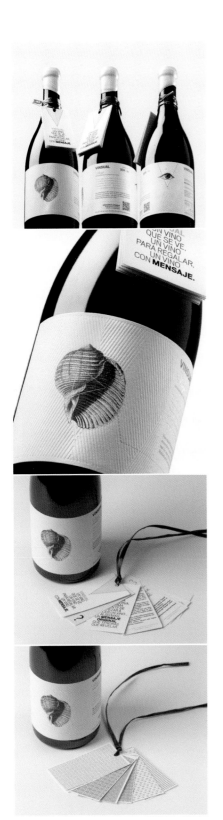

Art direction
Calcco

Project
Visual

Client
Visual wines

Project description
The Vinsual family consists of 3 wines QDO. Rioja which follow two packaging design lines: In one hand a Red wine and a White wine whose designs reflect the essence of ancient epistolary correspondence (those eagerly awaited letters which were read with passion) and are complemented by a cylindrical case as a mailbox (it could not be otherwise) and on the other hand, a Reserva red wine that leads us to the sea from the hand of one of his most lyrical elements, the conch, the starting point to guide us to the eye that sees everything and decipher the hidden message.

Vinsual is a wine to be watched, a wine as a gift, a wine with a message. Vinsual is a project which envolves packaging, graphic design, typography, mobile application, web development and augmented reality. Each bottle has the possibility to include a hidden message that only the recipient can decrypt making use of Smart pone or taablet. But basically, we're talking about the history of man. The need to communicate by any means. The new and the old shake hands.

Dirección artística
Calcco

Proyecto
Visual

Cliente
Visual wines

Descripción del proyecto
La familia Vinsual se compone de 3 vinos D.O.Ca. Rioja que siguen dos líneas de diseño del packaging: por un lado, un tinto y un blanco cuyos diseños reflejan la esencia de la antigua correspondencia epistolar (aquellas cartas que se esperaban con impaciencia y se leían con pasión) y se completan con un estuche cilíndrico a modo de buzón (no podía ser de otra forma) y, por otro lado, un tinto Reserva que nos lleva al mar de la mano de uno de sus elementos más líricos, la caracola, el punto de partida para guiarnos hasta el ojo que todo lo ve y descifrar el mensaje oculto.

Vinsual es un vino que se ve, un vino para regalar, un vino con mensaje. Vinsual es un proyecto que engloba packaging, diseño gráfico, tipografía, aplicaciones móviles, desarrollo web y realidad aumentada. Cada botella tiene la posibilidad de incluir un mensaje oculto, que sólo podrá descifrar el destinatario utilizando un teléfono inteligente o una tableta. Pero en el fondo, estamos hablando de la historia del hombre. La necesidad de comunicarse por cualquier medio. Lo nuevo y lo viejo se dan la mano.

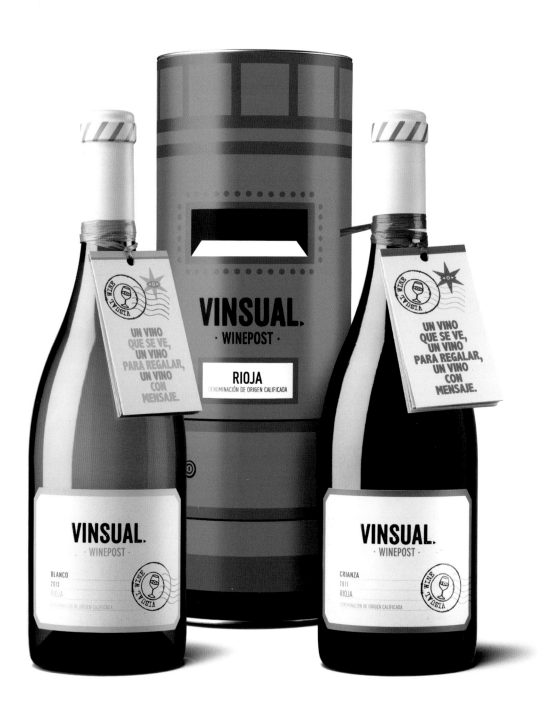

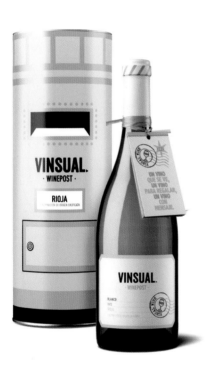

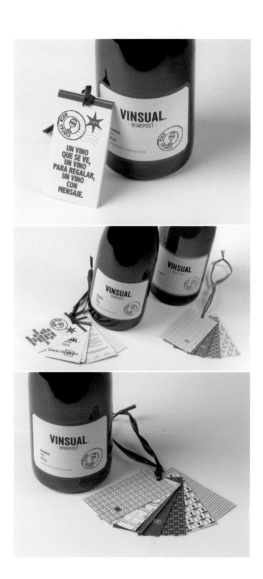

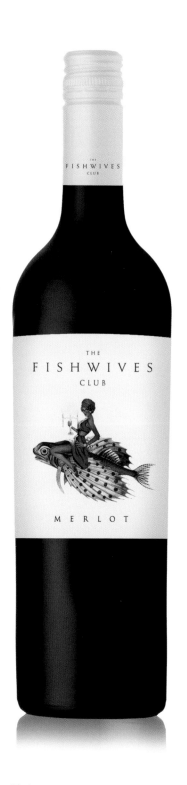
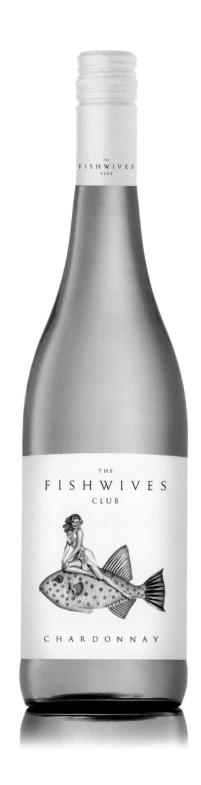
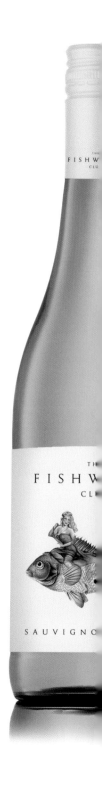

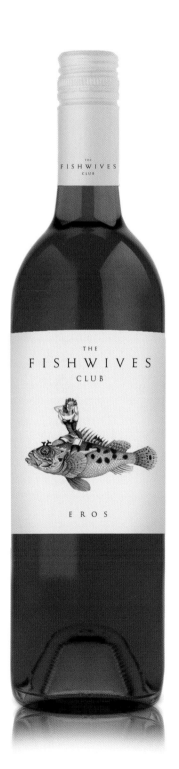

Art direction
Soil design

Project
Fishwives

Client
Fishwives Club Boutique Winery

Project description
The Fishwives Club Boutique Winery is an elegant and cheeky wine brand that hand makes wines for authentic, confident women. These women come from all walks of life but what makes them different is that when they get together to enjoy a bottle or two of The Fishwives Club, all pretentiousness, snobbery and insecure image-conscious bullshit falls away. It leaves only the authentic true-to-herself woman who is not afraid to speak her mind, stand out and be true to herself and her friends.

This is true freedom from society's controlling tentacles. Women are liberally emancipated to do what they want, when they want and without a hint of apology. The Fishwives Club is a glamorous brand that celebrates the true power and beauty that is Woman. It is a badge that symbolises this power in women to wield enough self-respect to stand their ground. It gives all who drink it this right. No apologies...just the beautiful truth from inside.

And if you don't like the truth, you can bugger off.

Have a super Sauvignon Blanc day,

Dirección artística
Soil design

Proyecto
Fishwives

Cliente
Fishwives Club Boutique Winery

Descripción del proyecto
La bodega boutique The Fishwives Club es una marca de vinos elegante y atrevida que elabora vinos caseros para mujeres seguras, auténticas. Estas mujeres provienen de todas las clases sociales pero lo que las hace diferentes es que, cuando se juntan para disfrutar de una o dos botellas de The Fishwives Club, todas las tonterías del cuidado de la imagen insegura, estirada y presuntuosa se disipan. Queda solamente la auténtica mujer sincera consigo misma que no tiene miedo a decir lo que piensa, a sobresalir y ser fiel a sí misma y a sus amigas.

Esta es la auténtica libertad de los tentáculos que controlan la sociedad. Las mujeres están muy emancipadas para hacer lo que quieran, cuando quieran y sin un atisbo de disculpa. The Fishwives Club es una marca glamurosa que celebra el verdadero poder y belleza que es la mujer. Es un distintivo que simboliza el poder de las mujeres que tienen suficiente respeto por sí mismas para mantenerse firmes. Le da a todo el que lo bebe este derecho. Sin disculpas... Sólo la maravillosa verdad desde el interior.

Y si no te gusta la verdad, puedes largarte.

Disfruta de un gran día con un Sauvignon Blanc,

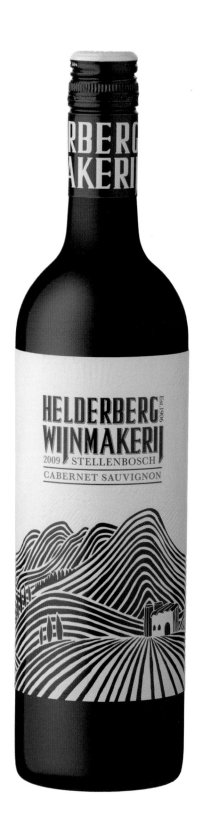

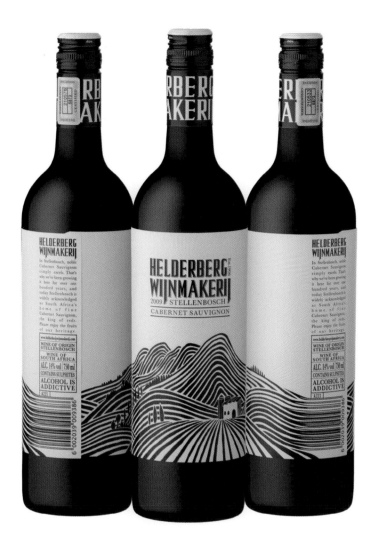

Art direction
Fanakalo

Project
Helderberg Wijnmakerij

Client
Helderberg Wijnmakerij

Project description
The Helderberg - named for its beauty, and meaning Clear or Bright Mountain - rises majestically above the sweeping False Bay. Around this mountain, farmers have planted vines for centuries; discovering that its soils and proximity to the ocean are ideal for the cultivation of premium grapes.

The full wrap-around label expresses this mountain and the debossed clouds and sun-rays gives the paper texture making it super tactile.

Dirección artística
Fanakalo

Proyecto
Helderberg Wijnmakerij

Cliente
Helderberg Wijnmakerij

Descripción del proyecto
Helderberg, que recibe su nombre por su belleza y significa montaña brillante o cristalina, se eleva de manera majestuosa sobre la extensa False Bay. Alrededor de esta montaña, los granjeros han plantado viñas durante siglos, descubriendo que sus tierras y proximidad al océano son ideales para el cultivo de uvas de calidad suprema.

La etiqueta completamente envolvente simboliza esta montaña y las nubes y rayos de sol en relieve le dan textura al papel haciéndolo muy agradable al tacto.

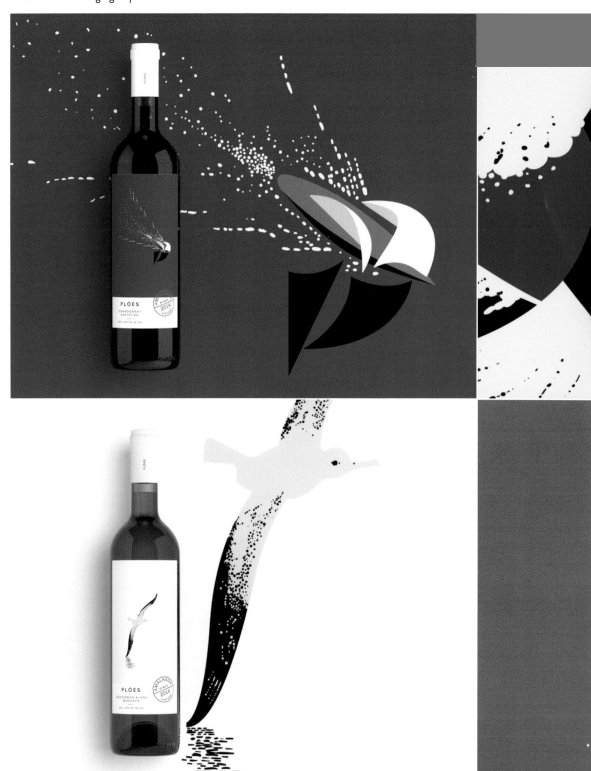

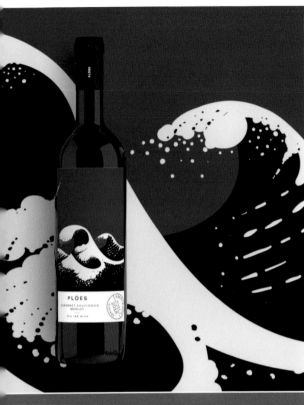

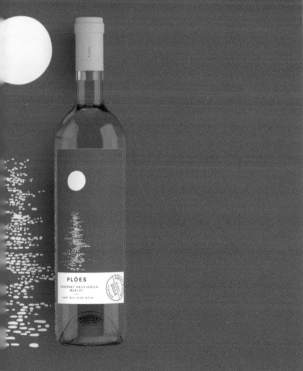

Art direction
Beetroot design group

Project
Ploes wines

Client
Amalagos wines

Project description
In this solution a large part of the label is filled with sea trips inspired illustrations. We designed our illustrations with simple clean forms on which handmade 'water' details are added.
The way a sailboat is reflected in the water, the low flight of a seagull that one feather barely scratches the surface of the sea, the journey of the moon that generates light wrinkles over in water and the water element that transforms into a wave.
The simple typography comes to subtly emphasise our sea pictures with a "random" mounted stamp to give the atmosphere of mystery and the validity and uniqueness of this excellent series.

Dirección artística
Beetroot design group

Proyecto
Ploes wines

Cliente
Amalagos wines

Descripción del proyecto
En esta solución, gran parte de la etiqueta la ocupan ilustraciones inspiradas en viajes por mar. Diseñamos nuestras ilustraciones con formas simples y limpias en las que se añaden detalles acuáticos caseros.
La forma en que se refleja un bote en el agua, el vuelo bajo de una gaviota con una pluma que apenas araña la superficie del mar, la travesía de la luna que genera pliegues de luz en el agua y el elemento agua que se transforma en una ola.
La tipografía simple viene a enfatizar de forma sutil nuestras imágenes del mar con un sello «aleatorio» para darle una atmósfera de misterio y la validez y singularidad de esta excelente serie.

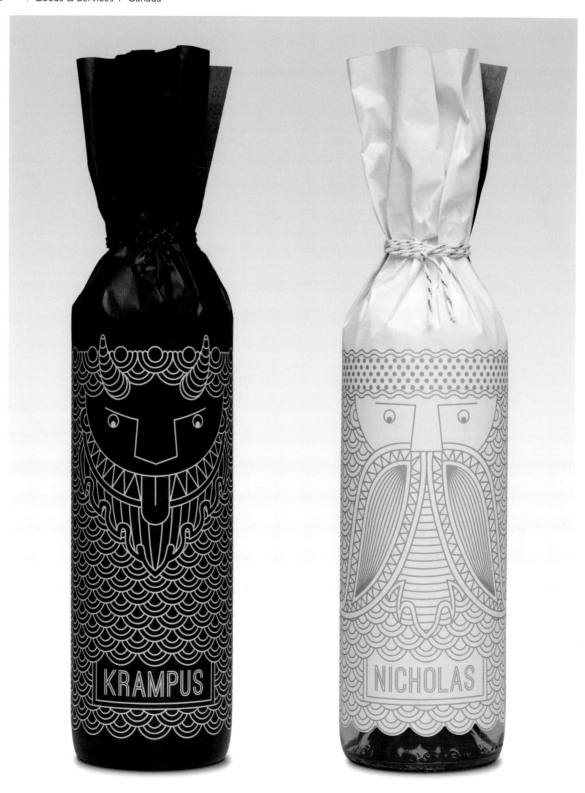

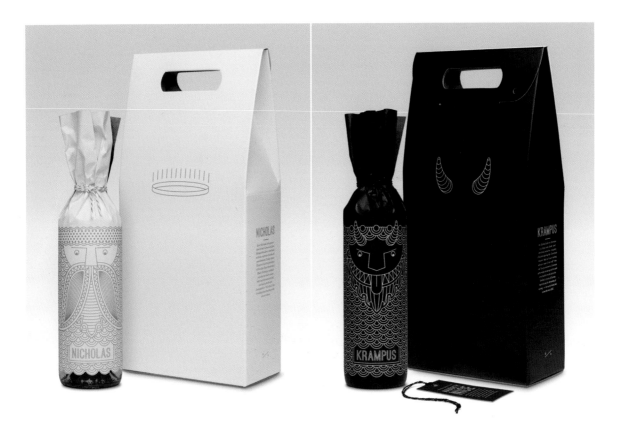

Art direction
Goods & Services

Project
G&S Holiday Nicholas &
Krampus wines 2014

Client
Goods & Services

Project description
Playing on the naughty/
nice holidays dichotomy,
this packaging features one
white wine and one red wine,
dressed up as Alpine folklore
characters Nicholas (the
basis of Santa) and Krampus
(the horned punisher).
Scalloped butcher-paper
wine labels are hand-
wrapped on the bottle
and tied with a decorative
string. An understated
black and white box gives
more information about the
characters and
their origins.

Dirección artística
Goods & Services

Proyecto
G&S Holiday Nicholas &
Krampus wines 2014

Cliente
Goods & Services

Descripción del proyecto
Jugando con la dicotomía de
malas/buenas vacaciones,
el envase presenta un
vino blanco y un vino tinto
disfrazados como los
personajes folclóricos
alpinos Nicolás (el origen
de Santa) y Krampus (el
castigador cornudo). La
botella se envuelve a mano
con las etiquetas de papel
de estraza festoneado y
se ajustan con una cuerda
decorativa. Una sencilla
caja blanca y negra ofrece
más información sobre los
personajes y sus orígenes.

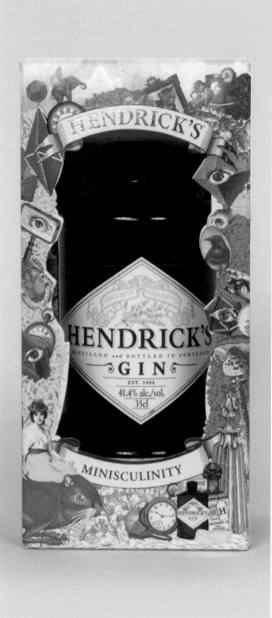

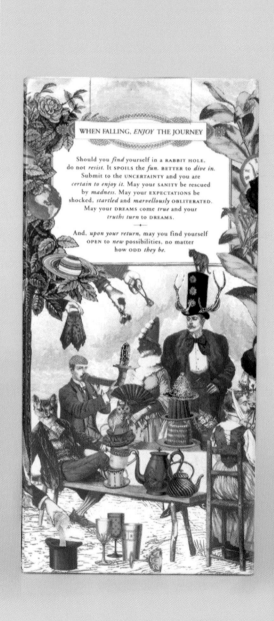

WHEN FALLING, *ENJOY* THE JOURNEY

Should you *find* yourself in a RABBIT HOLE,
do not *resist*. It SPOILS the *fun*. BETTER to *dive in*.
Submit to the UNCERTAINTY and you are
certain to enjoy it. May your SANITY be rescued
by *madness*. May your EXPECTATIONS be
shocked, *startled* and *marvellously* OBLITERATED.
May your DREAMS come *true* and your
truths turn to DREAMS.

And, *upon your return*, may you find yourself
OPEN to *new* possibilities, no matter
how ODD *they be*.

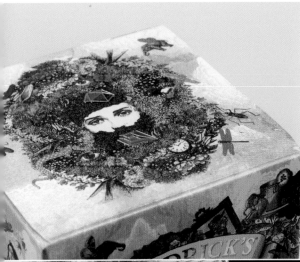

Art direction
Here Design

Project
Minisculinity
Hendrick's

Client
Hendrick's

Project description
The brief was to design a compelling solution for the outer packaging of a half size Gin bottle that would make an impact in the Global Travel Retail market.

This half-size Hendrick's gift pack is inspired by Classic fairytales of shrunken misadventure. The illustrations unravel around the bottle telling a surreal tale - with an unusual twist.

The design is bursting with neon hues juxtaposed with delicate silver micro engraved elements, an obsessive and pioneering print technique. The insides of the box are also printed, containing the little bottle within iconic fairytale scenes. Inside the box we have designed a miniature book of cocktail recipes.

Dirección artística
Here Design

Proyecto
Minisculinity
Hendrick's

Cliente
Hendrick's

Descripción del proyecto
Se trataba de diseñar una solución convincente para el packaging exterior de una botella de ginebra de tamaño medio que podría tener impacto en el mercado de los puntos de venta Travel Retail.

Este estuche de regalo con la botella mediana de Hendrick's se inspira en los clásicos cuentos de hadas de infortunios encogidos.
Las ilustraciones se descifran alrededor de la botella contando un cuento irreal con un giro inusual.

El diseño estalla con tonos neón yuxtapuestos con delicados micro elementos grabados en plata, una técnica de impresión pionera y obsesiva. Los interiores de la caja también van impresos, guardando la botella pequeña con escenas icónicas de cuentos de hadas. Dentro de la caja, hemos diseñado un libro en miniatura con recetas de cócteles.

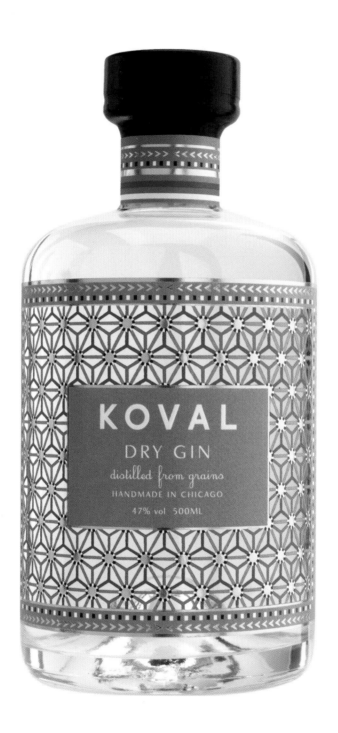

KOVAL

DRY GIN

distilled from grains

HANDMADE IN CHICAGO

47% vol 500ML

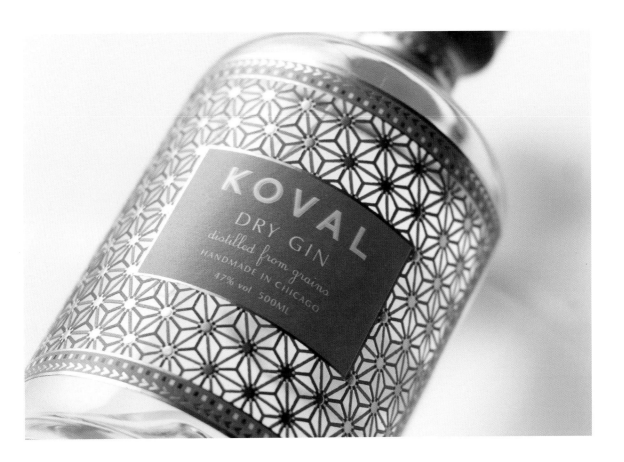

Art direction
Dando Projects

Project
Dry Gin

Client
KOVAL Distillery

Project description
KOVAL changed up the bottle and label to reflect the artistry and craftsmanship that goes into making the spirit itself. Printed using innovative and environmentally sustainable techniques, this new label features Flexo paper with gold foil, embossing, laser cutting, and diecutting. Gold foil disks surround the traditional KOVAL plaque.

Dirección artística
Dando Projects

Proyecto
Dry Gin

Cliente
KOVAL Distillery

Descripción del proyecto
KOVAL cambió la botella y la etiqueta para reflejar la destreza y artesanía que tiene que ver con fabricar el licor en sí mismo. Impresa utilizando técnicas innovadoras y respetuosas con el medio ambiente, esta nueva etiqueta presenta papel flexo con láminas doradas, relieves, cortes por láser y troquelados. Los discos de láminas doradas rodean la tradicional placa de KOVAL.

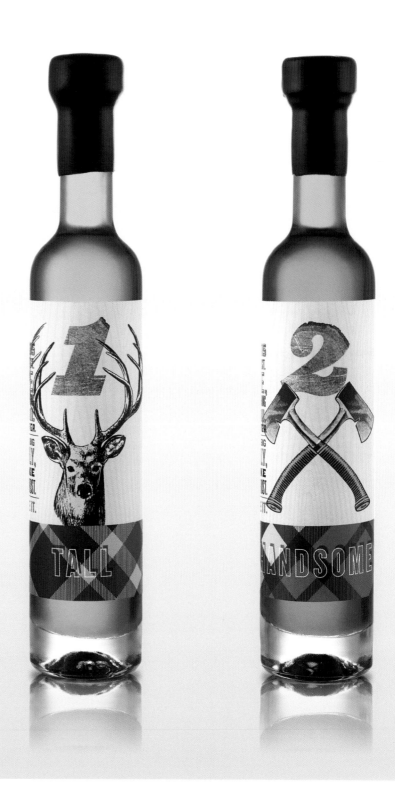

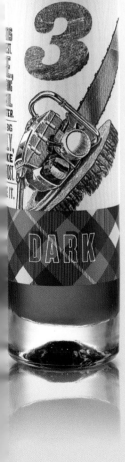

Art direction
Goods & Services

Project
Flash Holiday Maple Syrup
2013

Project description
For a client's 2013 holiday
gift, Goods & Services
created a flight of three
different grades of maple
syrup, which we sourced
from Matthews Maple
Syrup, a family-owned
farm in Powassan, Ontario.
Ranging from light to
medium to amber, each
of the syrups was custom
bottled and labelled with
names that reflect that
range: Tall, Handsome and
Dark. Continuing the theme
of Canadiana, all three
syrups are nestled inside
a specially designed box,
featuring classic Canadian
patterns and images, from
plaid to a deer head. Thanks
to precision measurement
and cutting techniques, each
bottle sits snugly inside
its own slot in the custom-
made box, held in place by
the box's label.

Dirección artística
Goods & Services

Proyecto
Flash Holiday Maple Syrup
2013

Descripción del proyecto
Para el regalo navideño de
2013 de un cliente, Goods &
Services creó una trayectoria
con tres grados distintos de
sirope de arce que obtuvimos
de Matthews Maple Syrup,
una familia canadiense dueña
de una granja en Powassan,
Ontario. Del ligero al medio
pasando por el ámbar,
cada uno de los siropes se
embotelló a medida y se
etiquetó con los nombres
que reflejan la graduación:
Tall, Handsome y Dark.
Siguiendo con la temática de
Canadá, los tres siropes se
recogen dentro de una caja
especialmente diseñada que
presenta imágenes y patrones
clásicos canadienses, desde
telas a cuadros a cabezas de
ciervos. Gracias a técnicas de
corte y medición de precisión,
cada botella se ajusta en
su propio hueco de la caja
personalizada, manteniéndose
en su sitio por la etiqueta de
la caja.

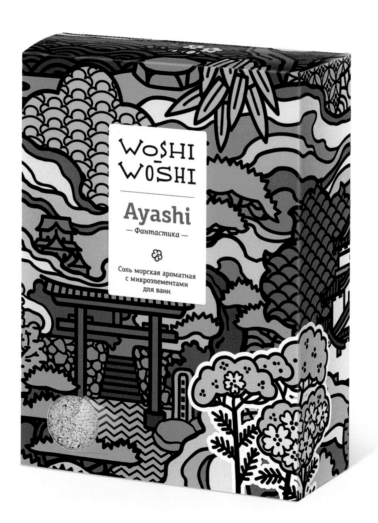

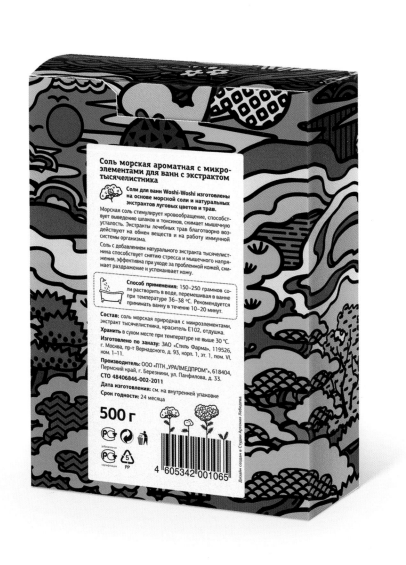

**Соль морская ароматная с микро-
элементами для ванн с экстрактом
тысячелистника**

Соли для ванн Woshi-Woshi изготовлены
на основе морской соли и натуральных
экстрактов луговых цветов и трав.

Морская соль стимулирует кровообращение, способст-
вует выведению шлаков и токсинов, снимает мышечную
усталость. Экстракты лечебных трав благотворно воз-
действуют на обмен веществ и на работу иммунной
системы организма.

Соль с добавлением натурального экстракта тысячелист-
ника способствует снятию стресса и мышечного напря-
жения, эффективна при уходе за проблемной кожей, сни-
мает раздражение и успокаивает кожу.

Способ применения: 150–250 граммов со-
ли растворить в воде, перемешивая в ванне
при температуре 36–38 °C. Рекомендуется
принимать ванну в течение 10–20 минут.

Состав: соль морская природная с микроэлементами,
экстракт тысячелистника, краситель Е102, отдушка.

Хранить в сухом месте при температуре не выше 30 °C.

Изготовлено по заказу: ЗАО «Стиль Фарма», 119526,
г. Москва, пр-т Вернадского, д. 93, корп. 1, эт. 1, пом. VI,
ком. 1–11.

Производитель: ООО «ПТК „УРАЛМЕДПРОМ"», 618404,
Пермский край, г. Березники, ул. Панфилова, д. 33.
СТО 48406846-002-2011

Дата изготовления: см. на внутренней упаковке
Срок годности: 24 месяца

500 г

4 605342 001065

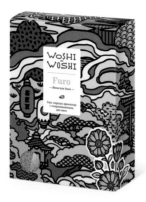
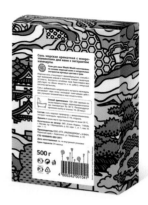

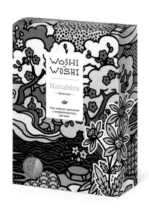
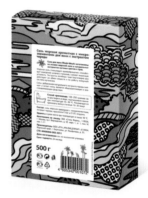

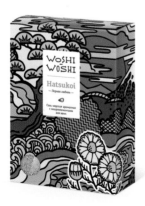
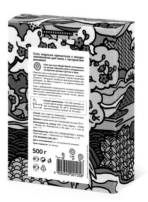

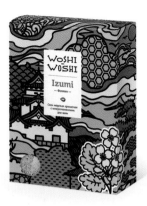

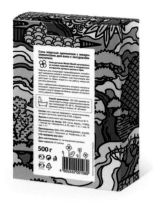

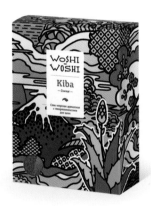

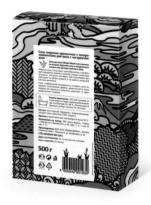

Art. Lebedev Studio

Art director
Artemy Lebedev

Designer
Evgeny Zorin

Project
Woshi-Woshi

Client
A5 pharmacy

Project description
A5 pharmacy chain offers a line of skin and hair care products under its own brand. It includes shower gels, liquid soap, bath salts, deodarants, shampoos, and hair conditioners. The logo for this product line is a monochrome text, especially designed to play up the busy signature pattern. Inspiration: the artwork on Japanese manhole covers.

Art. Lebedev Studio

Dirección artística
Artemy Lebedev

Diseñador
Evgeny Zorin

Proyecto
Woshi-Woshi

Cliente
A5 pharmacy

Descripción del proyecto
La cadena de farmacias A5 ofrece una línea de productos para el cuidado del cabello y la piel bajo su propia marca. Incluye geles de ducha, jabón líquido, sales de baño, desodorantes, champús y acondicionadores para el pelo. El logo para esta línea de productos es un texto monocromo, especialmente diseñado para resaltar el patrón de la firma. Inspiración: el trabajo artístico de las tapas de las alcantarillas japonesas.

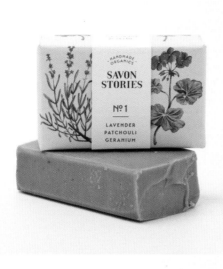

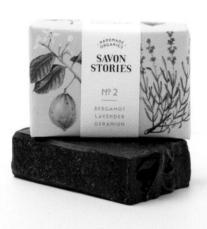

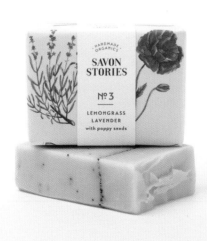

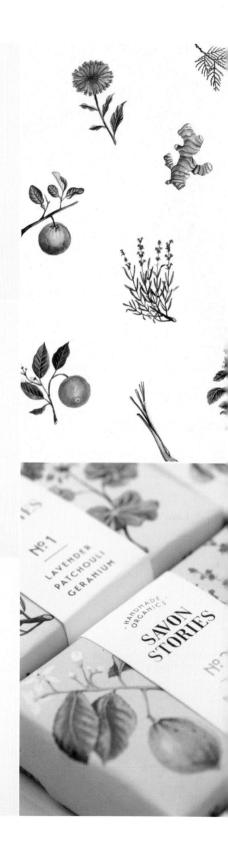

Menta Studio

Project
Savon Stories 2015

Client
Savon Stories

Art direction Laura Méndez

Designer Blanca Jiménez

Illustration Laura Méndez /
Blanca Jiménez

Photography Paola Chávez

Project description
Savon Stories is an English
company specialised in
the handcraft of 100%
organic soaps produced
in small batches, through
a cold-processed method
that retains all nourishing
properties to feed the skin.

Menta Studio

Proyecto
Savon Stories 2015

Cliente
Savon Stories

Dirección artística Laura Méndez

Diseñador Blanca Jiménez

Ilustración Laura Méndez /
Blanca Jiménez

Fotografía Paola Chávez

Descripción del proyecto
Savon Stories es una compañía
inglesa especializada en hacer a
mano jabones orgánicos 100%
fabricados en pequeños lotes a
través de un método de proceso
en frío que mantiene todas las
propiedades nutritivas para
cuidar la piel.

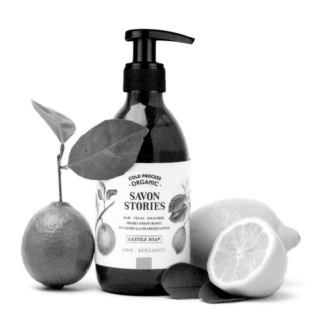

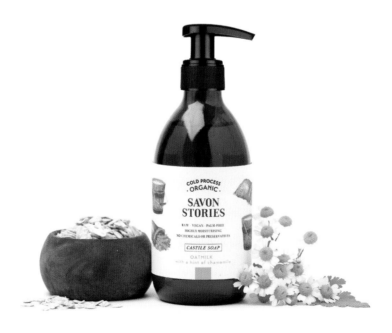

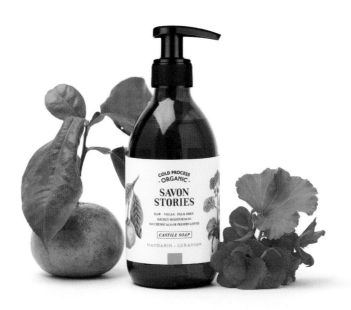

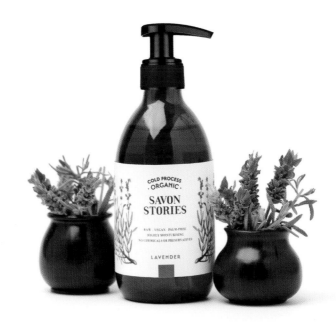

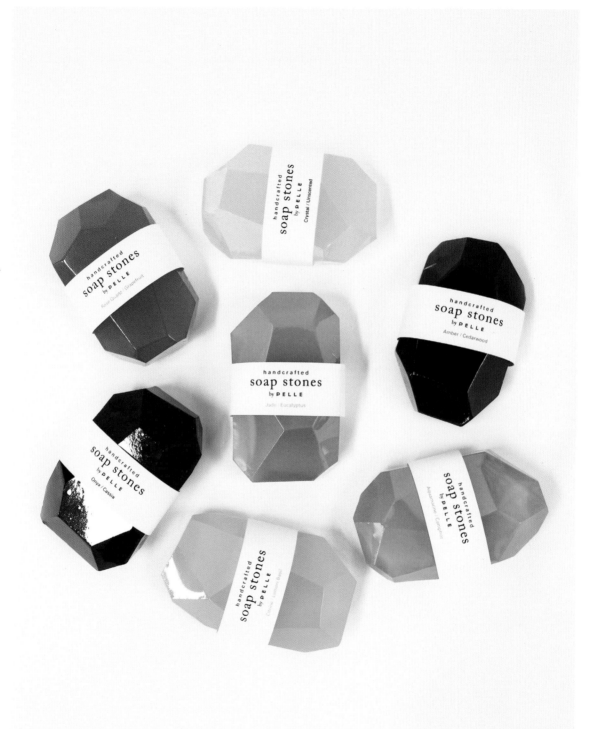

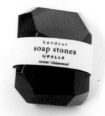

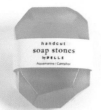

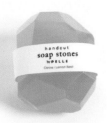

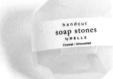

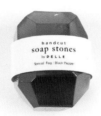

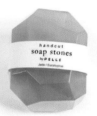

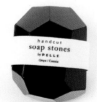

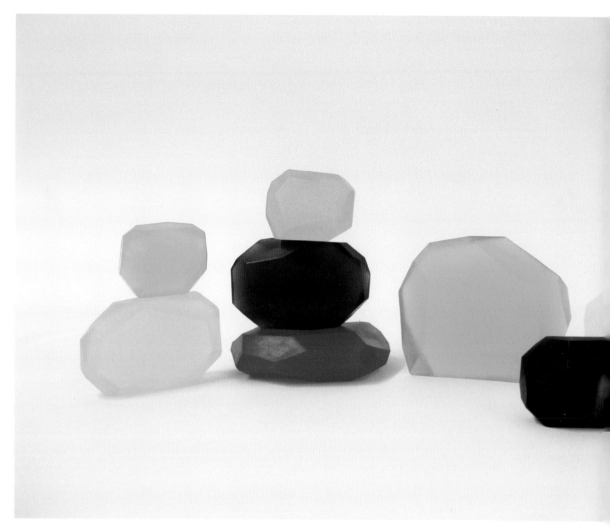

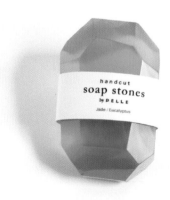

Art direction
PELLE

Project
The Soap Stones

Client
Self Initiated

Project description
The Soap Stones are handcrafted glycerin soap intended for both use and display. Consisting of all natural, vegetable-based soap ingredients, the Soap Stones are made and hand cut in our Brooklyn studio.

Drawing from a material palette inspired by naturally occurring gemstones and metamorphic rock, our soaps combine these brilliant colors with the potent effects of essential oils such as Eucalyptus and Camphor. The full collection of Soap Stones range between 3 sizes and 7 classic color/scent combinations. Special editions are available on a seasonal and rotating basis.

The Soap Stones debuted at The Museum of Modern Art in New York City in May 2013 as part of the NYC Destination Design Exhibition.

Dirección artística
PELLE

Proyecto
The Soap Stones

Cliente
Self Initiated

Descripción del proyecto
Soap Stones son jabones de glicerina hechos a mano que sirven tanto para utilizarlos como para exponerlos. Fabricados con ingredientes naturales para jabones de base vegetal, Soap Stones se fabrican y cortan a mano en nuestro estudio de Brooklyn.

Al dibujar a partir de una paleta de materiales inspirada en rocas metamórficas y gemas que se originan de forman natural, nuestros jabones combinan estos colores brillantes con los potentes efectos de aceites esenciales como el eucalipto y el alcanfor. La colección completa de Soap Stones presenta tres tamaños y siete combinaciones de colores/olores clásicos. Las ediciones especiales están disponibles de manera estacional y rotatoria.

Soap Stones hicieron su debut en el Museo de Arte Moderno de Nueva York en mayo de 2013 como parte de la exposición NYC Destination Design Exhibition.

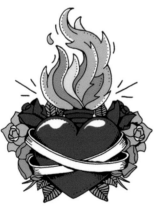

RECOVER

CLEANSE & REPAIR
SALVE

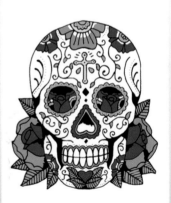

ENHANCE

VIBRANCY
SERUM

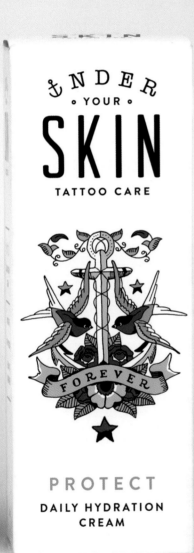

Art direction
Robot Food

Project
Under your Skin

Client
Self Initiated

Project description
Under your Skin is a range of skin care products for those who are inked. We created the proposition in response to the lack of specialist products available. The brand offers a growing sub-culture a product range to, 'Recover', 'Protect' and 'Enhance' their art and stays true to the heritage of tattooing. The brand's memorable name, striking illustrations and stylish typography are all balanced with a clean, cosmetic credibility and designed to attract everyone from the newly marked to the most hardcore tattoo lover.

Dirección artística
Robot Food

Proyecto
Under your Skin

Cliente
Self Initiated

Descripción del proyecto
Under your Skin es una gama de productos para el cuidado de la piel para aquellos que tienen tatuajes. Creamos la propuesta en respuesta a la falta de disponibilidad de productos especializados. La marca ofrece una creciente subcultura, una gama de productos, Recover, Protect y Enhance, que recupera, protege y realza su arte y se mantiene fiel a la herencia de los tatuajes. El nombre de la marca fácil de recordar, las llamativas ilustraciones y la elegante tipografía, todo se equilibra con una credibilidad cosmética, limpia, y se diseña para atraer a todo el mundo, desde los recién tatuados a los expertos aficionados a los tatuajes.

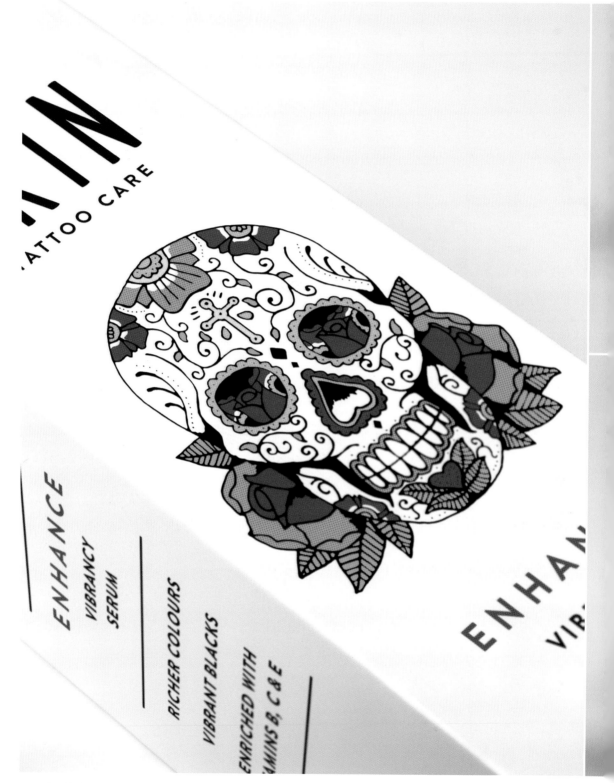

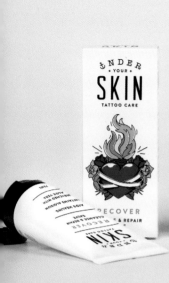
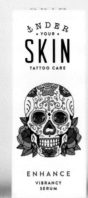
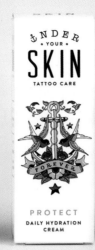
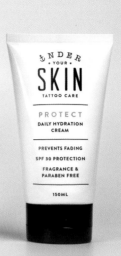

ÜNDER · YOUR ·
SKIN
TATTOO CARE

RECOVER
CLEANSE & REPAIR SALVE

ÜNDER · YOUR ·
SKIN
TATTOO CARE

ENHANCE
VIBRANCY
SERUM

ÜNDER YOUR
SKIN
TATTOO CARE

FOREVER

PROTECT
DAILY HYDRATION
CREAM

ÜNDER · YOUR ·
SKIN
TATTOO CARE

PROTECT
DAILY HYDRATION
CREAM

PREVENTS FADING

SPF 30 PROTECTION

FRAGRANCE &
PARABEN FREE

150ML

ÜNDER · YOUR ·
SKIN
TATTOO CARE

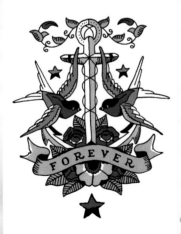

FOREVER

PROTECT

ÜNDER · YOUR ·
SKIN
TATTOO CARE

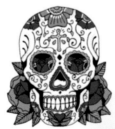

ENHANCE
VIBRANCY
SERUM

ÜNDER · YOUR ·
SKIN
TATTOO CARE

RECOVER
CLEANSE & REPAIR
SALVE

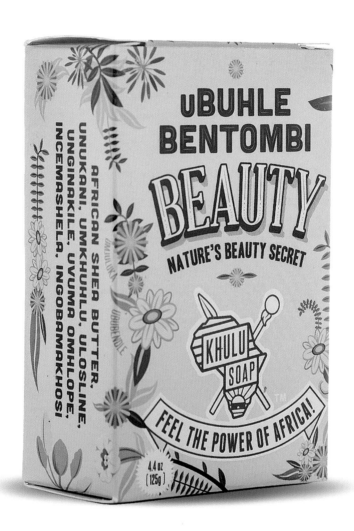

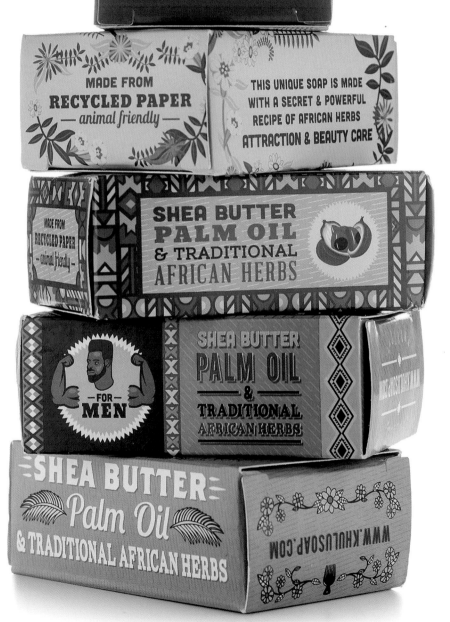

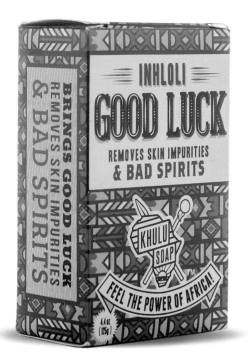

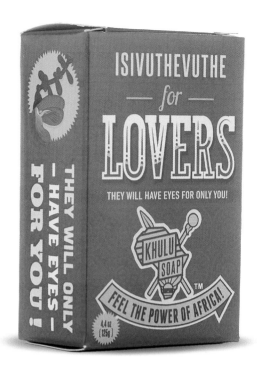

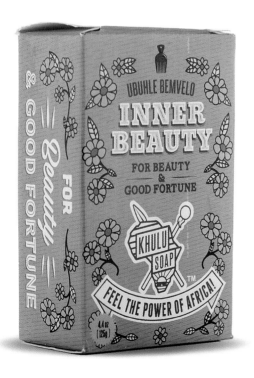

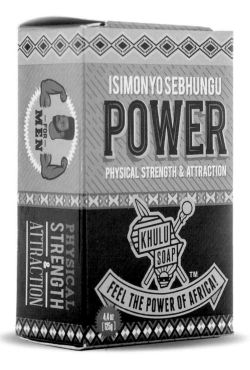

Art direction
Fanakalo

Project
Khulu Soap

Client
Khulu Soap

Project description
Khulu Soap is an original and
authentic manufacturer of
soaps infused with traditional
African herbs and was the
first to launch this type of
product in South Africa after
two years of experimentation
with different combinations
of herbs. Hand made soap,
infused with traditional wild
herbs from the heart of Africa.
There are 5 different soaps,
each packaged and designed
with a specific African theme.

Dirección artística
Fanakalo

Proyecto
Khulu Soap

Cliente
Khulu Soap

Descripción del proyecto
Khulu Soap es un fabricante
auténtico y original de
jabones infusionados
con hierbas tradicionales
africanas y fue el primero en
lanzar este tipo de productos
en Sudáfrica tras dos años
de experimentación con
diferentes combinaciones de
hierbas. Jabón hecho a mano,
infusionado con hierbas
silvestres tradicionales del
corazón de África. Hay cinco
jabones diferentes, cada uno
empaquetado y diseñado con
un tema africano concreto.

A Beautiful Design

www.abeautifuldesign.com.sg

Beautiful is about looking at things differently. It's about perception. It's about beauty in imperfection, beauty in the ordinary, beauty in everything. Most of all, it's about finding silver linings, living a happy life.

Beautiful is a design studio set up by creative director, Roy Poh. Nominated by Institute of Advertising Singapore as 15 most influential Creative Directors in Singapore for 4 consecutive years, Beautiful was awarded Design Agency of the year at the Creative Circle Awards.

Roy has proven that good work need not be given up just to survive in today's market with awards like the D&AD, Oneshow, Art Director's Club, Type Director's Club, Canneslion, Clio Awards, Young Guns, Communication Arts, Singapore Creative Circle Awards, Singapore Designers Award and many more of his projects have been featured in renowned industry periodicals. Most recently, he received the President's Design Award, the most prestigious design award in Singapore.

Roy has also been invited to judge at both international and local award shows like the D&AD Global Award in London, Cannes Lion and Spikes Asia Awards, Australia Young Guns Design & Advertising Award, the Singapore Crowbar Award, the Singapore Creative Circle Award and Young Asian Designers Award.

Beautiful trata sobre mirar a las cosas de manera diferente. Trata sobre la percepción. Trata sobre la belleza de la imperfección, la belleza de lo ordinario, la belleza de todo. Por encima de todo, trata sobre encontrar los aspectos positivos, vivir una vida feliz.

Beautiful es un estudio de diseño fundado por el director creativo Roy Poh. Propuesto por el Institute of Advertising Singapore entre los 15 directores creativos más influyentes de Singapur durante cuatro años consecutivos, Beautiful fue galardonado como Estudio de Diseño del Año de los premios Creative Circle Awards.

Roy ha demostrado que un buen trabajo no necesita darse por vencido para sobrevivir en el mercado actual con premios como D&AD, Oneshow, Art Director's Club, Type Director's Club, Canneslion, Clio Awards, Young Guns, Communication Arts, Singapore Creative Circle Awards, Singapore Designers Award. Otros muchos proyectos han sido presentados en publicaciones especializadas de prestigio. Más recientemente, ha recibido el galardón President's Design Award, el premio de diseño más prestigioso de Singapur.

Roy también ha sido invitado como jurado en festivales de premios tanto locales como internacionales como D&AD Global Award en Londres, los premios Cannes Lion y Spikes Asia, Australia Young Guns Design & Advertising Award, Singapore Crowbar Award, Singapore Creative Circle Award y Young Asian Designers Award.

Anastasia Genkina

behance.net/AnastasiaGenkina

Anastasia Genkina is a multidisciplinary designer from Moscow, Russia, based both in New Zealand and Moscow. After graduating she was working in the Gorky Park`s in-house design team art-directed by Misha Gannushkin. This team was responsible for all the park's communications, which resulted in producing many wonderful, illustrative and fun works, including the European Design Awards winner Gorky Park ice-cream packaging, Pervaya Parkovaya newspaper and many more.

Anastasia Genkina es una diseñadora multidisciplinar de Moscú (Rusia), que vive en Nueva Zelanda y Moscú. Tras graduarse, trabajó en el equipo artístico de diseño interno del Parque Gorki dirigido por Misha Gannushkin. Este esquipo fue responsable de toda la comunicación del parque, que dio como resultado la producción de muchos trabajos divertidos, ilustrativos y maravillosos, incluido el packaging de los helados Gorky Park, ganador de los premios europeos European Design Awards, el periódico Pervaya Parkovaya y muchos más.

Art. Lebedev Studio

www.artlebedev.com

Founded in 1995, Art. Lebedev Studio is a privately held company employing over 300 people. We offer advansed industrial, graphic, web, and interface design.

We work to find the most simple, elegant, and convinient solution to any problem without losing the purport.

As a matter of principle, we don't work with private persons, political parties, religious organizations, jerk-offs, and those whose views conflict with ours.
The Studio's headquarters is situated in Moscow, and another two offices are in Kiev and New York.

Fundada en 1995, Art. Lebedev Studio es una empresa privada de diseño que emplea a más de 300 personas. Ofrecemos diseño avanzado de interfaz, web, gráfico e industrial.

Trabajamos para encontrar la solución más conveniente, elegante y simple para cualquier problema sin perder el significado.

Como parte de nuestros principios, no trabajamos para personas particulares, partidos políticos, organizaciones religiosas, imbéciles y aquellos cuyas opiniones chocan con las nuestras.
Las oficinas centrales están situadas en Moscú y tienen otras dos oficinas en Kiev y Nueva York.

Beetroot design group

www.beetroot.gr

Beetroot Design Group is a Thessaloniki based, multi-awarded communication design office and think tank that provides excellent design services and solutions to a worldwide clientele including some of the most established brands in the world.

Our team is consisted of experts with a wide and diverse arrange of skills in the creative field. Beetroot's creative mission is to discover, develop and utilize the true essence of a brand, product or service and then grow and expand it so that it becomes recognized, appreciated, and praised all around the globe.

Beetroot was founded in 2000 by Vagelis Liakos, Alexis Nikou and Yiannis Charalambopoulos. Today Beetroot counts eighteen employees with background in graphic design, new media, photography, film direction, production design and marketing acquired through their studies and careers in Greece, Great Britain and USA.

Beetroot Design Group, localizada en Tesalónica, es una oficina de diseño de comunicación, con multitud de premios y un comité de expertos que proporciona excelentes soluciones y servicios de diseño a una clientela mundial, incluidas algunas de las marcas más sólidas del mundo.

Nuestro equipo está formado por expertos con un despliegue diverso y amplio de habilidades en el campo creativo. La misión creativa de Beetroot es descubrir, desarrollar y utilizar la esencia auténtica de una marca, producto o servicio y luego crecer y ampliarla de forma que sea reconocida, apreciada y elogiada en todo el mundo.

Beetroot fue fundada en 2000 por Vagelis Liakos, Alexis Nikou y Yiannis Charalambopoulos. En la actualidad, Beetroot cuenta con 18 empleados con experiencia en diseño gráfico, nuevos medios, fotografía, dirección de cine, diseño de producción y marketing, que han adquirido en sus estudios y carreras en Grecia, Gran Bretaña y EE.UU.

Calcco

www.calcco.com

Calcco arises from a natural evolution of the world of photography and graphic arts. It is not a superficial issue that much of its work focuses on creativity and an eminently visual communication (the power of the image), where printing techniques and finishes don't appear at the end of the process but they are the core indeed. Typography, shapes, textures, evocative images, natural inspiration... everything that can persuade our senses is part of the creative life of Calcco.

From La Rioja, where the world of wine is always present as an inspiring culture, Calcco wants to bring a new vision, a new way to create, where to say things, we must first feel them.

Calcco surge de una evolución natural desde el mundo de la fotografía y las artes gráficas. No es una cuestión superficial que gran parte de su obra y creatividad se centre en una comunicación eminentemente visual (el poder de la imagen), donde las técnicas de impresión y los acabados no surgen al final del proceso sino que lo condicionan por completo. La tipografía, las formas, las texturas, las imágenes evocadoras, la inspiración natural... Todo aquello que pueda persuadir a nuestros sentidos forma parte de la vida creativa de Calcco.

Desde La Rioja, donde el mundo del vino está siempre presente como una cultura inspiradora, Calcco quiere aportar una nueva visión, una nueva forma de crear, donde para decir las cosas primero hay que sentirlas.

Dando Projects

www.dandoprojects.com

Dando Projects, with offices in Los Angeles and New York City, is a full service design studio specializing in alcohol branding. Founded in 2013 by a husband and wife team, Dando Projects is rooted in a broad community of artists who work in fashion, magazine and web editorial, illustration, advertising, photography and bring a fine arts sense to brand identity. In the first half of 2015, Dando has won competitions at Applied Arts, Graphic Design USA, San Francisco World Spirits and Los Angeles International Spirits. Dando takes pride in getting clients' products into the hands of enthusiasts.

Dando Projects, con oficinas en Los Angeles y Nueva York, es un estudio de diseño que ofrece un servicio completo especializado en marcas alcohólicas. Fundado en 2013 por un matrimonio, Dando Projects se arraiga en una amplia comunidad de artistas que trabajan en moda, revistas y editoriales de webs, ilustración, publicidad, fotografía y dan un sentido de bellas artes a la identidad de la marca. En la primera mitad de 2015, Dando ha ganado concursos como Applied Arts, Graphic Design USA, San Francisco World Spirits y Los Angeles International Spirits. Dando se enorgullece de conseguir que los productos de los clientes lleguen a manos de los entusiastas.

DDB Copenhagen

ddbcopenhagen.dk

DDB Copenhagen is a modern network agency located in the centre of Copenhagen. We are part of the award-winning international agency network DDB Communications Group with more than 200 offices in 90 countries - a network with extensive knowledge sharing, international development of competencies and cooperation on strong global and regional brands.

In Denmark we are approximately 40 employees and we all share a burning passion for developing creative solutions for our clients based on our belief that creativity is the most effective means to solving business challenges. This passion is unfolded at the intersection of creativity, technology and human insight, and it leads to solutions that change attitudes, solve problems and create growth.

We can advise and develop across media platforms and in addition to account management and creative development we handle strategic advice on consumer behavior, brand development, digital media, CRM and content management.

DDB Copenhagen es una moderna red de oficinas ubicada en el centro de Copenhague. Somos parte de la agencia internacional DDB Communications Group, ganadora de premios con más de 200 oficinas en 90 países. Una red con un amplio intercambio de información, desarrollo internacional de competencias y cooperación con marcas fuertes regionales y globales.

En Dinamarca, somos unos 40 empleados y compartimos una intensa pasión por desarrollar soluciones creativas para nuestros clientes que se basa en muestra creencia de que la creatividad es el medio más importante para resolver desafíos comerciales. Esta pasión se despliega en la intersección de la creatividad, la tecnología y la perspicacia humana y conduce a soluciones que cambian actitudes, resuelven problemas y crean crecimiento.

Podemos asesorar y desarrollar a través de plataformas para medios y, además de la gestión de cuentas y el desarrollo creativo, nos encargamos del asesoramiento estratégico sobre el comportamiento del consumidor, el desarrollo de la marca, los medios digitales, la gestión de relaciones con el cliente y la gestión de contenidos.

Dorian

www.estudiodorian.com

Dorian is a small design and graphic communication studio located in Barcelona. Founded in 2009 by Gaëlle Alemany and Gabriel Morales, Dorian works with big and small companies and organizations, striving to give communications solutions based on great design and lasting power.

Specializing in corporate identity, packaging and editorial design, Dorian develops every project giving great attention to each and every step of the creative process, from idea to production.

Dorian's work has been recognized with national and international awards such as Laus Awards, D&AD, European Design Awards, Pentawards, German Design Awards, The Dieline Awards or Graphis.

Dorian es un pequeño estudio de diseño y comunicación gráfica ubicado en Barcelona. Fundado en 2009 por Gaëlle Alemany y Gabriel Morales, Dorian trabaja con organizaciones y empresas pequeñas y grandes, esforzándose por ofrecer soluciones de comunicación basadas en un gran diseño y una fuerza duradera.

Especializado en identidad corporativa, diseño editorial y packaging, Dorian desarrolla cada proyecto prestando mucha atención a cada uno de los pasos del proceso creativo, de la idea a la producción.
El trabajo de Dorian ha sido reconocido con premios nacionales e internacionales como Laus Awards, D&AD, European Design Awards, Pentawards, German Design Awards, The Dieline Awards o Graphis.

Ehrenstråhle & Wågnert

www.e-w.se

Ehrenstråhle & Wågnert is a young design agency in Stockholm that is focused on design within the areas of brand identities, packaging design and concepts for films. They strive to create an all-embracing visual impact for their clients, while at the same time ensuring that each element feels unique. They try to make everything they do meaningful and thoughtful. And sometimes even beautiful.

Ehrenstråhle & Wågnert es una joven agencia de diseño de Estocolmo centrada en el diseño en las áreas de la identidad de marca, el diseño de packaging y conceptos para películas. Se esfuerzan en crear un impacto visual global para sus clientes al tiempo que aseguran que cada elemento se sienta único. Intentan que todo lo que hacen sea significativo y razonado. Y, a veces, incluso precioso.

Fanakalo

www.fanakalo.co.za

Founded in June 2009 right in the middle of the recession, felt like the right time for 2 friends to start a studio together. Fanakalo is a small design studio in the heart of the Cape winelands: Stellenbosch South Africa.

Fundada en junio de 2009, justo en mitad de la recesión. Les pareció el momento adecuado a dos amigos para poner en marcha juntos un estudio. Fanakalo es un pequeño estudio de diseño en el corazón de Cape Winelands: Stellenbosch, en Sudáfrica.

Goods & Services

gsbranding.com

Goods & Services company began its life as a small graphic-design agency nearly 20 years ago. Today, They've grown to become brand-marketing specialists, integrating research, strategy, graphic design, content and digital services—and full implementation—all in one studio. They are also the publishers of Sway: A Journal of Branding.

Goods & Services es una compañía que empezó su andadura como una pequeña agencia de diseño gráfico hace casi 20 años. En la actualidad, ha crecido hasta convertirse en especialista en marketing de marcas, investigación integral, estrategia, diseño gráfico, servicios digitales y de contenidos, y una implementación completa, todo en un estudio. También publican Sway: A Journal of Branding.

Here Design

www.heredesign.co.uk

Here was founded in 2005 by partners Caz Hildebrand, Mark Paton and Kate Marlow. Tess Wicksteed joined as Strategy Partner in February 2015.

They design for buildings, brands, books or bottles. Their collective experience covers both brand and design disciplines so they can help clients from initial idea to ultimate expression.

As designers they always build from the roots up. Their process is very simple: understand and define a clear vision for the project; explore the visual and verbal roots of the idea and translate these roots into a unique authentic experience.

Here fue fundada en 2005 por los socios Caz Hildebrand, Mark Paton y Kate Marlow. Tess Wicksteed se unió como socia estratégica en febrero de 2015.

Hacen diseños para edificios, marcas, libros o botellas. Su experiencia colectiva cubre disciplinas tanto de marcas como de diseño, de modo que pueden ayudar a los clientes desde la idea inicial hasta la máxima expresión.

Como diseñadores, siempre construyen desde la raíz hacia la hoja. Su proceso es muy simple: entender y definir una visión clara del proyecto; explorar las raíces verbales y visuales de la idea y traducir dichas raíces en una experiencia auténtica y única.

Horse

www.horse-studio.com

Horse is an award winning, multi-discipline design consultancy based in the UK, founded by Ian Firth and Sarah Pidgeon.

The studio's work leads with creativity, supported by clear strategic thinking for a diverse client base. A common thread runs throughout their work: smart and memorable ideas that are beautifully executed.

Strong believers in the power of design and the strength of clear ideas, Horse's team are committed and passionate, delivering work that's effective and creatively unique to build meaningful, ongoing partnerships with brands big and small.

La galardonada Horse es una consultoría de diseño multidisciplinar ubicada en el Reino Unido y fundada por Ian Firth y Sarah Pidgeon.

El trabajo del estudio promueve la creatividad, apoyándose en un pensamiento estratégico claro para una cartera de clientes variada. Hay un rasgo común que está presente en todo su trabajo: ideas inteligentes y fáciles de recordar que se ejecutan a la perfección.

Convencidos del poder del diseño y de la fuerza de las ideas puras, el equipo de Horse está comprometido y es apasionado, ofreciendo un trabajo que es efectivo y con una creatividad única para construir colaboraciones regulares y significativas con marcas grandes y pequeñas.

Iván Bravo

www.ivanbravo.com

Iván Bravo is illustrator and graphic designer (Elisava school). He has worked for clients like TV3, Coca-Cola, Lay's, European Union, Banc Sabadell, Monografica.org or Regal Insurance doing illustrations, murals or animations. He thinks that every support can contain illustration, but both must be related in an intimate and ludic way. He loves to walk the line between concept and humour. Since 2010 he teaches in the illustration master of IDEP school in Barcelona. His work has been exhibited in Spain, USA, Italy, France and Portugal. His work has been recognized by Society of Illustrators 56, AOI 2015 and 2013 (shortlist), APIC 2013, Laus silver 2012.

Iván Bravo es ilustrador y diseñador gráfico (Escuela Elisava). Ha trabajado para clientes como TV3, Coca-Cola, Lay's, la Unión Europea, el Banco Sabadell, Monografica. org o Regal Insurance haciendo ilustraciones, murales o animaciones. Cree que cualquier soporte puede contener ilustraciones, pero ambos deben estar relacionados de forma íntima y lúdica. Le gusta estar en el borde entre lo conceptual y el humor. Desde 2010 enseña ilustración en el máster de IDEP en Barcelona. Su trabajo se ha expuesto en España, EE. UU., Italia, Francia y Portugal. Ha sido reconocido por la Society of Illustrators 56, AOI 2015 y 2013 (finalista), APIC 2013, Laus silver 2012.

Klas Fahlen

www.klasfahlen.se

Klas Fahlen was born 1962 in a small town called Sala. He is living in Stockholm and been working as freelance illustrator since 1990 when he left Beckmans College of design.

So after almost 25 years he's pretty much done everything as an illustrator, books, posters, advertising and so on. Like small personal business cards for friends to advertising campaigns.

After playing to much tennis a couple of years ago he got "tennis elbow" and had to switch to a Wacom pen instead of a mouse. So these days he is doing all his work digitally on a Wacom Cintiq 24 HD display. After a long learning curve he now considers it his priority working tool. Before he drew everything on paper and scanned it to the computer.

He has a Swiss-Finnish girlfriend named Nina who is a graphic designer and they have 2 kids.

Represented by an agency in Sweden (agentbauer.com), one in New York (www.art-dept.com) and one in Germany (www.2agenten.com).

Klas Fahlen nació en 1962 en la pequeña localidad de Sala. Vive en Estocolmo y ha trabajado como ilustrador freelance desde 1990 cuando dejó la escuela de diseño Beckmans.

Después de 25 años ha hecho de todo como ilustrador, libros, pósters, anuncios y demás. Como pequeñas tarjetas de visita personales para los amigos para publicitar campañas.

Después de jugar mucho al tenis un par de años, tuvo codo de tenista y tuvo que cambiar el ratón por el lápiz Wacom. Así que ahora hace todo su trabajo de forma digital en una pantalla Wacom Cintiq 24 HD. Tras una larga curva de aprendizaje, ahora la considera su herramienta de trabajo prioritaria. Antes lo dibujaba todo en papel y lo escaneaba al ordenador.

Tiene una novia suizo-finlandesa llamada Nina que es diseñadora gráfica y tienen dos niños.

Lai Shin

shaggylai.byethost17.com/wordpress/

Lai Shin, a graphic designer, born in 1983 in Taiwan, has worked in Ogilvy & Mather Advertising, Start up a studio in 2015. My ability is to bring up new unique and funny aspects, and make people feel wonderful and touching by my design and creativity. Achievement: Johnnie Walker, Glenrothes, IKEA, Warner and so on.

Lai Shin, diseñador gráfico nacido en 1983 en Taiwán, ha trabajado en Ogilvy & Mather Advertising. Fundó un estudio en 2015. Mi habilidad es presentar nuevos aspectos divertidos y únicos y hacer que la gente se sienta estupenda y emocionada con mi diseño y creatividad. Logros: Johnnie Walker, Glenrothes, IKEA, Warner, entre otros.

Maha Rabiyi

www.maharabiyi.com

Based in Montreal for over a decade, Maha Rabiyi is a multidisciplinary designer to the quest for novelties. Graduated in graphic design, she left Iran for new horizons with the hope of inspiring new creations and cultures. She continued her studies at Montreal UQAM University-School of Design to add a new string to her bow already well equipped.

Curious by nature, she is interested in all forms of design, media and disciplines. She experiences everything that could bring her further in her research and creative thinking: from paper to digital, through the object design, packaging and animation.

Her background includes years of experience in packaging design, illustration, edition as well as digital design. Her talent and creativity have crossed the borders by arousing international interest.

Instalada en Montreal hace más de una década, Maha Rabiyi es una diseñadora multidisciplinar en búsqueda de novedades. Graduada en diseño gráfico, se fue de Irán para buscar nuevos horizontes con la esperanza de inspirarse en nuevas creaciones y culturas. Continuó sus estudios en la Facultad de Diseño de la Universidad de Quebec en Montreal (UQAM) para ampliar su abanico de posibilidades, ya bien equipado.

Curiosa por naturaleza, está interesada en todas las formas de diseño, medios y disciplinas. Experimenta con todo lo que pueda hacerla avanzar en su investigación y pensamiento creativo: del papel a lo digital a través del diseño de objetos, el packaging y la animación.

Su historial incluye años de experiencia en diseño de packaging, ilustraciones, edición y diseño digital. Su talento y creatividad ha traspasado fronteras despertando el interés internacional.

Martin Azambuja

martinazambuja.com

Martin Azambuja is 26 and he has a degree in Graphic Design. Currently he is living in Montevideo, Uruguay. After working in advertising agencies and design studios, he decided to start working on his own. After a few months, he partnered with another illustrator and have their studio in Montevideo where they work mainly branding and illustration. Also in parallel he works as an illustrator for international clients and magazines.

Martin Azambuja tiene 26 años y un título de diseño gráfico. En la actualidad vive en Montevideo (Uruguay). Tras trabajar en agencias de publicidad y estudios de diseño, decidió empezar a trabajar por su cuenta. Después de unos meses, se asoció con otro ilustrador y tiene su estudio en Montevideo donde trabajan principalmente con marcas e ilustraciones. De forma paralela, trabaja como ilustradora para revistas y clientes internacionales.

Menta

www.estudiomenta.mx

Menta is an independent branding & illustration studio founded by Laura Méndez, in 2008.

We believe in the Simplicity of Allure, to deliver effective brand identities that balance classic & contemporary aesthetics, through research and clear concept definition.

Our work builds meaningful human connections and stirs up beautiful experiences. We fancy the carefully crafted & well executed print.

Based in Guadalajara, Mexico, we work with small businesses and international companies, listening to our clients and understanding their objectives.

Menta es un estudio independiente de ilustración y desarrollo de marcas fundado por Laura Méndez en 2008.

Creemos en la Simplicidad de la Atracción para ofrecer identidades de marca efectivas que equilibren la estética contemporánea y clásica a través de la investigación y una definición clara del concepto.

Nuestro trabajo construye conexiones humanas con significado y suscita experiencias maravillosas. Nos gustan los trabajos bien ejecutados y elaborados con minuciosidad.

Situado en Guadalajara (México), trabajamos con pequeños negocios y compañías internacionales, escuchando a nuestros clientes y comprendiendo sus objetivos.

PELLE

pelledesigns.com

PELLE creates objects and design for the modern age. Merging architectural practice and pristine craft-work, founders Jean and Oliver PELLE imbue their collections with a keen aesthetic and studied attention to functionality. Their pieces are to be lived with, handled, worn, and enjoyed.

At the heart of PELLE's work is a fusing of primary elements with modern form – geologic lines re-purposed, blown glass and coiled leather forged to light contemporary spaces.

Our studio is located in Red Hook Brooklyn where we have a small team of skilled individuals who carefully make our lighting, furniture, soap and other decorative objects, one piece at a time.

PELLE crea objetos y diseños para los tiempos modernos. Mezclando la práctica arquitectónica y la artesanía pura, los fundadores Jean y Oliver PELLE empapan sus colecciones con una estética aguda y una estudiada atención a la funcionalidad. Sus piezas son para vivirlas, tocarlas, ponérselas y disfrutarlas.

En el centro del trabajo de PELLE hay una fusión de elementos primarios con formas modernas: líneas geológicas reutilizadas, vidrio soplado y cuero enrollado forjado para iluminar espacios contemporáneos.

Nuestro estudio está situado en Red Hook, Brooklyn donde tenemos un pequeño equipo de personas habilidosas que con esmero hacen, pieza a pieza, nuestras lámparas, mobiliario, jabones y otros objetos decorativos.

Peter Gregson Studio

www.petergregson.com

Peter Gregson Studio is independent graphic design studio with a reputation for delivering intelligent and engaging creative solutions. Based in Novi Sad, Srbija, Studio was established in 1999. by Jovan Trkulja and Marijana Rot (Zaric). Working with clients both large and small, in the Serbia and overseas, Peter GregsonStudio produces a diverse range of work across multiple disciplines. The studio's team bring a wealth of knowledge and enthusiasm to every new project and offer a scope of capabilities that includes editorial, exhibition, signage, corporate literature, websites, brand identities and packaging design.

Peter Gregson Studio es un estudio de diseño gráfico independiente con fama de ofrecer soluciones creativas cautivadoras e inteligentes. Situado en Novi Sad (Serbia), Studio fue fundado en 1999 por Jovan Trkulja y Marijana Rot (Zaric). Peter Gregson Studio, que trabaja con clientes grandes y pequeños, en Serbia y en el extranjero, produce una variada gama de trabajos en múltiples disciplinas. El equipo del estudio aporta riqueza de conocimiento y entusiasmo a cada nuevo proyecto y ofrece un abanico de competencias que incluye redacción, exposición, carteles, literatura corporativa, páginas web, identidad de marca y diseño de packaging.

PROPERCORN

www.propercorn.com

Since launching in 2011, PROPERCORN have taken great pride in their popcorn, making sure that every pack is both delicious and guilt-free. But their ethos of 'Done Properly' extends beyond just popcorn. Whether designing bold, hand-illustrated packaging, creating their own clothing range or developing award-winning, guilt-free popcorn recipes, PROPERCORN believe everything should be the best that it can possibly be.

Desde su lanzamiento en 2011, PROPERCORN se enorgullece de sus palomitas, asegurándose de que cada paquete está delicioso y libre de culpa. Pero su eslogan «Bien hecho» («Done Properly» en inglés) va más allá de las palomitas. Al diseñar packagings llamativos, ilustrados a mano, al crear su propia línea de ropa, al convertirse en ganadores de premios, al desarrollar recetas de palomitas libres de culpa, PROPERCORN cree que todo debería ser lo mejor que sea posible.

Robot Food

www.robot-food.com

At Robot Food we love ideas, create compelling brands and tell good stories. We're independent, fearless, challenging and fun.

We find opportunities. We create a point of view. We add personality. We break the rules. We work hard to make things simple and easy to understand. Drawing from our interests, experience and alternative mindset, BOOM, we smash it every time. With modesty of course.

En Robot Food amamos las ideas, crear marcas cautivadoras y contar buenas historias. Somos independientes, valientes, exigentes y divertidos.

Encontramos oportunidades. Creamos un punto de vista. Añadimos personalidad. Rompemos las reglas. Trabajamos duro para hacer las cosas simples y fáciles de entender. Partiendo de nuestros intereses, experiencia y actitud alternativa, BOOM, triunfamos siempre. Con modestia por supuesto.

Soil design

www.soildesign.co.za

Soil Design is a boutique graphic design and illustration studio based in Cape Town which is recognised for its exceptional designs and artwork. This enthusiastic design company was formed by sisters, Kara and Mieke Wertschnig, one being a graphic designer and the other an illustrator with collective expertise in identity, print, packaging, textiles and the African environment.

Over the past few years Soil Design has worked on clothing brands, designing and illustrating textiles and graphics. More recently the team has focused on identity and wine label design for some of the world's leading producers.

Soil Design is largely inspired by the beauty surrounding them in their own city, and over time this has influenced them to create their own range of premium, boutique South African wear and accessories, under the brand Soil & Co.

In 2014 they opened their first retail outlet at the Watershed, V&A Waterfront in Cape Town and have an online store opening soon. soilandco.co.za.

Soil Design es un estudio boutique de ilustración y diseño gráfico situado en Ciudad del Cabo que es conocido por sus excepcionales diseños y trabajo artístico. Esta entusiasta compañía de diseño fue fundada por dos hermanas, Kara y Mieke Wertschnig, una diseñadora gráfica y la otra ilustradora, con experiencia colectiva en identidad, estampados, packaging, telas y el entorno africano.

Durante los últimos años, Soil Design ha trabajado con marcas de ropa, diseñando e ilustrando telas y gráficos. Más recientemente, el equipo se ha centrado en la identidad y el diseño de etiquetas de vino para productores líderes a nivel mundial.

Soil Design se inspira principalmente en la belleza que les rodea en su propia ciudad y con el paso del tiempo esto les ha influido para crear su propia gama de ropa y accesorios sudafricanos, exclusivos y de alta calidad, bajo la marca Soil & Co.

En 2014 abrieron su primera tienda en Watershed, V&A Waterfront, en Ciudad del Cabo y pronto tendrán tienda online. soilandco.co.za.

The North South Studio

www.thenorthsouth.net
www.omnomchocolate.com

The North South Studio is based in Reykjavík Iceland established in 2010.

We are a dynamic duo with a passion for design and photography. Like the arctic tern, our migration is between the Atlantic North and South of the globe.
Our second home is the west coast of South Africa, where we try to spend most of the warmer months.
We are constantly influenced by the natural environment with a love for birds and volcanoes.

The North South Studio, situado en Reikiavik (Islandia), se fundó en 2010.

Somos un dúo dinámico con pasión por el diseño y la fotografía. Como el charrán ártico, nuestra migración se produce entre el Atlántico Norte y el sur del planeta.
Nuestro segundo hogar es la costa oeste de Sudáfrica, donde intentamos pasar la mayoría de los meses más cálidos.
Nos influye de manera constante el entorno natural y el amor por los pájaros y los volcanes.

student projects

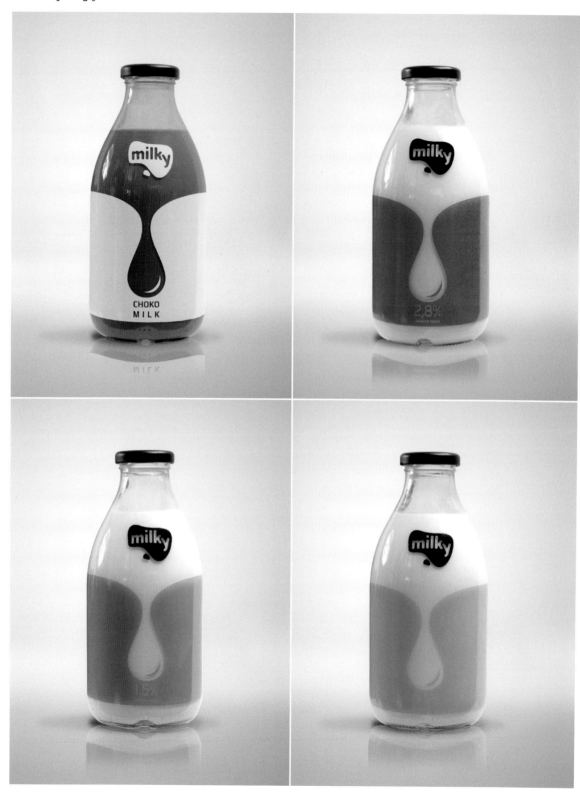

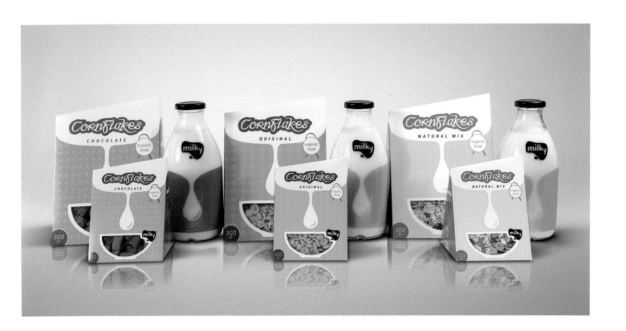

Art direction
Matija Blagojevic

Project
Milky

Dirección artística
Matija Blagojevic

Proyecto
Milky

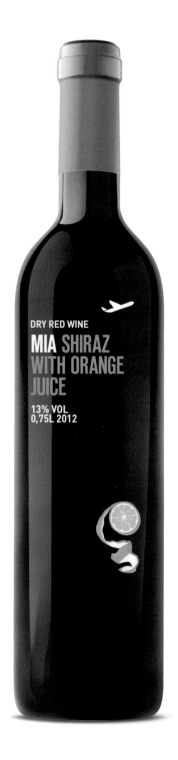
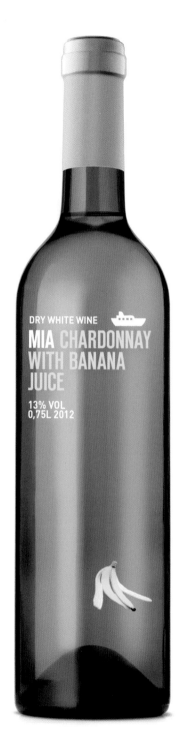
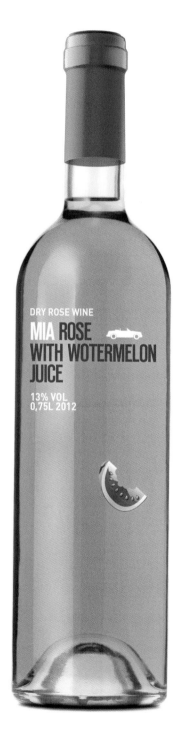

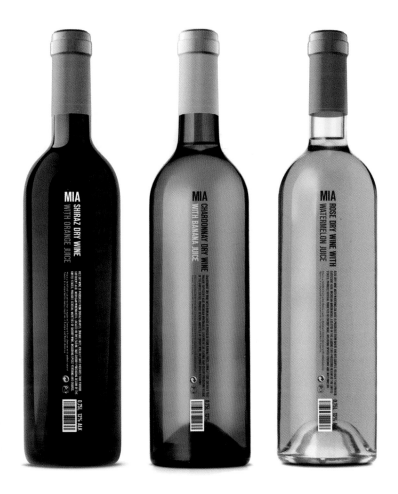

Art direction
Milya Ptitsyna

Project
MIA wine with fruit juice

Project description
The packaging concept.
Student's work of British
Higher School of Art and
Design (Moscow, Russia).
We remember the events of
life by the smell, taste and
sounds.

"For example, in Russia we
remember the New Year
holidays by the smell of
tangerines.
Wine MIA - a nostalgia for
the vacation. "

Dirección artística
Milya Ptitsyna

Proyecto
MIA wine with fruit juice

Descripción del proyecto
The packaging concept.
Trabajo de los estudiantes del
centro British Higher School of
Art and Design (Moscú, Rusia).
Recordamos los
acontecimientos de la vida por
el olor, el sabor y los sonidos.

«Por ejemplo, en Rusia
recordamos las fiestas de
Año Nuevo por el olor de las
mandarinas.
Vino MIA – nostalgia de las
vacaciones».

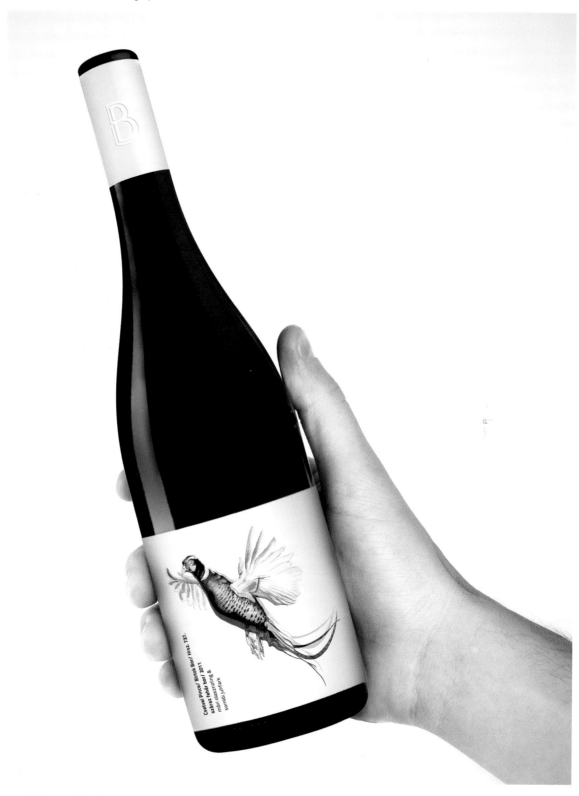

Csetvei Pince / Birtok Bor / Hrsz. 737.
száraz fehér bor / 2011
móri olaszrizling &
somlói juhfark

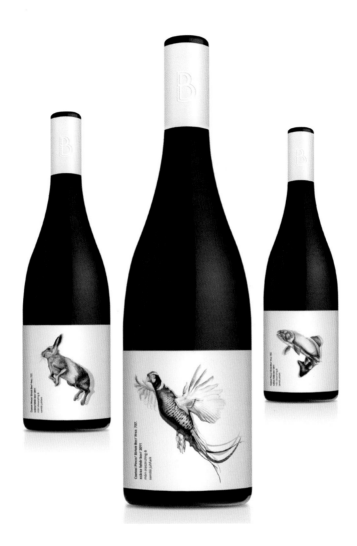

Art direction
Szani Mészáros

Project
Bitrok Bor

Project description
Bitrok Bor is a Hungarian wine that is made out of two different kind of wines (Riesling and Juhfark), therefore I tried to find a representation which can show one whole thing out of two elements. 3D drawings create spatial pictures with special kind of eye-glasses, however we can get an interesting and unique image also without them.

I thought to draw animals that match with the taste of the wine (pheasant, hare and fish), and then I made them 3 dimensional digitally.

The label itself is clean, white, indicating only the most important informations, putting the 3D drawings forward.

Dirección artística
Szani Mészáros

Proyecto
Bitrok Bor

Descripción del proyecto
Bitrok Bor es un vino húngaro que se hace a partir de dos tipos distintos de uvas (Riesling y Juhfark). Por eso, intenté encontrar una representación que pudiese mostrar una totalidad hecha de dos elementos. Los dibujos en 3D crean imágenes espaciales con un tipo de gafas especiales, aunque sin ellas también podemos conseguir una imagen única e interesante.

Pensé en dibujar animales que combinasen con el sabor del vino (faisán, liebre y pescado) y luego los hice digitalmente en tres dimensiones.

La etiqueta en sí es sencilla, blanca, mostrando sólo la información más importante, con los dibujos en 3D delante.

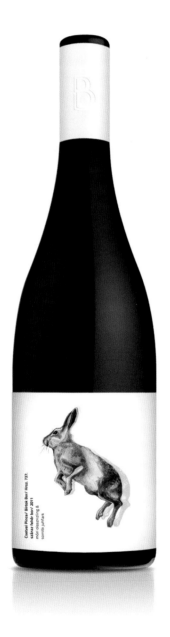
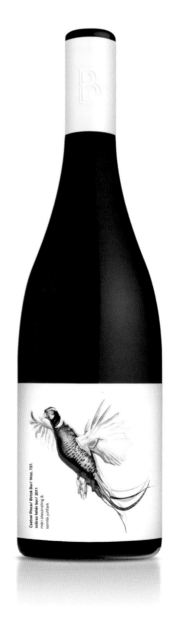
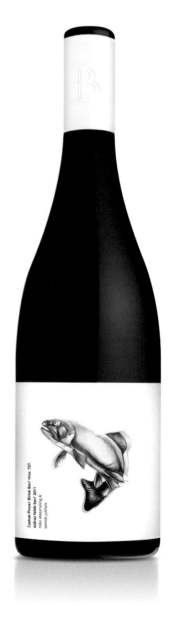

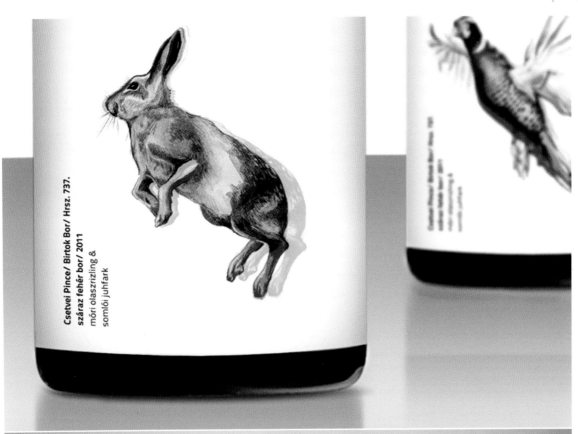

Csetvei Pince / Birtok Bor / Hrsz. 737.
száraz fehér bor / 2011
móri olaszrizling &
somlói juhfark

TIME TO LAY MERLOT-LO-LO

BITCHFEST LETS WOMEN DO WHAT THEY DO BEST. GET IT ALL OFF YOUR CHEST WHILE VENTING OVER A BIG GLASS, STEIN OR MUG OF WINE.

WE RECOMMEND SHARING A BOTTLE WITH THE LADIES OR HAVING A BIT OF SELF THERAPY AFTER A WONDERFULLY CRAPTASTIC DAY.

THIS MERLOT HAS BEEN BLENDED WITH GRAPES FROM THE POMEROL AREA OF BORDEAUX. FRANCE TO HELP YOU RELAX WITH MELLOW FLAVORS INSTEAD OF THAT BITTER TASTE THAT THE DAY LEFT YOU WITH.

GOVERNMENT WARNING: (1) ACCORDING TO THE SURGEON GENERAL, WOMEN SHOULD NOT DRINK ALCOHOLIC BEVERAGES DURING PREGNANCY BECAUSE OF THE RISK OF BIRTH DEFECTS. (2) CONSUMPTION OF ALCOHOLIC BEVERAGES IMPAIRS YOUR ABILITY TO DRIVE A CAR OR OPERATE MACHINERY, AND MAY CAUSE HEALTHY PROBLEMS.

BITCH FEST

750 ML ALC 14% BY VOL

BACK STAB BING BITCH

FOR THE LOVE OF MALBEC

BITCHFEST LETS WOMEN DO WHAT THEY DO BEST. GET IT ALL OFF YOUR CHEST WHILE VENTING OVER A BIG GLASS, STEIN OR MUG OF WINE.

WE RECOMMEND SHARING A BOTTLE WITH THE LADIES OR HAVING A BIT OF SELF THERAPY AFTER A WONDERFULLY CRAPTASTIC DAY.

THIS MALBEC HAS BEEN BLENDED WITH GRAPES FROM NEAR LOIRE VALLEY IN BORDEAUX, FRANCE. DRINK CAREFULLY, IT GOES DOWN EASY, ESPECIALLY WITH ATTITUDE.

GOVERNMENT WARNING: (1) ACCORDING TO THE SURGEON GENERAL, WOMEN SHOULD NOT DRINK ALCOHOLIC BEVERAGES DURING PREGNANCY BECAUSE OF THE RISK OF BIRTH DEFECTS. (2) CONSUMPTION OF ALCOHOLIC BEVERAGES IMPAIRS YOUR ABILITY TO DRIVE A CAR OR OPERATE MACHINERY, AND MAY CAUSE HEALTHY PROBLEMS.

BITCH FEST

750 ML ALC 14% BY VOL

Art direction
Kenzie V

Project
Bitch Fest

Project description
Wine for the longest time has been cornered into being made for special occasions. Bitch Fest changes the game by making a wine that isn't meant to be savored or kept on the shelf. Bitch Fest lets women do what they do best. Get it all off your chest while venting over a big glass, stein or mug of wine. We recommend sharing a bottle with the ladies or having a bit of self therapy after a wonderfully craptastic day.

Published in the Student Spotlight section on www.thedieline.com

Dirección artística
Kenzie V

Proyecto
Bitch Fest

Descripción del proyecto
Durante mucho tiempo, se ha arrinconado al vino por estar hecho para ocasiones especiales. Bitch Fest cambia el juego haciendo un vino que no está llamado a ser saboreado o dejado en un estante. Bitch Fest permite a las mujeres hacer lo que hacen mejor. Desahogarte mientras vacías un vaso grande, un tanque o un tazón de vino. Recomendamos compartir una botella con las damas o un rato de autoterapia después de un día maravillosamente horrible.

Publicado en la sección Student Spotlight www.thedieline.com

Art direction
Kajsa Klaesén

Project
Vosges Haut-Chocolat

Project description
This is a school project that I did for Louise Fili's food packaging class at School of Visual Arts in New York. It's an imaginary packaging and rebranding project for the existing brand Vosges Haut-Chocolat. I was assigned to design a new box for chocolate truffles. My plan was to make a collection of three boxes with different patterns. The patterns are made using only one single shape, which is also a part of the logotype. The shape is a loose interpretation of the Fleur-de-lis.

Dirección artística
Kajsa Klaesén

Proyecto
Vosges Haut-Chocolat

Descripción del proyecto
Se trata de un proyecto académico que hice para la clase de packaging de comida del centro School of Visual Arts en Nueva York. Es un proyecto imaginario de packaging y renovación de la marca existente Vosges Haut-Chocolat. Me asignaron diseñar una nueva caja para trufas de chocolate. Mi plan era hacer una colección de tres cajas con diferentes modelos. Los modelos se hacen utilizando sólo una única forma, que también es parte del logotipo. La forma es una interpretación poco definida de la flor de lis.

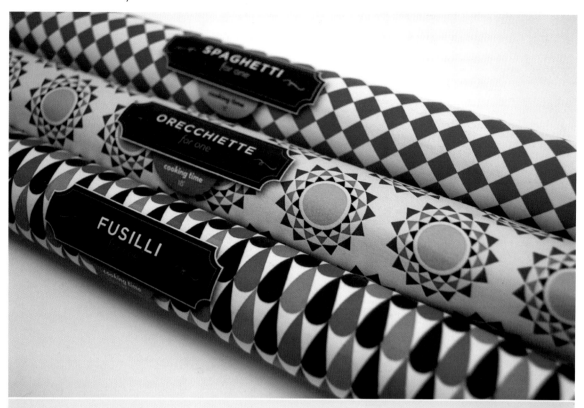

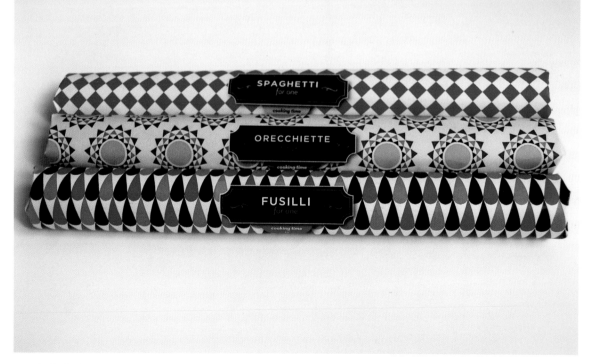

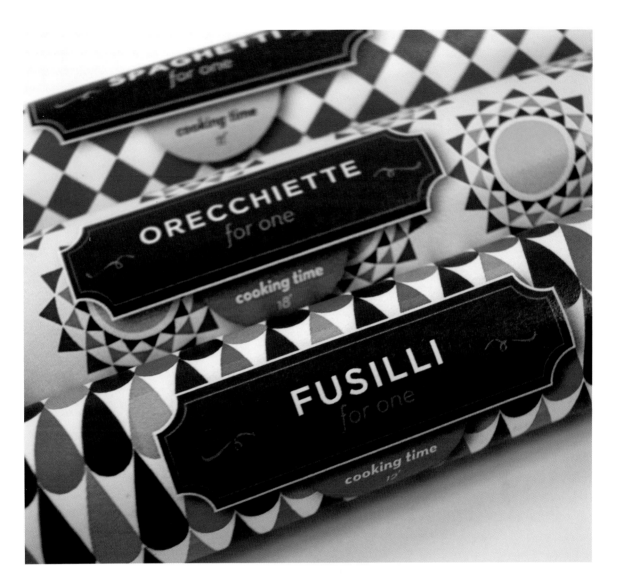

Art director
Alessia Olivari

Dirección artística
Alessia Olivari

Project
Pasta for One

Proyecto
Pasta for One

Project description
Pasta for One is a concept project that explores culinary habits outside of Italy. In all those countries where pasta isn't a diet pillar, single-portion pasta boxes could be a real alternative to standard boxes in order to avoid food waste.

Descripción del proyecto
Pasta for One es un proyecto conceptual que explora los hábitos culinarios fuera de Italia. En todos aquellos países en los que la pasta no es un pilar de la dieta, las cajas con raciones individuales de pasta podrían ser una buena alternativa a las cajas estándar para evitar el desperdicio de comida.

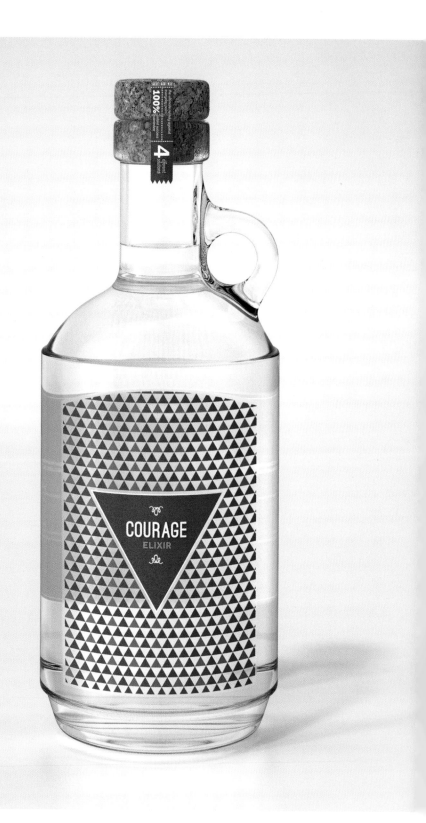

Project
Feel Better

Project description
Feel Better was born from
the idea that our personality
can be improved with
medicines. Sometimes we
wish we were better people,
so wouldn't it be great if
changing was as easy as
taking a pill?

Alessia tried to imagine
how would these magical
medicines look like with
the help of 3D illustrator
Vincent Del Jesus.

Proyecto
Feel Better

Descripción del proyecto
Feel Better nació de
la idea de que nuestra
personalidad puede mejorar
con medicinas. A veces,
desearíamos ser mejores
personas así que, ¿no sería
estupendo si cambiar fuese
tan fácil como tomarse una
pastilla?

Alessia intentó imaginar
cómo serían estas
medicinas mágicas con
la ayuda del ilustrador 3D
Vicent Del Jesús.

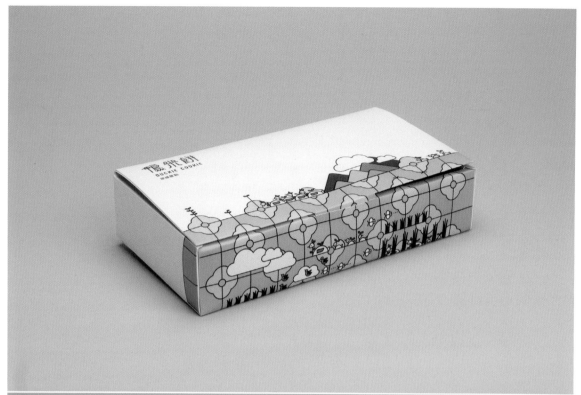

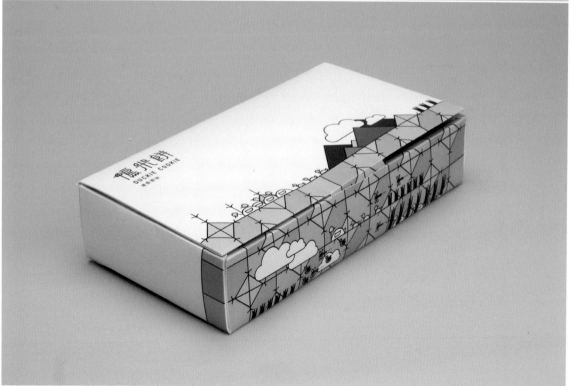

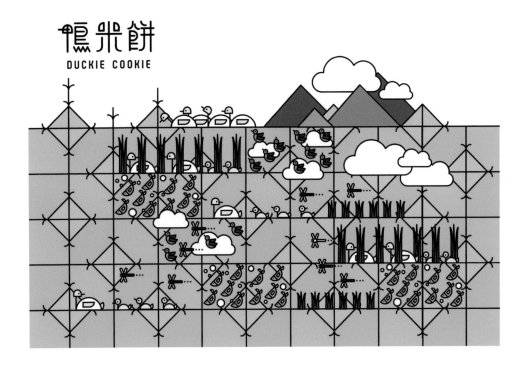

鴨米餅

DUCKIE COOKIE

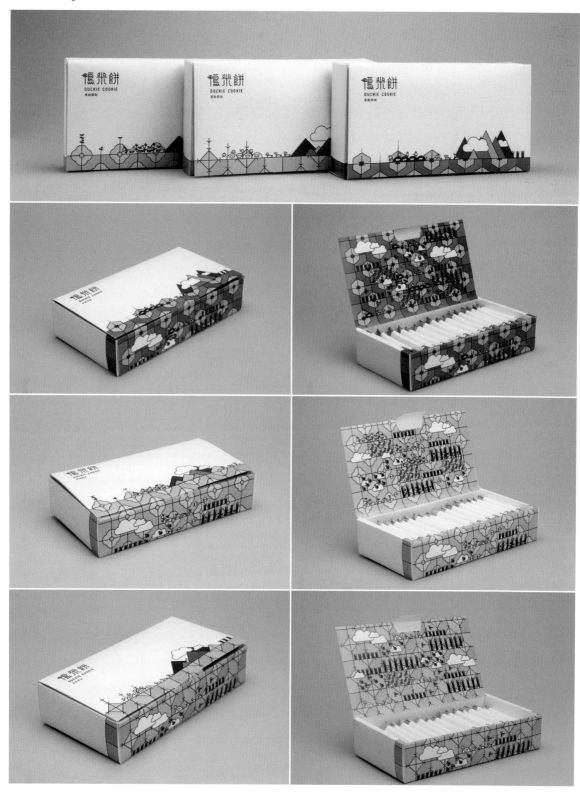

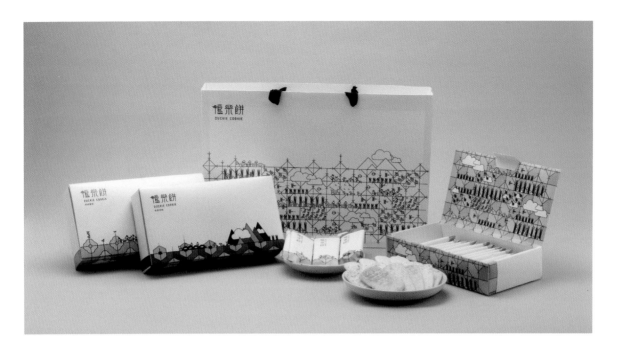

Art direction
Yu-Heng Lin

Project
Duckie Cookie

Project description
Duckie Cookie is a new rice product in Taiwan. There are three main flavors, namely, Fresh Original Duckie Cookie, Sweet Basil Duckie Cookie, and Pepper Spice Duckie Cookie. The cookies made from a kind of special rice, Duck Rice, which is a special natural growing method and new rice-eating culture in Taiwan, Yilan. It's is a great eco-circle that paddies have bugs and weeds; ducks will eat them, and duck's excrement will become the paddies' fertilizer. It's designed with many line-icons in bright color to represent the specialty. The repetition of symbols represents how Duck Rice was grown, and combines Taiwanese window pattern and rice paddy shape.

Dirección artística
Yu-Heng Lin

Proyecto
Duckie Cookie

Descripción del proyecto
Duckie Cookie es un nuevo producto de arroz de Taiwán. Hay tres sabores fundamentales, que son Duckie Cookie, Sweet Basil Duckie Cookie y Pepper Spice Duckie Cookie. Las galletas están hechas de una clase de arroz especial, Duck Rice, que es un método especial de cultivo natural y una nueva cultura de consumo del arroz en Yilan (Taiwán). Es un gran círculo ecológico: los arrozales tienen hierbas e insectos, los patos se los comen y los excrementos de los patos se convierten en abono de los arrozales. Se diseña con muchos iconos lineales en colores brillantes para representar su especialidad. La repetición de símbolos representa cómo ha crecido Duck Rice y combina patrones de ventanas taiwanesas y formas de arrozales.

KOLUMBIA
MEDELLIN EXCELSO

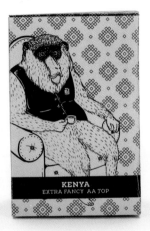

KENYA
EXTRA FANCY AA TOP

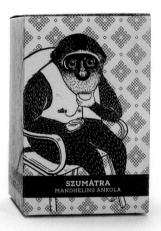

SZUMÁTRA
MANDHELING ANKOLA

mortyblackcoffee.com

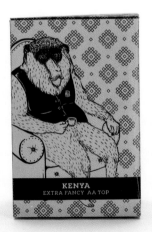

KENYA
EXTRA FANCY AA TOP

Nettó tömeg: 250 g

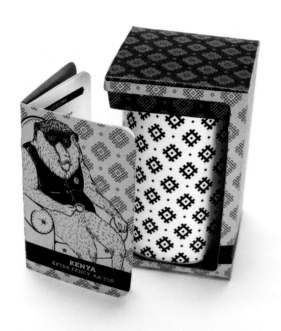

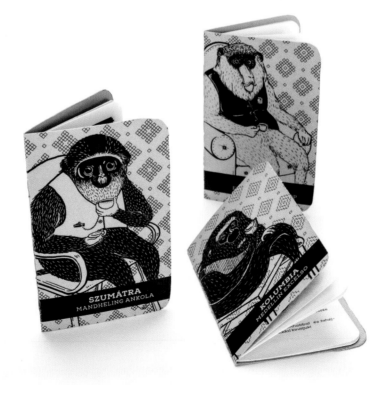

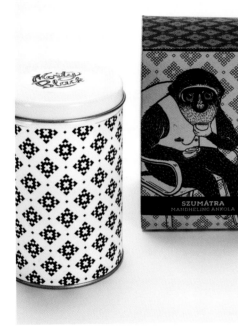

Art direction
Bori Pócsik

Project
Morty Black

Project description
Morty Black is a package design for a fictious coffee brand. "One main element of the design is that I choose a specific monnkey species for each coffee-type's origin country. Technically I wanted to achieve that after unfolding the item, the leadt part of wrapping would go directly into the rubbish."

Photography Geza Talaber

Dirección artística
Bori Pócsik

Proyecto
Morty Black

Descripción del proyecto
Morty Black es un paquete diseñado para una marca ficticia de café. «Un elemento fundamental del diseño es que elijo una especie concreta de mono para cada país de origen del café. Técnicamente, quería lograr que, una vez abierto el paquete, la menor parte del papel del envoltorio acabase directamente en la basura».

Fotografía Geza Talaber

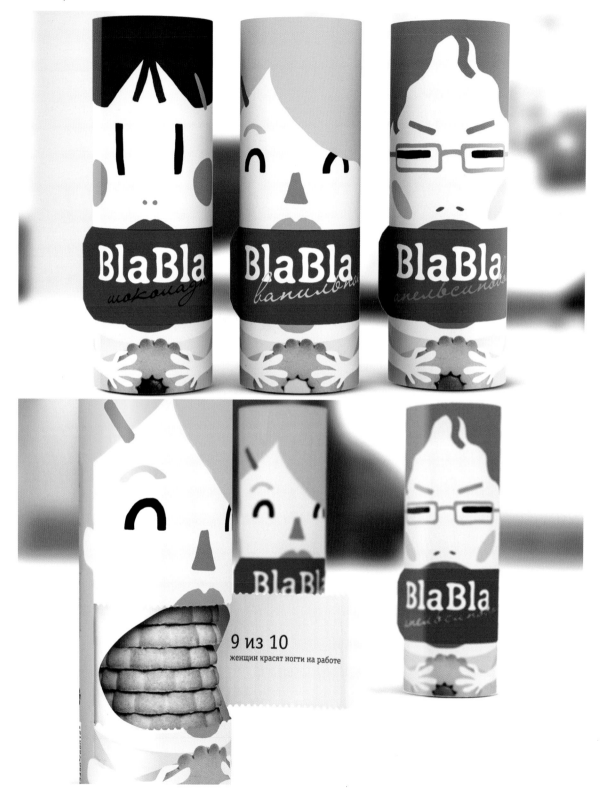

9 из 10
женщин красят ногти на работе

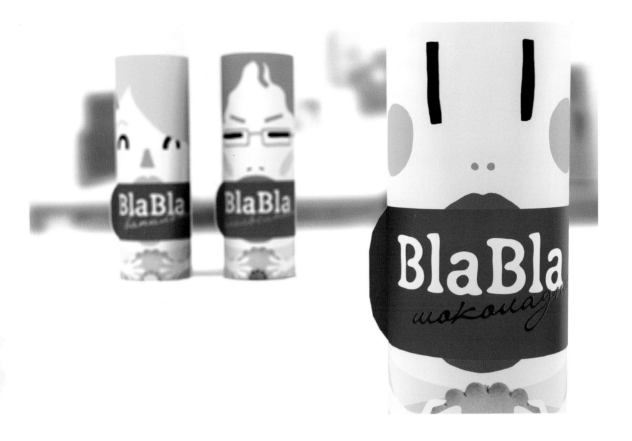

Art direction
Oksana Paley, Adeliya
Koldarova, Zaira Panaeva,
Daria Sapozhnikova,
(students – british higher
school of art and design
moscow)

Dirección artística
Oksana Paley, Adeliya
Koldarova, Zaira Panaeva,
Daria Sapozhnikova,
(students – british higher
school of art and design
moscow)

Project
Bla-Bla Cookies

Proyecto
Bla-Bla Cookies

Project description
There are 3 characters
at the core of package.
Typical office employee,
who can not talk at work:
they are in stiff office
regulations and corporate
labor policy.
But during a coffee break,
they can gossip plenty of
everything. Bla-bla and
so on ...).

Descripción del proyecto
Hay tres personajes en el
centro del paquete. Típico
empleado de oficina que
no puede hablar en el
trabajo: tiene unas reglas
de oficina y una política
laboral corporativa rígidas.
Pero durante la pausa
para el café, pueden
chismorrear de todo. Bla-
bla y eso ...).

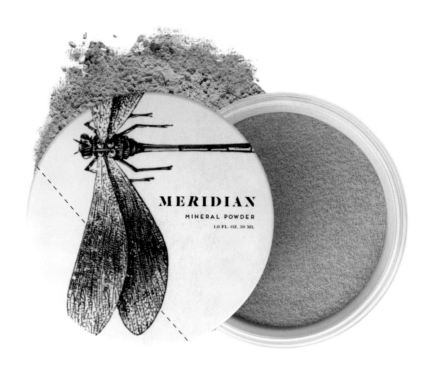

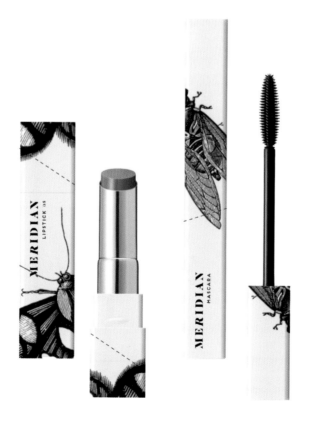

MERIDIAN

INTRIGUING COSMETICS

Art direction
Sally Carmichael

Project
Meridian Cosmetics

Client
None (Student Work)
Branding and Packaging

Project description
Meridian is beauty with deviance. Offbeat, obscure and intriguing, it appeals to women who embrace their oddities and affirm to express them. Meridian aims to dissect the clichéd notions of beauty in order to discover the lovely peculiarities that lie within each of us.

Dirección artística
Sally Carmichael

Proyecto
Meridian Cosmetics

Cliente
None (Student Work)
Branding and Packaging

Descripción del proyecto
Meridian es belleza con aberración. Poco convencional, oscura e intrigante, suplica a las mujeres para que abracen sus rarezas y las expresen. Meridian pretende diseccionar las ideas estereotipadas de la belleza para descubrir las agradables peculiaridades que encerramos cada una de nosotras.

Alessia Olivari

www.alessiaolivari.com

Alessia Olivari is an Italian graphic designer and illustrator. Passionate about music, scientific illustration and craft beer, she spent her childhood drawing for fun. Now, she still draws for both local and international clients. She studied industrial design in Italy and then experienced life abroad in both the Netherlands and Sweden, where she was widely influenced by Northern European approach to design. Today, she is back in Rome where she lives, works...and plays her ukulele now and then.

Though she enjoys working on the computer, most of her work begins sketching. She believes that working on the computer is limiting at the beginning of a Project and sketching helps in exploring different possibilities. Key elements of her work are a strong visual impact that impresses at first sight, clean lines and a great use of patterns.

Her main clients include Save the Children, Fendi and Wienslev.

Alessia Olivari es una ilustradora y diseñadora gráfica italiana. Apasionada de la música, la ilustración científica y la cerveza artesana, pasó su infancia dibujando por diversión. Ahora, todavía dibuja tanto para clientes locales como internacionales. Estudió diseño industrial en Italia y luego experimentó la vida en el extranjero en los Países Bajos y Suecia, donde recibió una amplia influencia del enfoque noreuropeo del diseño. En la actualidad, ha vuelto a Roma donde vive, trabaja... Y toca su ukelele, entonces y ahora.

Aunque disfruta trabajando con el ordenador, la mayor parte de su trabajo comienza con bocetos. Cree que trabajar en el ordenador es restrictivo al principio de un Proyecto y los bocetos ayudan a explorar distintas posibilidades. Los elementos clave de su trabajo son un fuerte impacto visual que impresiona a primera vista, líneas limpias y un gran uso de patrones.

Entre sus principales clientes están Save the Children, Fendi y Wienslev.

Bori Pócsik

Behance.net/boripocsik

Bori Pócsik is freshly graduated graphic designer from Hungary.

Morty Black is a package design for a fictious coffee brand. "One main element of the design is that I choose a specific monkey species for each coffee-type's origin country. Technically I wanted to achieve that after unfolding the item, the least part of wrapping would go directly into the rubbish."

Bori Pócsik es un diseñador gráfico de Hungría recién graduado.

Morty Black es un paquete diseñado para una marca ficticia de café. «Un elemento fundamental del diseño es que elijo una especie concreta de mono para cada país de origen del café. Técnicamente, quería lograr que, una vez abierto el paquete, la menor parte del papel del envoltorio acabase directamente en la basura».

Kajsa Klaesén

www.kajsaklaesen.com

Kajsa Klaesén is a graphic design student and freelance designer currently based in Gothenburg, Sweden. Her main focus is branding and packaging. She strives to always keep things simple and clean, because she believes that is the best way to communicate through graphic design. She also likes to include illustration and patterns in her work.

Right now Kajsa is studying to get her Bachelor degree at HDK School of Design and Crafts in Gothenburg. She has previously done an exchange semester at School of Visual Arts in New York, and attended Dômen School of Fine Arts in Gothenburg. Although she has a background in fine arts, she's always been driven towards design. She thinks it's an advantage to have experience from both fields, but graphic design is just what makes her heart beat extra fast.

Kajsa Klaesén es una estudiante de diseño gráfico y diseñadora freelance que en la actualidad vive en Gotemburgo (Suecia). Se centra principalmente en desarrollo de marcas y packaging. Se esfuerza en mantener siempre las cosas simples y puras porque cree que es la mejor forma de comunicarse a través del diseño gráfico. También le gusta incluir ilustraciones y patrones en su trabajo.

En la actualidad, Kajsa está estudiando para obtener un título de Grado en la HDK School of Design and Crafts en Gotemburgo. Con anterioridad, estuvo un semestre de intercambio en la School of Visual Arts en Nueva York y asistió a la Dômen School of Fine Arts en Gotemburgo. Aunque tiene experiencia en bellas artes, siempre se ha dirigido hacia el diseño. Cree que es una ventaja tener experiencia en ambos campos, pero el diseño gráfico es lo que hace que su corazón lata con mucha fuerza.

Kenzie V

www.behance.net/zieziedesign

Kenzie V was raised in the snow drifts of Wisconsin where she has been creating packages since she was four years old. Inspired by a gift with a much better package, she has been collecting and reconstructing packages ever since. Encouraged by sustainability and presentation, she is always looking for the next collaboration and challenge to take on head first.

Kenzie V se crio en las ventiscas de nieve de Wisconsin donde ha estado creando paquetes desde que tenía cuatro años. Inspirada por un regalo con un paquete mucho mejor, ha coleccionado y reconstruido paquetes desde entonces. Alentada por la sostenibilidad y la presentación, siempre está buscando la siguiente colaboración y el reto para competir.

Lacy Kuhn

www.lacykuhn.com

Lacy Kuhn is a multidisciplinary graphic designer and adventurer from the Pacific Northwest (USA). She has design experience Seattle, London, and Melbourne, specializing in full brand experiences including branding, packaging, environmental, and digital design. She loves traveling, films, and browsing petfinder.

Lacy Kuhn es una aventurera y diseñadora gráfica multidisciplinar del noreste de EE.UU. Tiene experiencia como diseñadora en Seattle, Londres y Melbourne, especializándose en experiencias completas de marcas que incluyen desarrollo de la marca, packaging, medio ambiente y diseño digital. Le encanta viajar, el cine y navegar por webs para la adopción de mascotas.

Matija Blagojevic

www.behance.net/gallery/Milky/4220803

Matija Blagojevic was born in Kraljevo, Serbia in 1988. He completed Bachelor and Master studies at the Faculty of Philology and Arts in Kragujevac at the Department of Graphic Design. Since 2007 he has been actively engaged and participating in all artistic and cultural happenings as graphic designer and multidisciplinary artist. He is the winner of various national and international awards for projects in the areas of packaging design, graphic design and art. Furthermore, he is the founder and director of "216 design fest."

Matija Blagojevic nació en 1988 en Kraljevo (Serbia). Realizó estudios de Licenciatura y Máster en la Facultad de Filología y Humanidades de Kragujevac, en el Departamento de Diseño Gráfico. Desde 2007, ha participado y se ha involucrado de manera activa en todos los acontecimientos culturales y artísticos como diseñador gráfico y artista multidisciplinar. Ha ganado varios premios nacionales e internacionales por proyectos en las áreas del diseño de packaging, diseño gráfico y arte. Además, es el fundador y director del 216 Design Fest.

Milya Ptitsyna

mimimilya.com

Milya Ptitsyna is a graphic designer with 10 years of working experience based in Moscow, Russia.
She graduated ORT College, Moscow State University for Humanities and British High School of Art and
Design (Moscow). She's worked in small branding studios and now she works as an Art Director in Advertising agency Progression group.
Her favourite fields are packaging and branding, but she's interested in digital projects too. In her works she pays a lot of attention to typography and work with the analogue instruments.
Milya thinks that idea and clear communication are fundamental to creating projects.

Milya Ptitsyna es una diseñadora gráfica con diez años de experiencia laboral que vive en Moscú (Rusia). Se graduó en la ORT College, la Universidad Estatal de Humanidades de Moscú y el British High School of Art and
Design (Moscú). Ha trabajado en estudios pequeños de desarrollo de marcas y en la actualidad trabaja como Directora de Arte en la agencia de publicidad Progression Group.
Sus campos favoritos son el packaging y el desarrollo de marcas, pero también está interesada en proyectos digitales. En sus trabajos, presta mucha atención a la tipografía y trabaja con instrumentos analógicos.

Milya cree que las ideas y una comunicación claras son fundamentales para crear proyectos.

Sally Carmichael

www.sally.ai

Sally Carmichael is a designer from Kansas City currently working in San Francisco. Her work has been featured in Creative Review, How Magazine, Badass Lady Creatives, Web Designer Depot, Book Design Blog, App Design Served, Editorial Design Served, and Packaging Design Served. She specializes in publication design, branding, packaging, and illustration. Give her a call.

Sally Carmichael es una diseñadora de Kansas City que en la actualidad trabaja en San Francisco. Su trabajo ha aparecido en Creative Review, How Magazine, Badass Lady Creatives, Web Designer Depot, Book Design Blog, App Design Served, Editorial Design Served y Packaging Design Served. Se especializa en diseño de publicaciones, desarrollo de marcas, packaging e ilustración. Llámala.

Szani Mészáros

www.behance.net/szani_meszaros

Szani Mészáros is a freelance graphic designer in Budapest, Hungary.

She studied graphic design at the Hungarian University of Fine Arts for 5 years.

Her favourite fields are packaging and branding, but she also likes to make more 'alternative' projects, that are not necessarily for a customer, but rather for joy and for having fun.

Szani likes to mix manual and digital works, so a project can become more unique and special. Her plan for the future is to open her own graphic design studio with her friends, which she already started to work on.

Szani Mészáros es una diseñadora gráfica freelance de Budapest, Hungría.

Estudió diseño gráfico en la Universidad de Bellas Artes de Hungría durante cinco años.

Sus campos favoritos son el packaging y el desarrollo de marcas, pero también le gusta llevar a cabo proyectos más «alternativos» que no son necesariamente para un cliente sino más bien por placer y para divertirse.

A Szani le gusta mezclar trabajos digitales y manuales, de modo que un proyecto pueda ser más único y especial. Su plan para el futuro es abrir su propio estudio de diseño gráfico con sus amigos con los que ya ha empezado a trabajar.

Yu-Heng Lin

www.behance.net/Aslin

Yu-Heng Lin is a student studying graphic design at National Taiwan University of Science and Technology in Taipei. Her greatest expertise revolves in the worlds of graphic design, packaging design, Web design, brand identity design and editorial design. Duckie Cookie is one of her work in class. The cookies are made from a kind of special rice, Duck Rice, which is a special natural growing method and new rice-eating culture in Taiwan, Yilan. It's is a great eco-circle that paddies have bugs and weeds; ducks will eat them, and duck's excrement will become the paddies' fertilizer. To communicate the story of products, illustration plays an important role. The style of line-icons in bright color represents its specialty. The repetition of symbols and patterns represents how Duck Rice was grown. It also combines Taiwanese window pattern and rice paddy shape in to the illustration.

Yu-Heng Lin es una estudiante de diseño gráfico en la Universidad Nacional de Ciencia y Tecnología en Taipei (Taiwán). Su gran experiencia se centra en el mundo del diseño gráfico, diseño de packaging, diseño web, diseño de identidad de marca y diseño editorial. Duckie Cookie es uno de sus trabajos de clase. Las galletas están hechas de una clase de arroz especial, Duck Rice, que es un método especial de cultivo natural y una nueva cultura de consumo del arroz en Yilan (Taiwán). Es un gran círculo ecológico: los arrozales tienen hierbas e insectos, los patos se los comen y los excrementos de los patos se convierten en abono de los arrozales. Para comunicar la historia de los productos, las ilustraciones juegan un papel importante. El estilo de iconos lineales en colores brillantes representa su especialidad. La repetición de símbolos y patrones representa cómo ha crecido Duck Rice. Combina patrones de ventanas taiwanesas y formas de arrozales en la ilustración.

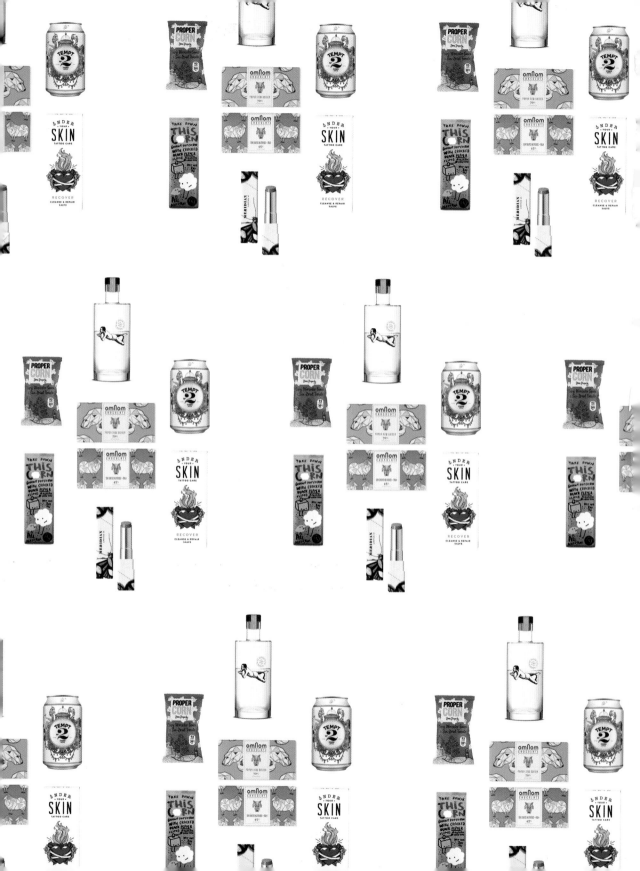